Graceland

GOING HOME WITH ELVIS

Karal Ann
MARLING

Graceland

**GOING
HOME
WITH
ELVIS**

HARVARD UNIVERSITY PRESS

Cambridge, Massachusetts · London, England

Illustrations by the author

First Harvard University Press paperback edition, 1997

Library of Congress Cataloging-in-Publication Data

Marling, Karal Ann.
Graceland : going home with Elvis / Karal Ann Marling.
 p. cm.
Includes bibliographical references.
ISBN 0-674-35889-9 (cloth)
ISBN 0-674-35890 -2 (pbk.)
1. Presley, Elvis, 1935–1977—Homes and haunts—
Tennessee—Memphis. 2. Graceland Mansion
(Memphis, Tenn.) I. Title.
ML420.P96M325 1996
782.42166′092—dc20 96-17477

Designed by Gwen Frankfeldt

ontents

Graceland

Graceland

GOING HOME WITH ELVIS

*G*oing to Graceland

Tourists go to Graceland looking for all sorts of things, not the least of which is entertainment. They don't all believe that Elvis died for their sins and just might rise again during the 8 A.M. tour on a Sunday morning, which is the one they happen to be booked on. It's unfortunate that Protestantism doesn't have official saints to bridge the gap between the here and the hereafter. You could do worse than good St. Elvis, though. Great sinners make great Catholic saints but Americans generally recoil from that much unrestrained wickedness. Elvis Presley's sins were blessedly ordinary ones magnified by money. Fooling around. Lying to yourself. Popping a pill. Sitting on the sofa when there are better things to be done. Our sins. Elvis died of our sins, if not for them, and so will we. It's sad to see the graves in his garden but then it's always sad to visit the family plot, figure out which place is left for you—and contemplate the void.

Graceland's no void, either. It's full of things, crammed into corners and crowded onto shelves. All the cabinets have at least one compartment with a solid wooden door. You know they barely got that door to close. Company's coming. You do the

white tornado number and sweep up a month's worth of pencil ends, Cracker Jack prizes, loose change, and dog-eared supermarket paperbacks in twenty seconds. You shovel everything into the nearest receptacle, slam the door, and pray. Graceland strains and bulges with that kind of secret stuff. It's like looking at your own living room through the eyes of the Avon lady.

Albert Goldman, who hated Elvis, said in his biography that nothing in the whole house was "worth a dime." Well it isn't so. Those of us born any time between 1935 and 1977—the Age of Elvis—can tell you to the dime what everything in Graceland is worth, in hard cash, in hours of overtime, in months of dropping quarters into polyvinyl pigs. The Price-Is-Right generation can extrapolate the dollar value of Elvis's extra-long sofa from the cost of normal models without breaking a sweat. When the dining-room guides tell tour groups the name of Elvis and Priscilla's Noritake china pattern, you can watch the mental calculators start to work. Everybody's got a niece who listed Noritake on her bridal registry. Everybody, at one time or another, priced the gravy boat and settled for a salad plate.

The house is full of things that we all have or used to have, or used to want, or hate. Ashtrays. Plastic plants. TVs everywhere. White wall-to-wall in the living room. A stained glass room divider. Graceland is a historical marker in time not-quite-past. We still remember rooms like these—and live in them besides. The blue and white living room, the white chairs with the fat upholstered feet, are elegant in some absolute sense. But they're also slightly out of style, like the houses of people who don't, who can't toss everything out every five years and start over.

The den doesn't match anything. If the living room suggests being thirty-five and prosperous in the early '80s, with a point to make to guests, the den is seedier and younger. The memories aren't in sync. But then, they never are. I put in my new kitchen

in 1981, when white appliances were all the rage. I redid the bedroom four years ago, when pink and blue were everywhere. Same house. Different times and different memories. Layers of time, none of them really gone.

Historic houses are peculiar places, austere and unreal. Try to imagine staying overnight. How would you brush your teeth at Mount Vernon? Could you read in bed there? What's for breakfast at Monticello? Tell me how Biltmore would smell at breakfast or at lunch. In Graceland, there's no need to imagine. It's plain as day. We've been here before. When Elvis's Aunt Delta still lived in the house, she used to leave the kitchen door ajar. The machinery of real life showed and the smell of bacon settled in the den during morning tours. When we are gone, you and I, with our waterpiks and percolators, maybe Graceland will look historical and dead. For now, the house quivers with the shock that clings to places where life has been interrupted, stopped dead in its tracks. Death and sorrow came here, to a place we know, down to the price tags on the ashtrays. And they will come for us some day.

Graceland and the other places Elvis Presley stopped at and lived in and marveled over along the way all bear the marks of living, the scars of hard use. Memories cling to them, even when the memories are Elvis's, and he is dead. But we still live here, in these same places. We add things to them. We take things away. The world of houses and hotels, housing projects and tourist traps comforts us or kills us. It sings to us, in lovely words like Tupelo and Tennessee. In the glow of neon lights along dark streets, it makes us into creatures of the night, all blue or red or pink. It summons up the Civil War in a fusillade of pediments and columns. Howdy Doody in a picture window. Ghosts walk through houses, calling out our names. Ghosts walk through Graceland alongside every tourist, whispering softly about the places we call home.

Elvis probably *is* everywhere, as Mojo Nixon's tribute song insists. But not among the crowd of pilgrims who shuffle through his house every day except Christmas, listening to the whispers. He's dead all right, and that's the point of coming. When Greil Marcus puts "dead" first in the title of his book, he means to say that Elvis is as much a force in the world of the living as he ever was. *Dead Elvis*. Sexy Elvis. Las Vegas Elvis, pictured on a calendar or a wristwatch, in a costume dipped in diamonds. Video Elvis, thin as a rake and handsome as ten movie stars, forever. Take your pick. But in some essential way, he's gone from here. Graceland is our house now, bought and paid for with the price of a ticket. Elvis has left the building. The story that the silent walls have to tell is our story. Softly and tenderly, the ghosts call our names.

Mississippi

*T*upelo: blue lights, shotgun shack

There they were, heading northwest, on the road to Memphis, with the morning sun behind them, shining hot through the big back window, hot on the trunk of the mole-colored Plymouth coupe. Highway 78 on a sunny Sunday, angling through the cool, dark hills and forests of northern Mississippi toward the Tennessee line and Memphis, 102 miles up ahead.

Back in Depression times, when the '37 Plymouth was new, the government worked on the roads outside Tupelo. The WPA made the old gravel tracks so straight and smooth that drivers martyred themselves to demon speed all over Lee County. But not today. The battered two-door Plymouth limped along toward the city. Curved and chromed and streamlined for speed, the car was slow and quirky now, in its antiquity. The father steered. The son, age thirteen, sat close beside him and pressed down hard on the balky accelerator. September 12, 1948. Sunday morning on Mississippi State Highway 78, with Tupelo a distant glimmer in the rear view mirror.

The mother had gathered up her sheets and her pans again: she was used to moving. The boy had sung one last song for his

schoolmates, a sad song he heard on the radio called "A Leaf on a Tree." The father had loaded up the car in the chill darkness of midnight, in a spill of yellow light from the doorway of another rented house in northeast Tupelo, on the edge of the black ghetto known as Shakerag. "We were broke, man, broke, and we left Tupelo overnight. Dad packed all our belongings in boxes and put them on top and in the trunk . . . We just headed to Memphis. Things had to be better."

Jesus, Mary, Joseph. Elvis, Gladys, and Vernon. The flight into Egypt. To *Memphis* no less, from the very spot where the Mississippi Delta is said to begin. It's purely mythic in the telling—biblical: Egypt, Memphis, and the Delta; flight, danger, and destiny.

Vernon Presley was a great storyteller, in the Faulknerian mode. Reporters couldn't get enough of him, but he also buttonholed his son and any number of startled, half-stoned musicians and regaled them over the years with long, meandering, dynastic tales, full of twists and oddities and portents. Vernon's favorite story concerned the birth of his only living child, in January 1935, back in East Tupelo, on the wrong side of two separate sets of railroad tracks. The lying-in was a state occasion, as he remembered it, with a houseful of humble retainers in attendance, a mysterious blue light hovering over the room, and his own father pressing Gladys's distended stomach after the delivery of a stillborn boy and discovering—Hallelujah!—a second baby, a miracle baby. Identical twins, Vernon insisted, alike in every way—except that poor little Jesse Garon was cold and dead and buried in a shoebox tied with a red ribbon while little Elvis Aron squirmed and cried for his mama's breast. The Bethlehem story, only better.

The Vernon Presley version of the flight into Egypt was a real hair-raiser, too. There they were, the Presleys, poor but honest, living in Tupelo proper now, still on the shady side of the Gulf, Mobile and Ohio right-of-way, but in Tupelo nonetheless, a step up from *East* Tupelo. Then, late one night in the steamy summer of 1948, a terrible argument broke out next door, at the house of a taxi driver. The man's wife screamed in the darkness and then fell silent. In the hours before dawn, strange muffled noises were heard in the backyard, furtive sounds. At first light, the whole neighborhood could see a hummock of fresh-turned earth and the cabby sitting red-eyed on his porch.

Birthplaces of the great were once major features in the landscape of nineteenth-century tourism, along with lowly dwellings that such personages had occupied before fate came knocking. The fashion peaked at the turn of the century, when world's fairs vied for the honor of displaying important historic habitations.

The St. Louis Fair of 1904 had record numbers of these traveling house museums, including the Kentucky log cabin in which Abraham Lincoln was said to have lived at the age of four. Set up indoors to protect it from the elements, the cabin made a profit of $2,099.14. St. Louis also boasted a reconstruction of the Scottish birthplace of the poet Robert Burns, a copy of the New Hampshire birthplace of Daniel Webster, the actual cabin in which U. S. Grant had lived in Missouri before his call to save the Union, and the cabin in which Teddy Roosevelt had dwelled as a young man in the Dakota Badlands. The purpose of the displays was to show that humble beginnings were no impediment to future success. Log cabins seemed to make the point best: the cruder the cradle of greatness, the more dramatic the rise of poet or president appeared.

Today, you can visit the birthplace of John Wayne off US 169 in Winterset, Iowa, west of Des Moines, or the boyhood home of JFK within the Boston beltway. But the old didactic theme retains its strongest allure in the South, where it has become part of the mythological structure of country music. Loretta Lynn's three-thousand-acre museum-of-myself complex in Hurricane Mills, Tennessee, near Nashville, contains a replica of her childhood home, her grandfather's log cabin in Butcher Holler, Kentucky (theme of her well-known song "Coal Miner's Daughter"). With its iron bedsteads, rickety chairs, and newspaper-for-wallpaper decor, the house is a roomier version of the Elvis Presley Birthplace in Tupelo. The difference is that her own home, a becolumned white antebellum mansion, stands nearby, so that the lesson is absolutely clear. From sturdy roots in the soil of the Southland grow columns, crystal chandeliers, and block-long cars.

Two weeks later, by the light of bobbing kerosene lanterns, the authorities came to dig behind the house. They found the decapitated corpse of the wife. Word along Green Street was that the murderer had kept the head in the front seat of his taxicab, just for company. Or had flung it from the driver's-side window into somebody else's bushes. Scared out of her wits, Gladys told Vernon to pack the car that very minute. The Presleys were going to Memphis. It was a genuine flight into Egypt, just like the Good Book said. The Presleys were going to the Promised Land.

Or was Vernon thinking of that other flight *out of* Egypt chronicled in Exodus 16—the Israelites hastening across the featureless wasteland on the bottom of the Red Sea with Pharaoh's armies nipping at their heels? The Green Street grapevine said that Vernon had been running bootleg liquor up Highway 78 to Memphis for years; the law was closing in fast. On those forays into Tennessee, he drove by night, with Tupelo at his back, through an inky landscape haunted by the awful shapes of ordinary sheds and fences masked in kudzu vines, watching for bright lights in the rear-view mirror, listening for sirens in the darkness. Evil and goodness. Sin and redemption. Saturday night and Sunday morning. In the clear light of a September dawn, with East Tupelo and Tupelo and fear and failure behind him, Vernon Presley steered toward Memphis through the Sunday sunshine in search of miracles and wonders.

Prophecies and miracles. The musical Presliad—all the maudlin psalms and dirges written after August 1977, when Elvis died—is full of them: "The King will walk on Tupelo. Tupelo-o-o! O Tupelo!" But Tupelo itself has always been a little wary of wonderment. The Tupelo Museum in Ballard Park, on the far west side of town, makes a virtue of prosaic things. There are historic fire trucks and ladies' hats of the '40s and '50s. A mock-up of a local movie palace like the downtown Strand or

the Lyric in the days before television. The contents of a turn-of-the-century drugstore. A sickly-looking mannequin in a wheelchair is dressed up as FDR, who came to town in November 1934 to announce the founding of the Tennessee Valley Authority. In 1936, Tupelo became the first city in the New South to use the power provided by TVA dams, although the high-tension wires didn't reach as far as East Tupelo, out near the Birmingham cutoff, where the Presleys and their surviving infant lived. In the museum, in among the hats and the theater seats, the Elvis Presley birthplace on Old Saltillo Road is represented by a homemade wooden model about the size of a walk-in playhouse for a three-year-old. It's a big dollhouse, a cheerful, well-wrought toy that turns Vernon's spooky story about blue lights and miracles into an A+ project for a high school shop class. The Tupelo Museum is not given to wide-eyed hagiography.

O Tupelo! Machine Gun Kelly, they say, once robbed the Citizens State Bank of Tupelo of $17,000. Reed's Department Store held the country's first twenty-four-hour sale sometime during the 1920s. The Yankees burned the town down after a two-day battle at the tail end of the Civil War. In 1916, boll weevils ravaged the cotton crop. A town like any other Southern town. But in 1936, at 9:04 on a sultry Sunday night in April, a twister boiled out of the heavens over Tupelo, killing 235 people and injuring 350 more. The tornado laid waste to forty-eight city blocks. The church directly across the street from the Presleys' house was flattened. Yet little Elvis was saved. A portent? A miracle? Legend has it that Hernando de Soto tried to make camp near the site of Tupelo on his great Mississippi River expedition of 1541—until the Chickasaw Indians ran him off, that is: Indian names still adhere to the natural features of Lee County, to creeks called Chiwapa and Tishomingo. Elvis Presley's future mansion in Memphis, Tennessee, was built in 1939 of white Tishomingo stone, specially shipped in by the original owners. Coincidence or prophecy? O Tupelo! "Premier City of Northeast Mississippi," according to the old Chamber of Commerce slogan. "TVA City." And "Birthplace of Elvis Presley."

The birthplace used to be on Old Saltillo Road, at number 306. The address reads Elvis Presley Drive now. The little house used to be in East Tupelo, a place so poor and mean the city only got around to annexing the district in 1948, after the family left. Today, it's Presley Heights, suburbanized, aspiring to a modest grandeur. In this hilly section, on the road that meandered north until it met Highway 78, Vernon built the Presley place with his own two hands in 1934. He was eighteen years old that summer, tall, broad-shouldered, handsome to a fault, shiftless, generally, and about to become a daddy. Jessie, his own father, and his brother Vester, who lived about thirty yards to right of the homesite in the family's "big house," both helped out with the work. But the new house was Vernon's show:

hree blocks from US 220, in the side yard of Kim and Don Epperly's bungalow at 605 Riverland Avenue, Roanoke, Virginia, stands Miniature Graceland. Kim is the real Elvis fan, but Don built the tiny townscape from odds and ends while sitting on his porch, watching tourists ooh and aah over his Ken-and-Barbie-sized village of significant Presley habitats. He made the Music Gates outside the four-foot Graceland out of scraps of wire and copper tubing; stone is simulated by sand dropped onto wet paint. The roof of the house flips up like the lid of a music box for easy cleaning.

Kim has a collection of full-scale memorabilia, too, including a towel stolen from Elvis's poolhouse. But the small size of this Elvis world—Graceland (with gates, plastic pool, barbecue, and Meditation Garden), a garage full of Elvis vehicles, the Heartbreak Hotel restaurant complex across the highway from the house, three airplanes, Vernon's Memphis home, the Roanoke Coliseum where Elvis had been scheduled to perform eight days after his untimely death, the country church the Presleys attended in Tupelo, and of course the birthplace—gives the maker and the visitor the comforting illusion of control.

In *The Great Gatsby*, F. Scott Fitzgerald's rags-to-riches hero is astonished to hear that he can't repeat the past and make it better. At Miniature Graceland, why not? Fill the Roanoke civic center with a doll audience in little spangled outfits, and let a ten-inch Elvis rock on, long after August 16, 1977. Open the roof of the shotgun house in Tupelo, and sprinkle in some fairy dust to keep the mama doll and the papa doll and the baby doll safe and happy forever. Ten thousand guests come every year to feel those feelings.

The birthplace complex at Tupelo is hoping for 60,000 paying visitors this season. Tickets to see the house cost $1; the museum is another $4. Miniature Graceland is free.

Vernon, the carpenter of East Tupelo. Being a carpenter may have been the only thing he was ever really good at. The house still stands, square and true, after sixty years of mudslides and hailstorms and sporadic restoration. The rain blasts on the roof like the trumpet of Judgment Day, sounding inches above the tourist's head. No attic here. No cellar.

The birthplace is a shotgun house, a wood frame house perched up on piles of rocks to let the rainwater and the spring floods pass underneath. One room wide, two rooms deep, a shallow gable end facing the street, with the roof extended to form a porch supported at each corner by a spindly two-by-four. There's no porch in back, just a stoop. If you were to open the front door on the right-hand side of the porch and the back door over the steps, you could fire a shotgun right through the house without hitting anything.

The experts think the narrow dwelling type aligned just so came to the South through New Orleans, built by free blacks, who brought the idea with them from Africa, by way of Haiti. The front of the typical shotgun house looks Greco-Roman, somehow, with its hint of a pediment and a pair of emaciated columns. The interior disposition—one room lined up behind another—is un-classical, un-Western, and deeply mysterious, like the layout of a mummy's tomb. Vernon divided his house into two perfectly square rooms, the bedroom in front, the kitchen behind it. Four hundred fifty square feet, all told. The structure is precisely thirty feet long (ten steps from front to back) and fifteen feet wide, a 2:1 ratio maintained in the proportions of the windows, too. Two plus one equals three. Each room has three windows: Jesus, Mary, and Joseph the Carpenter; Elvis, Gladys, and Vernon.

Although Vernon did the work, the house and the lot it stood on belonged to Orville Bean, the squire of East Tupelo. For part of 1934, Vernon drove one of Bean's milk trucks, and it was

from this wily entrepreneur that he borrowed $180 for nails and lumber to build the shotgun, a little barn, and an outhouse. Every tongue-and-groove board he fitted, every chimney brick he laid was someone else's. He was Bean's tenant, pledged to pay rent each month until the loan was retired. In practice, such loans were seldom paid off in East Tupelo. Something always happened. There was the matter of Vernon and the pig, for instance. Vernon and two of his kinsmen sold a pig to farmer Bean for $4, but the check they cashed read $40. Arrested in 1937 for forgery, Vernon went to jail and then off to Parchman Farm, the toughest, nastiest prison in the Delta. In the meantime, the house payments came due, and in 1938 Gladys was evicted along with her tow-headed boy-child, who was not quite three. There was no room in the inn, no room in the manger his own father had built.

The tiny house looks better today than it did back then. The white paint is sparkling fresh and every June the trim gets touched up in time for the tourist season. In the '30s, once an East Tupelo house was given a primer coat to seal the wood, it was never painted again. Gladys used oil lamps; there are electric ceiling lights in both rooms now. Wallpaper, knickknacks, pretty curtains, a sewing machine, thick green grass, and a boxwood hedge around the foundation to mask the missing basement. Railings on the porch steps and a porch swing on chains. A screen door. A brick walkway of faux-antique design. Cute. The place is cute—a fairy-tale cottage, out of a storybook, quaint and sweet. A doll's house full of things that never were.

Blame the paint and the Depression-era geegaws on the East Heights Garden Club. Chalk up the cuteness to tourism. In a dilapidated state, the house had been open for the inspection of diehard Elvis fans since 1971, but even Tupelo boosters were unsure of its location then. During a 1961 press conference in Memphis, Elvis told a reporter that he'd driven down to Tupelo

himself a few weeks earlier, to check on the progress of a youth center slowly rising behind the house, thanks to the proceeds of two appearances there in 1956 and 1957. The sign that marked the spot had fallen over in the wind. "We tried to put it back up," he said. "And it fell on us. There was three of us trying to lift it back up." His friend Eddie Fadal remembered another late afternoon run to Tupelo in 1959 and that same "Birthplace of Elvis Presley" sign lying face down on the ground, in a tangle of weeds. Until 1977, when any spot connected with the earthly sojourn of the late Elvis Presley became precious, Tupelo had treated its native son with the same indifference nearby Oxford, Mississippi, once lavished on William Faulkner.

Posthumous fiddling with the birthplace has prettified the sullen face of Southern poverty: the Presleys pumped water by hand and used an outhouse, like characters in a Faulkner novel. The walls were bare boards. Gladys didn't have rugs or curtains, checkered tablecloths or a sewing machine. For many years to come, the family wouldn't have a radio, either, except in the trucks Vernon drove from time to time. In the '40s, Elvis used to sit out in the yard, in the front seat of the truck, to listen to the Grand Ole Opry broadcasts from Nashville. The yard on Old Saltillo Road had no carpet of lush green grass. It was a square of hard-packed Mississippi dirt, a spot for the chickens to peck at, scoured clean every morning with a homemade dogwood broom. In the heat of the day, the flimsy shotgun shack was an oven. Folks sat on the porch after supper, hoping to catch a breeze, listening to hillbilly music on the radio in somebody else's truck. The birthplace of Elvis Presley wasn't cute in 1935.

The new, improved birthplace makes sense from Tupelo's point of view. The mills, the railroad lines, the big milk process- ing plant, the TVA: in the New South of the 1930s and '40s, with the gospel of progress affirmed daily by signs like these, the

stubborn poverty of Old Saltillo Road amounted to blasphemy. But in its just-minted perfection, the shotgun shack no longer bears the stigmata of a dirt yard and an outdoor privy. The calico-and-cuteness version of the Presley house sustains a country life mythology that goes back to Jefferson: it stands for simplicity, self-reliance, plain living—the same cluster of imagined virtues postwar suburbanites used to justify their private obsessions with crabgrass and touching up the trim once a year. East Tupelo, after all, is Elvis Presley Heights nowadays, suburban Tupelo in all its glory.

For Elvis Presley, the memory of Tupelo sustained another kind of myth, at once intensely personal and so universal as to be called the American Dream, the old dream of a lightning rise from rags to riches. In pain and wonderment, he drove back to Mississippi at odd moments over the years, often late at night, pulled over in front of the shotgun house, killed the headlights, and sat there in the dark on the uphill stretch of Old Saltillo Road, thinking about the course his life had taken. Except for the rich Midwestern motorists who stopped overnight on their way to Florida, for a long time Elvis was Tupelo's only regular tourist. Vernon bought Elvis his first car in March 1953, for $50: a pale green '42 Lincoln Zephyr, a sharp car once upon a time. Giddy with joy, Elvis rounded up his high school buddy Luther Nall and tooled off down to Tupelo on four bald tires to show Luther the house in which he had been born. They sat in the dark for a while and looked at the house, had a Coke, and drove home again. Elvis wasn't famous then. He wasn't rich. He was just a kid from the Memphis projects and Humes High, enthralled by his own birthplace. Sitting in the dark wondering about the blue lights, the dead twin, about miracles and destiny.

In the early '50s, people spotted Elvis downtown, too. The birthplace run often included a stop at Tupelo Hardware, where

Gladys had bought Elvis his first cheap guitar. The owner thought young Presley dressed to impress in bright colors and slicked-up hair when he sauntered in with his Memphis friends to look over the guitar picks. For his big homecoming concert in 1956, the new RCA recording star wore a blue velvet poet's shirt with sparkly silver buttons, an outfit his mother had fixed for the occasion. There must have been a sweet irony to the festivities Tupelo staged at the fairgrounds on that 100-degree September day. Eight years before, the Presleys fled Tupelo with all their belongings tied to the carcass of an old car. Now they were back, Vernon, Gladys, and Elvis, driving a showroom-new orchid-purple Cadillac. Mayor Jim Ballard solemnly presented Elvis with a three-foot-long key to the city, in the shape of a guitar. A giant banner strung across Main Street welcomed home "Tupelo's Own" favorite son. There must have been a special satisfaction in the deal Elvis struck with Tupelo to donate the concert take for creation of a new youth center, provided the city built it right behind the lot on Old Saltillo Road and acquired the birthplace site with city funds. The house that Orville Bean had once foreclosed on would someday be a civic monument to orchid-colored Cadillacs and dreams come true.

Whatever Tupelo had meant to Elvis Presley before September 1956, thereafter it became the benchmark against which all his worldly success could be judged with absolute precision. During army service in Germany, Elvis went to Paris on leave, and was persuaded one morning to watch the sunrise over Notre Dame and the shimmering Seine. "They never had anything like this back in Tupelo," he sighed. The Eiffel Tower was a long way from northern Mississippi. He never tired of telling guests at his twenty-three-room mansion on the Mississippi side of Memphis that you could set the house on Old Saltillo Road down in the middle of Graceland's living room and still have space left over. It wasn't a boast. It was a fact. There was awe and puzzlement

in his voice. Why me, Lord? To a poor boy from a shotgun house on the wrong side of Tupelo, Graceland was a miracle.

But Tupelo was always there, just down Highway 78, full of meaning, a question in need of an answer, a prophecy surely yet to be fulfilled. "I love it here," he told the mayor and the dignitaries during his 1956 visit. "I'll come back as often as I can." In 1955 hardly anybody had noticed when Elvis, in wild pink and black pegged pants, came back to sing in Tupelo along with Johnny Cash and Webb Pierce: only 3,000 brought tickets. A mob of 50,000 turned out in 1956. Late the next summer, wearing his famous cloth-of-gold suit from a Hollywood tailor, Elvis returned for another series of sold-out shows at the fairgrounds to pay the remaining bills for the youth center, the thirteen-acre parkland around it, and the guitar-shaped swimming pool called for in the ambitious plans. The park, the ballfield, and the pool redressed old wrongs: the city fathers admitted that the center was the kind of facility Tupelo hadn't provided for Elvis when he was growing up poor on the east side of town.

But a first-class Tupelo park had no place, in the end, for the baleful relics of once-upon-a-time poverty. Take the Presley birthplace, the derelict shotgun house on Old Saltillo Road. If you had to have a house like that in a city park, it had better be a pretty-as-a-picture, snowy white shotgun house with crisp black trim, floating on a nice green lawn. Vaguely Old South. A spit-and-polish shotgun house right out of a Hollywood movie about cheerful sharecroppers. Something like Graceland, only smaller. A sort of backwards prophecy, the new and improved birthplace offered for inspection the 1970s read Elvis Presley's past by the blinding light of his eventual stardom. Improving history is a process not without its hazards. In Tupelo, on the green lawn of his birthplace, the gilded present met the well-scrubbed past and the circle of life snapped shut. There was, it

appeared, no undiscovered future still ahead, at the end of Highway 78, no more dreams left to come true.

In the clouded years after his 1973 divorce, Elvis Presley brought his little daughter Lisa down to Tupelo to sit outside the house with him in a fancy car and wonder what it meant. Was this all? Just Graceland and Vegas and one-night stands and Cadillac-giving sprees? Or had the blue lights promised more? It seemed as though the answers ought to be here, in the place where life's long journey had begun. After Elvis died and Tupelo gathered to plan a suitable tribute, a friend said that he would have liked a little church in the park. While looking at recent pictures of the birthplace and making the usual jokes about its size one night at Graceland, Elvis had suggested a chapel "so my fans can go and meditate and reflect on their own lives" just as he did. Maybe they would find the answers that eluded him.

The Elvis Presley Memorial Chapel was dedicated in 1979, on the second anniversary of his death, and was financed by contributions from admirers. A concrete walkway winds up the slope from the birthplace, in the southwest corner of the park, through Vernon Vale and Gladys Glen. It is cool inside on the hottest summer days. When the sun shines, the interior is aglow with beautiful stained-glass windows, the largest of which seems to show a figure in a white jumpsuit and a cape, arms uplifted, straining toward the heavens, as if to find the answers. There is only one clear-glass window in the whole building. That window frames the white shotgun house, as if to suggest a silent conversation between tourist, Elvis, and the ineffable. What did it mean, Elvis? What does it mean? Your little white house at the Mississippi end of Highway 78.

In 1992 the Youth Center became the Elvis Presley Center. The kids still have their baseball diamonds, but the brick building (except for a pair of dank restrooms around back) is now a souvenir shop and a new Elvis museum—"Times and Things

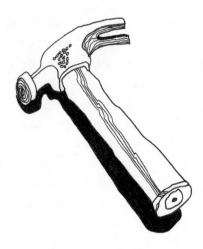

Remembered." Like other fan collections that used to be on view in stops along the tourist circuit, the displays are odd, too intimate and too banal all at the same time, embarrassing and boring. The effect is like pawing through the closets of a mere acquaintance, unbeknownst to him, for no particular reason: old clothes, worn shoes, dog-eared albums, used towels, a pair of coffee cups with the dregs left to dry in the bottom. The room smells funky and human and sad. The nervous, hard-faced women who run the place follow you from case to case, expecting trouble. The best thing in the whole museum is the hammer that built the birthplace.

Elvis's things seem bereft without him. The hammer is useful, unsentimental, impersonal. Outside, not ten steps away, a man with a paintbrush in the back pocket of his overalls is standing on a ladder, hammering on the side of the shotgun house, on the bedroom wall, just under the eaves. Hammers have a present tense, like Highway 78 that still unrolls toward Memphis in the clotted light of a humid June afternoon. Since December 1977, Route 78 through northern Mississippi has been officially known as the Elvis Presley Memorial Highway. The road map shows it as a thick blue line from Tupelo almost to Myrtle, from

Memphis to just past Holly Springs. A main road, a parkway made for speed without stoplights or crossroads. In between, through a stretch of National Forest, the line turns red for no apparent reason. There are detours in the summer, when construction crews are working. Guidebooks warn of speed traps. But the view is pretty much the same from end to end, detours or no. Greenery. Small white houses with hollow aluminum columns wavering in a line across the front porch. Patches of hard-packed dirt. Tupelo in the rear view mirror and Memphis up ahead.

Oxford: Mr. Billy's mansion

Oxford, Mississippi, is a beautiful, torpid place. It spreads itself out in the summer sunshine in two sleepy pools of inactivity. Gown and town, Ole Miss and Oxford proper. The University of Mississippi campus is a greener version of downtown, arranged in a flourish of antebellum columns around the leafy commons known as The Grove. The nearby business district is a classic courthouse town, laid out in a hollow square around an imposing seat of power and justice. Courthouse Square.

The Lafayette County Courthouse faces due south, down Lamar Boulevard. In front of four Corinthian columns that uphold the pediment above the entrance stands a ghostly rebel trooper on a tall column of his own, put there by the United Daughters of the Confederacy in 1907. The marble soldier has laid down his rifle. He gazes southward down Lamar Boulevard, brooding over defeat and ruin and the end of the Old South. The Union army swept through Oxford and torched the courthouse in August 1864. It was rebuilt nine years after the War Between the States, the blackened columns on the southernmost facade shining whiter and prouder than ever before.

The square in which the courthouse stands dates from the 1870s and '80s, mostly. Only one small structure on the side closest to the monument survived the fire. In a fierce afternoon rain, you can walk almost all the way around the square under awnings and overhangs, looking in the windows of the bookstore (the old drugstore), the jeweler's, the ladies' clothing store, the three-story Thompson House hotel, and Neilsen's, the oldest department store in the South and the first business in Oxford. The circuit ends back at the pale stone soldier and the courthouse.

In 1947 there was talk of tearing the courthouse down, in the name of progress. William Faulkner, Oxford's best-known native son, raised a fuss and the building was saved. In his novel *Requiem for a Nun*, published in 1951, Faulkner told how General Smith and the Yankees burned out the inside woodwork in 1864 but were frustrated in their efforts to pull down the sandstone columns. A plaque at the south entrance of the building, behind the trooper on his pedestal, quotes Mr. Billy Faulkner of Oxford on the subject of the Southern courthouse: "The center, the focus, the hub . . . looming in the center of the county's circumference . . . laying its vast shadow to the uttermost rim of the horizon."

Oxford is a self-contained place, the hub of its own universe, a city built of hollow squares and circles that turn inward on themselves in twilight reverie. The soldier looking south from Courthouse Square in the gathering dusk sees the woods and the campus and the turn for Old Taylor Road, where Faulkner's house stands at the end of a double row of ancient cedars. Built in 1840-something like the courthouse, the front of the Faulkner residence echoes its plan on a domestic scale: a tall white house with four plain Doric columns made of wood, a pediment, and a balcony for looking back toward Courthouse Square in Oxford.

olly Springs, Mississippi, lies twenty-nine miles north of Oxford, at the intersection of highways 7 and 78, exactly halfway between Tupelo and Memphis. All roads to Memphis from northeast Mississippi run through Holly Springs, which boasts more than three hundred structures listed on the National Register of Historic Places. Most of these are the palatial homes of nineteenth-century cotton barons—big, stately, colonnaded mansions named Montrose and Oakleigh.

On East Gholson Avenue, right off the square, stands a somewhat diminished version of these big houses, a bit too close to the street for baronial comfort. The whole place leans a hair to the right. Individual clapboards ripple and bow. The black shutters at the windows have been slathered in fresh paint, laid on thick and smooth like just-churned country butter on a hot biscuit. Two widely spaced columns uphold a pediment above the front door and shelter a narrow porch muffled in bright green kitchen carpeting, or cut-rate Astroturf. Built in 1853 along the lines of Rowan Oak and other Mississippi mansions of respectable scale and demeanor, this is Graceland Too.

Graceland Too is home to the self-proclaimed "World's Number One Elvis Fan," Paul MacLeod; his mother; and his son, Elvis Aaron MacLeod, who dresses and sounds a lot like Elvis Presley. The MacLeod house is named after Presley's Memphis mansion, to which it bears a superficial resemblance thanks to the columns and two concrete lions, guarding either edge of the facade, and a certain eccentricity of taste, expressed in pink and yellow drapes visible at the upstairs windows.

Graceland Too is an Elvis museum, full of items like petals from the first flower laid on Elvis Presley's grave. It is also a sort of respectful parody of the real Graceland. Elvis had a TV set in every room. In Graceland Too, TV sets are monitored day and night for any mention of his name. References are filed away in more than a thousand notebooks stacked in the hallway at the foot of the staircase. The MacLeods claim to have 10 million Elvis items. Admission is $3.

The faraway world outside Oxford begins at Memphis. Northern Mississippi, so the story goes, has always believed in the Memphis *Commercial Appeal*, the Sears Roebuck catalog, and the Holy Bible, in that order. Highway 51, the "hard road" from Jackson to Memphis, was paved in the mid-'30s. At the junction of Route 6, roadhouses and honky-tonks sprang up catering to the recreational needs of the Ole Miss crowd, but the real vice was to be found farther up the road, in Memphis, the Sodom of the New South. Until World War II, the Illinois Central ran from Oxford to Memphis. Memphis: gateway to anyplace in the wide wicked world. When he was feeling flush, Mr. Billy went up to Memphis once a week, took a room at the Peabody Hotel, and tasted the city's illicit joys: cocktails, genuine French wines, a gaudy sense of style, and the spectacle of deep-dyed vice flourishing along nearby Beale Street under the aegis of the local political machine. In Faulkner's books, Memphis was the place where his characters went for bawdy houses, much too fancy furniture, branded liquor, and guns. In *The Mansion,* when a vengeful Mink Snopes gets out of Parchman after thirty-eight years at hard labor and goes gunning for his cousin, he buys a pistol and three cartridges in Memphis and then walks home to Oxford along the tracks of the Illinois Central.

Oxford becomes Jefferson in Faulkner's books, and Jefferson is the seat of Yoknapatawpha County. His hand-drawn map of this fictional piece of real estate ("William Faulkner, Sole Owner & Proprietor") is bounded by rivers at top and bottom; an arrow alongside the railroad tracks points across a bridge to Memphis. But the borders on the east and west are indefinite and formless, as befits the vastness of the writer's imagination. Or a spot on earth with the capacity to encompass any human experience, except those sullied few reserved for Memphis. In Memphis, things changed; fashions in furniture and mixed drinks came and went. In Oxford, something old and elemental endured, and Faulkner built his world upon it.

He began with his own house, Rowan Oak. Rowan Oak sounds like a name Margaret Mitchell might have made up for one of her fabulous planter's mansions in *Gone With the Wind*. Tara. Twelve Oaks. Rowan Oak. The name was Faulkner's aristocratic fancy, an allusion to Frazer's *Golden Bough* and a Celtic legend that recommended nailing a branch of the rowan tree over the doorway to ward off evil spirits. In the beginning, in the 1840s, it was just the Sheegog place, built by an Irish immigrant planter who died rich in 1860, owning 6,000 acres of land and some ninety slaves. Although the pedigree of Colonel Sheegog's house has been polished over the years by talk of a genuine English architect, a William Turner, on the scene, Turner was probably just an honest contractor, using plan books. The style was as common as good Mississippi dirt and there are ten more such houses within a day's ride of this one. It was a classic Southern planter's house, a white Greek Revival house, two stories high, with a five-bay Doric portico across the front, sidelights on either side of the front door, and a central pediment, just like the courthouse, downtown.

The colonel's widow, who lived through the Civil War, called the house "The Mansion." Whether she used that title while her husband was alive is not entirely clear, but the term has an artificial grandeur about it, as though the moonlight and magnolia myth of the Old South might have begun right here, circa 1870, at the end of an alley of cedars. In memory, everything seemed lovelier and more imposing then, back before the War. Seen just before sunset, through the mists of nostalgia, the Sheegog place became The Mansion, set like a jewel in a landscaped oasis of brick walkways, of fragrant magnolia trees and gardens laid out in concentric circles around them.

By the time William Faulkner came home to Oxford, decided that Yoknapatawpha County was his life's work, and bought the house in April 1930 (no money down, $75 a month), The Man-

sion was a noble ruin, sadly deficient by most standards of modern comfort. The proportions were generous; the exterior columns rose to a height of twenty feet and the central hallway alone measured 450 square feet, the size of the average Mississippi shotgun house. But Rowan Oak had no electricity, no plumbing, no central heat. No insulation, or screens for the windows. The exterior had not seen a coat of paint in several generations. For almost twenty years, Faulkner himself was too poor to do much but patch the worst leaks and, with the help of the Sears catalog, carry out such improvements as proved unavoidable. His meager income from Hollywood scriptwriting went into the land surrounding the house. Eventually, like a country squire on a very small scale, Faulkner acquired thirty-one acres of the old Mansion's former gardens and woodlands.

One of the most frequently photographed historic houses in the United States, Rowan Oak is a significant tourist attraction, despite the fact that Oxford provides none of the usual electric arrows pointing the way through the woods south of Courthouse Square. The impact of the house is all the greater, perhaps, because it suddenly appears at the end of any number of overgrown paths through the brush, absolutely without fanfare. A thick, humid blanket of June afternoon smothers the trees and muffles the sounds of footsteps; nothing disturbs an eerie, not-of-this-time privacy that Faulkner cultivated. He is supposed to have dug yawning potholes in his own driveway to deter unwanted company curious about the abode of the famous writer.

But in his daily life, and in the restoration of Rowan Oak, Faulkner also resisted the blandishments of his own era, even when he could well afford them. To the occasional dismay of his wife and daughter, he scorned first the radio and later the TV set, along with air conditioning, adequate winter heating arrangements, and most of the creature comforts associated with

middle-class prosperity. The house is austere and cheerless on the inside, like most historic houses from which the best furnishings have fled.

Rowan Oak is a special case, however. An effort has been made to show the visitor the human side of Faulkner through his possessions—a Westinghouse electric range, a can of dog repellent, a bottle of Schaeffer's ink. Yet the intermittent bits of clutter only serve to call attention to the aesthetic emptiness of the rooms in which they pose. The carpets are thin, the chairs stiff. Every surface hard, unyielding, and dark. Chairs and stoves are necessary evils here, unwelcome reminders of the present day. The meaning of this house comes from its old bones, its essence, from a structure of hollow cubes, tall rectangular piers, from the Greek geometry of a pediment, first conceived in time out of mind. Architecture endures, and Rowan Oak connects Faulkner with the enduring past.

Faulkner wrote two novels directly related to his stewardship of Rowan Oak. The first of them, *Absalom, Absalom!*, appeared in 1936, as the restoration slowly gathered momentum. The book chronicled the construction and eventual decay of a vast antebellum planter's mansion in northern Mississippi known as Sutpen's Hundred. The seventy-fifth anniversary of the Civil War, 1936 also marked publication of Margaret Mitchell's bestseller, *Gone With the Wind*, in which the mansions of Georgia signify a gracious way of life obliterated by Sherman's armies. For both writers, the house was the abiding relic around which an urgent search for the meaning of the past revolved. In 1936 the last living Confederate veterans were passing from the scene. The agricultural Old South of cotton and tobacco was becoming a New South of cities, industry, and modern gadgetry. In the heedless bustle of change, the tottering mansion stood for continuity, substance, and grace.

There is something primordial about Sutpen's Hundred. Its fictional owner, Thomas Sutpen, rides into Faulknerland in the

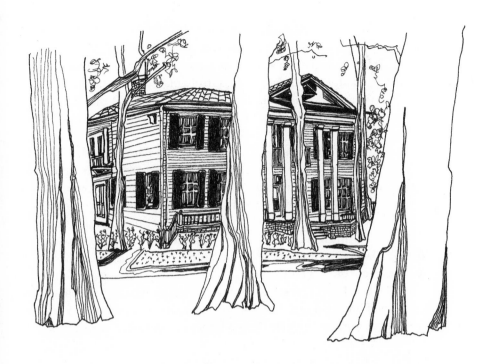

1830s with a French architect and gang of slaves and rears a magnificent edifice in the middle of nowhere, twelve miles from town, out of timber cut in the surrounding swamp and brick burned from the very mud of Mississippi. Then, for three years, Sutpen camps in the empty shell of a house the size of the county courthouse, surrounded by formal gardens and promenades. Whatever the earth cannot provide, he does without: windows and doorknobs, paint, hinges and furniture. When these appurtenances of the good life suddenly and mysteriously appear—along with an acceptable wife, daughter of a local storekeeper—Sutpen and his estate begin the long slide into ruin. The War Between the States. Festering family secrets. The novel ends in 1910, as the house burns to the ground in "one last wild crimson reflection."

Faulkner is no Sutpen—William Faulkner, the native son whose Rowan Oak (seven-eighths of a mile from the courthouse)

\mathcal{I}f there is such a thing as historical food, they serve it at Smitty's in Oxford, on South Lamar, just off the square, on the way to Rowan Oak. Guidebooks recommend Smitty's for breakfast. Grits, biscuits, and gentle discourse on the news of the day.

A late supper is better, in the twilight, when the counter is empty and the two waitresses are in a mood to reminisce about the old days and Southern cooking. Try the homemade country ham, they say. One thick reddish slice on a thick white platter, with red-eye gravy on the side and a plate of hot biscuits. And that's all, unless you want some deep fried pickles to start with. No salad or vegetables, and the only condiment is blackberry preserves, put up on the spot.

The meal is a cardiologist's nightmare, so foreign to a palate weaned on roughage, lo-cal ersatz mayo, and breast of chicken that it tastes and smells like food from another planet. Salty and greasy. Pungent. A country ham comes from a three-hundred-pound hog fed on peanuts. The haunch is rubbed in a secret mixture of salt and sugar, buried in more salt for a month, and finally sweated in a smokehouse through the heat of at least one summer, maybe two.

No wonder country ham is meaty and insistent, lying pink and heavy on the plate. And salty. The gravy consists of a dollop of darkish juices puddled at the bottom of a dish, underneath a thick transparent layer of something oily. It's made by adding a teacupful of water—no more—to the skillet in which a slice of country ham is fried. Cut a little piece of ham, dunk it in the gravy dish, and eat it on a corner of a biscuit, with a glob of jam.

If you were to put butter on one of these biscuits, your arteries would seize up and you'd die at the table with a smile on your face. It must happen to passing Yankees all the time. You don't need any butter. The biscuits get their heft and substance from flakes of purest lard. Ham and gravy and biscuits are old food, Southern food. Blackeyed peas in their own little bowl. Slabs of cornbread. A cornmeal crust on a just-caught catfish.

reminded Oxford that the Faulkners were people of breeding and substance, even though Mr. Billy's father had once tended a livery stable. Sutpen came out of nowhere. Faulkner was a member of one of the first families of northern Mississippi. His great-grandfather belonged to the heroic generation that fought the Civil War, a man of action who also wrote, in his years of retirement, an epic entitled *The White Rose of Memphis*. Judged against the Faulkners of Oxford, Sutpen is a carpetbagger, a robber baron, an interloper with money but without ancestral connections to the South.

For that reason, Sutpen's Hundred is a monstrous folly, a monument to cash and vanity and pointless grandiloquence. But the rotting portico that burns so red in the final pages of *Absalom, Absalom!* speaks directly to Faulkner's personal obsession with the meaning of Southern architecture. Although Sutpen imports the doors and windows and the other factory-made geegaws Faulkner despises, the house has arisen like some poisonous, night-blooming flower, straight from the soil of Mississippi. The mansion is the South, for good or ill. And there is a sentience to such houses, a visceral connection to those who first imagined them and set their columns in place. Sutpen's mansion, writes Faulkner, was a part of Sutpen, "which some suppuration of himself had created about him as the sweat of his body might have created/produced some . . . cocoon-like and complementary shell." Just as Faulkner's meditations on Oxford, time, and being William Faulkner bound him forever to the Southern mansion he called Rowan Oak, with its four slender columns, each carved from the trunk of a single tree that had grown in the nearby woods.

The Mansion is a novel of the 1950s. Parts were serialized in *Mademoiselle* in 1955, when Elvis Presley, another famous scion of northern Mississippi, was playing one-night stands in Booneville, Meridian, Biloxi, Clarksdale, and Tupelo with a new hit song, "Baby, Let's Play House." The book was finished, ac-

cording to the inscription on the final page, in 1959, by which time young Presley had bought himself a pseudo-Southern mansion in suburban Memphis where he intended to live after completing his military service in Germany. Faulkner was not a fan. In 1957, he complained that "there is not one place in fifty miles that I have found where I can eat any food at all without having to listen to a juke box." He dined more and more often at the Mansion restaurant in Oxford because they hung an out-of-order sign on the offending apparatus as soon Mr. Billy crossed the threshold.

Elvis and jukeboxes were two more examples of what had gone wrong with modern civilization in general and the South in particular. But Bill Faulkner of Oxford and Elvis Presley of Tupelo shared an interest in houses, in mansions, and in the relationship between people and the places they created in their own image. In the 1950s, as Faulkner was writing *The Mansion*, Elvis was sitting in the dark outside his birthplace in Tupelo, trying to figure out what a shotgun house with two skinny columns on the porch had to tell him about family, fame, and fate.

The Mansion is about the fleeting nature of human success. Flem Snopes, one of Faulkner's awful New South Snopeses, who has taken over the local bank, also acquires the banker's modest house, "a physical symbol of respectability and aristocracy." To solidify his standing in the community, Snopes sets a motley crowd of relatives to work improving the place, along the lines of Mount Vernon, the ultimate Southern mansion. They throw up two-story homemade "colyums" far too large for the exterior, cram the interior with "sweets" of Memphis-bought furniture, and slather everything with a coat of shiny white paint. But respectability proves elusive. For all his monetary success, Flem the financier sits home every night alone, with his feet propped up on a piece of scrap lumber nailed, for that purpose, onto the

snowy white mantel of his Mount Vernon–style fireplace. Faulkner makes fun of Flem's twenty-year-old antebellum mansion, the Snopes-colonial mausoleum in which he is finally executed by a poor relation. Once a Snopes, always a Snopes: new money can't buy honor or good taste.

At Rowan Oak, Faulkner lived his life in the 1950s, in the aftermath of the Nobel Prize, like Mitchell's Ashley Wilkes or some other Southern gentleman out of cavalier fiction. Modest affluence never overwhelmed gentility. Nor did labor: the study was tucked away at the back of the house, off-limits to family and visitors. Mr. Billy looked to be a man of leisure. He rode his horses through the woods of an afternoon, and rode to the hounds when he could. Dinner was a formal affair, with finger-bowls, and a black manservant, and wines sent down from Memphis. One dressed for dinner at Rowan Oak. What the plantation stood for in the twentieth-century imagination was a spaciousness of life, an ease and a perpetual leisure, unspoiled by the grim necessities of making a living. Nostalgia for an Eden without regular jobs and hard cash (the infallible mark of modern Snopeshood). Rowan Oak was such a genteel refuge, a kind of Southern Shangri-La from which notes written in pen and ink on stationery engraved with the name of the house were dispatched like messages from a mythical yesterday to those unlucky enough to dwell elsewhere, in a real enough today.

Rowan Oak was a lovely myth, given tangible form in century-old, hand-carved columns. To further enhance its legendary status in the eyes of Oxford, however, Faulkner purposefully invented a romantic history for his house based on plausible scraps of local lore. Because a proper mansion, he said, "needed a ghost" to flit across the upstairs balcony on starlit nights, Faulkner conjured up the fictitious Judith Sheegog, beautiful daughter of the original owner, who had fallen in love with a Yankee prisoner of war and plotted to run away with him in the

dark of midnight. The lovers were betrayed; the Union officer was shot dead on his way to their rendezvous at Rowan Oak. And when he failed to signal at the appointed hour, Judith threw herself off the balcony in despair, only to walk the night forever afterwards, down the staircase, out the door, through the columns, across the lawn, to the graves where North and South lay buried together. Mr. Billy told the story at Halloween, with convincing props, and in time, Judith became just as real as the Faulkners who also lived at Rowan Oak.

Or died there. After a fatal fall from his horse, William Faulkner was buried from the parlor of Rowan Oak in the sweltering summer of 1962. Like the ghostly Judith on her way to her lover's grave, the coffin traced a path down the central hallway and through the screen of columns. Then, beneath a blazing sun, the funeral cortege crept between the cedars and turned up Lamar into Courthouse Square. Under the awnings at the old drugstore, in the shade of the courthouse, around the pale Confederate on his marble column, Oxford stood in the heat and watched the cars pass by, heading north, toward the graveyard, toward Memphis, and a wide world that still wonders at the haunted mansions of the Sutpens and Snopeses, the Presleys and the Faulkners.

Main Street at Beale

Highway 78 out of northern Mississippi becomes Lamar Avenue, Memphis, Tennessee, about seven miles past the state line. Near the city limits on all the major roads into Memphis there once squatted a clutch of hillbilly honky-tonks straight out of a Hank Williams song. Lamar Avenue was no exception. The Eagle's Nest at Clearpool, a nightclub attached to a public swimming pool and a seedy motel, was no better than the rest. That stretch of Lamar was where the city really began in the fall of 1948, when the Presley family drove past Clearpool with their worldly goods strapped to the roof of the car. After Clearpool, the stores and the houses multiplied as Lamar Avenue angled toward the river and finally lost itself in the fingers of traffic that pointed to downtown Memphis.

Elvis and his father had been spotted often on the fringes of downtown, on Poplar Avenue, the year before. This time, they were here to stay. The Presleys ended their day in a $35-a-month boarding house on Poplar, in a district known as Little Mississippi, an easy stroll from Beale Street. After they unloaded the car, Vernon decamped to a nearby beer joint. Gladys

and Elvis walked to Loew's State Theater on South Main to see *Abbott and Costello Meet Frankenstein.*

The house on Poplar was a horror-movie hellhole, with one kitchen for sixteen families and hairs in the single bathtub: today's guidebooks caution Elvis fans to avoid all the downtown sites after dark. But in 1948 the intersection of Beale and Main was the most exciting place in the world, the great symbolic crossroads of postwar Memphis where business stopped for pleasure and black America let well-behaved white boys sit inside rusty screendoors and listen to the blues.

Beale Street begins at the cobblestone levy along the Mississippi and runs east for a mile and a third, perpendicular to the river; a north-and-south thoroughfare, Main used to cross Beale on the high ground above the docks, a couple of blocks from the Peabody Hotel. There has been a Peabody Hotel in downtown Memphis for 120 years. In the main lobby, in a cherub-encrusted travertine fountain, a flock of ducklings quack and splash, and the deal-makers sit in high-backed chairs and watch them: at the fountain in the lobby, the Mississippi Delta is said to begin.

Main Street is all government, commerce, department stores, theaters, and banks, or was before urban renewal mall-ized it and cut it off from Beale in the '60s and '70s. Main Street was where mothers took bright-eyed kids to see Santa Claus every Christmas at Coca-Cola's Snow Hut. Main Street was where Elvis's schoolmates window-shopped for new shirts at Gold-smith's and Gerber's and then bought one-dollar versions at the chain stores down the block.

Main Street was mostly white. Beale Street was the black Main Street of America and, in the late 1940s, one of the most celebrated streets in the South. Ground Zero. What the Champs Elysées is to Paris, what Broadway is to New York, what Bourbon Street is to New Orleans, Beale Street was to Memphis,

Tennessee. On the weekends, it was thronged with thousands of rural blacks come to town from the surrounding countryside by train and bus to sell a fresh-killed chicken or a catfish, to buy a sack of pancake flour, a sticky bucket of sorghum, a hat, or new shoes.

They came to Beale Street to go to the beauty parlor, to see the herb doctor for a love potion, to eat pulled-pork barbecue, to pawn a watch, to lay a bet. They stopped in their tracks and gaped at city swells in blinding yellow suits from Lansky Brothers' Emporium at Beale and 2nd Avenue. $1 down. $1 a week. Lansky's opened in 1949 as an army surplus store with a sideline in cool drapes for the uncommon man. Hillbilly musicians out of Nashville shopped there. Bernard and Guy Lansky also outfitted Junior Parker and Rufus Thomas and the black musicians drawn up out of the Delta to Beale Street by the storefront clubs that never closed.

W. C. Handy and his trumpet had settled on Beale Street in 1909, among the social clubs, the pool halls, the bawdy houses, and the solid businesses owned by a black middle class that had lived and prospered in the neighborhood since the days of Reconstruction. Handy was the father of the blues. He took the mournful cadences of the Mississippi Delta, the music of poor, black, country people, and wrote it down for brass bands in the cities to play. Once ensconced in Memphis, William Christopher Handy was commissioned to write a campaign song for E. H. "Boss" Crump, the white politician who ran the city. His "Boss Crump Blues" ("Mister Crump don't 'low no easy riders here!") was published as "The Memphis Blues" in 1912 and added the finishing touch to the legend of Beale Street.

"If Beale Street could talk . . .," Mr. Handy was fond of musing. "If Beale Street could only talk!" After World War I, at the high-water mark of Crump's long reign, it was positively wicked. Whores hung out the windows of the backstreets nearby and

heroin was delivered by bicycle. But when white culture forbade blacks to go here or there, Beale Street became *the* place for men and women of color, the best and the only place to be. "The seven wonders of the world I have seen," said Handy. "Take my advice, folks, and see Beale Street first."

Beale Street offered an escape from prejudice. And if the soulful music of the Beale Street blues was a cry of protest against the pain of segregation, music was also an arena in which a person, an artist, could be judged on talent alone. Music tinkled and boogied across the rigid color line of the South. In the late '40s and early '50s, you heard the blues on Beale at the Monarch Club, sleek and smart, with mirrored walls and cushiony banquettes. The Hippodrome, down the block, catered to white kids who listened to black music on their colorblind radios and idolized the horn players and the singers who wore the Lansky Brothers' cloth-of-silver ties and yellow suits.

By day, white Memphis came to Beale Street seldom and a little furtively, for a passport photo or a rent-by-the-event tuxedo. By night, the place was alive with a raw, illicit sound full of hurt and sass and ragged hope. Up and down the street, from Pee Wee's Saloon and the Panama Club and Casino Henry to Reuben Cherry's Home of the Blues, the music muttered and blared. Live music and race records and the radio. B. B. "The Blues Boy" King on station WDIA, new in 1948—with the first all-black format in the South. Willie Mae Thornton's "Hound Dog." Jackie Brenston, up from Clarksdale, Mississippi, singing "Rocket 88" in front of Ike Turner's Kings of Rhythm, resplendent in a Beale Street tux with gleaming silver lapels.

The artist Thomas Hart Benton stopped off in Memphis in broad daylight in the course of a riverboat trip to New Orleans during the early years of the Depression and went to Beale Street looking for something picturesque to sketch. He watched

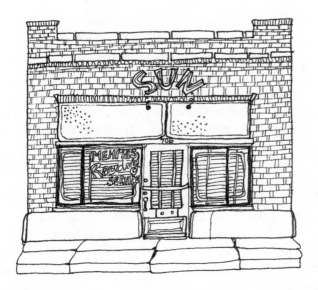

"a few flashy colored sports" amble by, stopped in a poolroom where nobody seemed interested in him or his sketchpad, and came away disappointed. Beale Street was too businesslike, too tame to match its reputation as an uproarious place, even livelier than Harlem. "For abandoned Negro gaiety," wrote Benton, "it was a flop."

Benton wanted spectacle. Entertainment. He'd probably like Beale Street better today, in its guise as a bluesy version of Disneyland. The bread-and-butter businesses are gone along with most of the buildings. The rest are just facades, propped up with girders to lend a touch of atmosphere to an undistinguished row of t-shirt stores and bars that charge $3.50 for domestic beer. At one end, around a bronze statue of W. C. Handy, in a little vest-pocket park shaded by sycamores, street musicians still do play the blues. At the other end, atop a strange concrete mound across the street from the store that used to be Lansky's, stands a bronze Elvis whose shirt is adorned with tendrils of flashy bronze fringe. The Elvis is often

Sun **Studios** is the stuff of legends. The best known holds that Elvis Presley was "discovered" by accident there one Saturday in the summer of 1953 when he wandered in, fresh out of Humes High School, to make a record of his own voice for his mother's birthday. After cooling his heels in an officeful of other young hopefuls with guitars, he did two Ink Spots numbers, "My Happiness" and "That's When Your Heartaches Begin." Owner Sam Phillips's secretary asked him if he sang hillbilly and he allowed as how he did. She wondered who he sounded like. "I don't sound like nobody," he replied. And he didn't. The rest is history, Cadillac cars, and bright lights. After years of looking, Phillips had finally found a white boy "with a Negro sound." He was sure the discovery was worth a billion dollars.

Just seven blocks from Crown Electric (Elvis drove a truck for Crown while he was starting his recording career), Sun Records on Union Avenue looks like the kind of storefront concern where you'd go for house paint, car radiator work, or wholesale restaurant supplies. After Phillips sold his business, it became an auto parts shop and a plumbing wholesaler. The studio is a bare thirty-by-eighteen-foot room, with a glassed-in control booth elevated on a short flight of stairs at the back. The booth was the perfect perch from which a plumbing magnate, say, could peer down on his stock, the occasional customer, or a larcenous clerk. Sam Phillips sat up there in the heyday of Sun Records.

Sam met his $150-a-month rent by running a recording service. Anybody could cut a 10" acetate record for $3.98, plus tax. Gladys Presley's birthday was in April. Elvis may have claimed his recording was a birthday gift to cover up his itch to know how he'd sound on the family's $8 Sears record player.

Sun is open for tours. There's not a lot to see in one thirty-by-eighteen-foot room. But Mrs. Taylor's old cafe next door still has RC Cola over ice, the perfect cure for first-record drymouth. Upstairs, there's a new museum featuring a made-for-TV replica of the studio you just saw downstairs, minus the cola.

under repair because tourists love to break off strings of fringe as souvenirs.

By the time he was fifteen, Elvis Presley was a fixture on Beale Street. The family lived in Lauderdale Courts, the big public housing project above Poplar in a neighborhood the locals called Pinch or Pinchgut. Originally the Irish ghetto of Memphis—for immigrants so poor they had no belly fat to pinch—the district at the junction of the Bayou Gayoso and the Wolf River marked the far north margin of the city during the Civil War era. On its south end, Lauderdale ran straight into Beale in the heart of the old black enclave. Elvis took the city bus sometimes, out Jackson to the park on the Wolf River; boys from Pinch swam there, at the end of the line, on hot summer days. But mostly they walked, after school, on Saturdays, in the summer, down Lauderdale to Beale Street and Main.

One favorite stop was the Blue Light Studio, on the corner of 2nd and Beale. The portraits in the window seemed almost as glamorous and grand as Tony Curtis in the swashbucklers Elvis watched at the Suzore #2 on Main Street, and at Loew's, where he worked as an usher in a fancy, funky tux in 1950 and 1951. The people in the portraits had been caught in the very act of re-creating their faces for the camera, like movie stars, turning, preening, flirting with the lens. Elvis had his picture taken there while he was still in high school, before he ever cut a record or did much more than dream about being a star someday. His hair is dyed black. His sideburns are long. He seems to be wearing mascara. His lip curls with the effort of convincing the photographer that he is somebody to be reckoned with. The collar of his two-toned shirt is turned up to his ears. No ordinary shirt collar, either, this one is covered with pixie-dust sparkles à la Lansky.

The Lanskys first noticed Elvis hanging around their store in the summer of 1951, gravely attentive to the purchases made by local musicians. When he went back to Humes High in the

fall, for his junior year, it was to unveil a cool new image—blues and black and Hollywood schlock—predicated on sparkles, lace, and two-toned anything, $1 down, $1 a week, up to the limits of a slender line of credit. White boys with an appetite for true opulence were rare enough on Beale Street. But Elvis was also seen, from time to time, leaving a ladies' beauty parlor at Lauderdale and Poplar with a blacker pompadour and shapelier sideburns.

This kid might have stood out from the crowd even if he had worn the buckle-back khakis and buttoned-down shirts favored by boys from the classy high schools on the east side. But Elvis was downtown, all the way. He looked like Main Street viewed from the perspective of Loew's balcony. He looked like Beale Street might have looked if the Jim Crow laws had never existed. B. B. King distinctly remembers meeting him in a pawnshop on Beale in the early '50s: as sheer visual spectacle, the young Elvis Presley was hard to forget.

In 1948, the year the Presleys moved to Memphis, an almost imperceptible shift in the demographics of the city began. Lowenstein's, the queen of the Main Street department stores, broke ground for a new store at Poplar and Highland, in the Poplar Plaza Shopping Center, the first major retail complex outside the boundaries of downtown. Air-conditioned, modern, and chic, Lowenstein's East reflected the flight of upwardly mobile, white Memphis toward the eastern edges of town in the prosperous postwar era. New suburban-style developments sprang up out past Chickasaw Gardens and Memphis State University; the long trek back to an old-fashioned, nineteenth-century Main Street lost its appeal. When Elvis, the movie star, decided to buy himself a Memphis mansion in 1957, the family met with the real estate agent for the first time in the crowded parking lot of Lowenstein's East.

Beale Street, too, began its slow decline in the 1950s. Some

blamed a relaxed attitude toward segregation in parts of Memphis. Because local stores like Kress and the Black and White had integrated their lunch counters before Rosa Parks insisted on sitting in the front of a Montgomery bus, there were opportunities for black entrepreneurs to do business outside ghetto areas. The Civil Rights Act of 1957 only hastened the exodus from Beale Street. Although it was the 1968 assassination of Martin Luther King, Jr., at the black-owned Lorraine Motel in the neighborhood below Beale Street, that finally led planners to raze the district, the process had begun decades earlier, when Memphis gave up on downtown and moved east.

In a modest way, so did the Presleys. From Poplar, from the projects, from Cypress and Alabama and the hillbilly ghetto, from single rooms and dingy flats where Elvis slept on a cot in the dining room, to a brick house, a whole house on Lamar Avenue, not far from the corner of Airways Boulevard, in 1954 and 1955. By that time Elvis was out of high school, had a contract with Sun Records, and was on the road, on the schoolhouse circuit through Texas and the deep South. On the weekends, for $5 or $10 a night, he still appeared around Memphis, in the rough hillbilly bars that had given him his start. The Eagle's Nest at Clearpool ("Don't wear a tie unless your wife makes you") placed ads in the *Commercial Appeal* and the *Press-Scimitar*. Grim little boxes announcing that he could be seen for a $1.20 cover charge ran alongside splashy picture layouts for the latest Martin and Lewis comedy.

When he started at the Eagle's Nest, Elvis sang Dean Martin's "That's Amore" and Hank Williams's "Kaw-Liga." He sang Eddy Arnold and Bob Wills like a country crooner, and his backup band wore cowboy suits. In July of 1954 he met Nashville star Webb Pierce, making an unadvertised appearance at the Eagle's Nest, but Pierce scoffed at his clothes and made fun of his music. By then Elvis was the Hillbilly Cat, a rising Sun Records

urgers were the teenagers' food of choice in the 1950s. First introduced at turn-of-the-century fairs and other venues in which sit-down meals were impractical, the self-contained, eat-it-with-one-hand hamburg steak in a bun was perfectly matched to the culture of the automobile. The hamburger struck high schoolers with their first cars as profoundly cool. Or kool: Krystal was the name of the premier burger chain in the South (and Krispy Kreme was the crème de la crème of donut shops).

Elvis Presley loved burgers. As a boy in Tupelo, where they were still a novelty item in the 1940s, he hoarded his pennies, walked three miles to Dudie's Diner, and ate up his savings, with mayo and an RC Cola on the side. Diner burgers were so cheap that many people believed they were made with flavored bread or tinned salmon—and no meat.

In Memphis, the last of the twenty-four-hour-a-day Gridiron Restaurants at 4101 Elvis Presley Boulevard (half a mile from Graceland) capitalizes on Elvis's storied fondness for the well-done cheeseburgers he consumed at all hours in a booth opposite the counter and its row of backless chrome-and-vinyl stools. The minimal decor consists of photos of the Gridiron's most famous customer taken in and around Memphis. None of the pictures catches Elvis in the act of eating a Gridiron Palm Beach Burger. The Palm Beach Burger merited its fancy moniker thanks to a dollop of melted pimento cheese.

Elvis cookbooks—and they are legion—agree on the basics of the perfect cheeseburger: burnt beef, American cheese, mayo, pickles, onion, tomato, lettuce. A variation allows for chili sauce mixed with mustard instead of mayonnaise. One of the Graceland cooks recommends toasting the buns in a frying pan in batches of two, each pair to be browned in a full half-stick of butter.

star, who put a disconcerting Beale Street spin on country ballads by Bill Monroe, and wore outfits, on stage and off, that would have made the Lanskys blush.

The great Hank Williams, the first of Nashville's Cadillac cowboys, had been buried in Montgomery, Alabama, in 1953 wearing a white stage costume made by Nudie's Rodeo Tailors of Hollywood. Nudie suits were famous in the country music business. Hank had a beauty, with the opening bars of "Lovesick Blues" appliquéd across the Western yoke and down the pant legs in white leather and lavender sequins against a blue background, exactly the blue of the customized Cadillac convertible in which he died. Elvis went Hank Williams one better in pink trousers and sport coats with velvet collars and a slick, iridescent sheen.

Elvis already dressed like a star in high school. Vintage Lansky was the uniform preferred for tossing down burgers and double-chocolate milkshakes in the front seat of his green 1942 Lincoln parked alongside drive-in hangouts like the Jungle Inn, K's, or Porky's. For his 1953 prom in the ballroom of the venerable Peabody Hotel, Elvis wore blue suede shoes that matched his suit *and* the blue Chevy he had rented for the occasion. A snapshot taken in the parking lot of the Eagle's Nest a year or so later shows him wearing white shoes with black wing tips, dark trousers with a colored "flash" running down the leg from hip to ankle, a jacket with epaulets in a contrasting tone, and a skinny little tie with a skinny little matching belt buckled off to one side. Hank Williams's former manager ran into Elvis Presley outside the Eagle's Nest (or was it the Airport Inn?) after a show and recognized a touch of inspired madness when he saw one; back in Nashville, he talked up the newcomer to Colonel Parker, the wheeler-dealer who booked the likes of Eddy Arnold and Hank Snow. Real stardom was only months away.

In Memphis, meanwhile, Elvis played the countrified east side

clubs, like the Bon Air. More often, though, he was to be seen in parts of town organized around the thrilling new amenities of civic life in the 1950s. Like the airport. Some of the new joints on Airways Boulevard were too laid back to look at IDs; under-age drinkers could always get a beer at the Whirlaway. But there was a Tomorrowland, life on-the-edge quality to the very idea of flying away in sleek winged tubes of silver, a romance that attached itself to any place remotely near the runway. Mem-phians still recall Elvis's appearances at the Airport Inn in the days when going out to watch the planes take off was a novelty symbolic of tract-house modernity and forward thinking.

If Elvis was an old-time hillbilly, he was also the cool cat, on the prowl through airports and proto-malls. He sang at the Grand Ole Opry in Nashville one Saturday night in September 1954, and then hurried home—a four-hour drive down a wind-ing, unimproved, two-lane road—to open the Lamar-Airways Shopping Center, about a mile down the street from his family's new address. Performing on the back of a flatbed truck outside Katz's Drug Store, the centerpiece of the latest strip mall in Memphis, he drew a crowd of three hundred and earned an-other $10 toward another move, farther east, first to Getwell Street, and then, in May of 1956, to 1034 Audubon Drive, in the heart of suburbia.

The Getwell house was a full five miles from downtown and the projects, every mile a measure of rising social status. A house five miles from downtown meant that a family had a car somewhat more reliable than a 1942 Lincoln pushed around Memphis almost as much as it was driven. And the farther from downtown, the newer the house and the greater the odds that the family owned its own home. By that yardstick, the ranch house on Audubon Drive, for which Elvis Presley paid $40,000 cash after signing his Hollywood contract, was a world away from the rentals on Getwell and Lamar. Those places were a step up from Lauderdale Courts but were not, in truth, much larger

than his birthplace back in Tupelo. The ranch house had separate bedrooms for everybody, a backyard big enough for a movie-star swimming pool, and a front lawn worthy of a Southern mansion in *Gone With the Wind*.

The green lawn and the trees along the meandering street blended readily with the plantings and the pathways of Audubon Park, the centerpiece of the neighborhood. Boss Crump died in 1954, just as the Presleys began their long march eastward into the suburbs Memphis annexed at regular intervals to maintain its tax base. One of his last official acts had been to approve the layout of Audubon Park in the section of the city undergoing the fastest growth spurt. The remote park and its surrounding subdivisions were testimony to the role mobility played in the imagination of postwar Memphis.

This was the city where the modern supermarket had been invented a generation before: shoppers parked outside, dashed in, and raced their carts along streetfuls of groceries, as they had once walked or bused from store to store to store. When Audubon Park was completed in 1954, the Holiday Inns, another Memphis idea, were two years old. Motels with flashy signs along the highway, they were all alike, all filled with the latest consumer luxuries, glamorous and glitzy—just like the Presley house on Audubon Drive, which had TVs everywhere, a

hi-fi, bedside phones, and a carport large enough to be mistaken for the drive-thru canopy outside the registration desk of a Holiday Inn.

Despite a long flirtation with modernity in every form, however, Crump's Memphis felt genteel and gracious in a peculiarly antebellum way. The city was proud of its parks and trees and quiet streets; laws against the gratuitous tooting of car horns helped retain the rustic somnolence. And Memphis relished its Civil War stories. Every old house with columns came equipped with a legend about a cache of buried silver in the rose garden or the time General Grant commandeered the ballroom for some evil Yankee purpose (as he had, in fact, taken over the Hunt-Phelan House on lower Beale Street). Local historians cited Manassas Street, once the far eastern boundary of the city, as proof of Confederate spunk, since it had been named in defiant memory of the rebel victory at the Battle of Bull Run.

The Mississippi River was America's own Nile. The original Greek word for the city in Egypt after which General James Winchester named Memphis in 1819 meant "good abode." Winchester, one of the many land speculators who took a hand in the creation of Memphis, was probably inspired by Napoleon's colorful campaigns in the Near East. But it all fit, somehow. Memphis and the Nile, slumbering in the steamy heat, a stone's throw from the pyramids and the ancient city of the dead, and Egypt's endless past. Memphis, Tennessee, the Mississippi, and the glories and the tragedies of the Civil War. The historian David Potter once described the South as "a kind of Sphinx on the American land." Black and white, old and new, the City of Good Abode seemed sometimes as mysterious as any sphinx. And it would be the eternal abode of the gilded young pharaoh from Beale and Main who was about to be crowned the King of Rock 'n' Roll.

All roads lead toward home

A Cadillac cowboy

goes to Nashville

Nashville once gave itself serious airs. The city is, after all, the capital of Tennessee. Andrew Jackson's house is a mere twelve miles from the bluff above the Cumberland River where the historic 1845 State House lofts a replica of the Lysicrates Monument heavenward, to support a flagpole. The original monument—a particularly fine example of the use of Corinthian columns—is in Athens, Greece. Nashville sees itself as "the Athens of the South," a place of culture and refinement. In Centennial Park there's a full-scale concrete replica of the Parthenon, built in 1897 and lovingly reconstructed several times since. The shape and the angle of the Doric columns along the flanks of the building create an optical illusion: when you look through the columns, you see the outline of a giant Grecian urn.

Nashville likes green lawns and big white houses that look like plantations, with columns across the front porch. It has always been of two minds about long, four-door Cadillac touring cars with loudspeakers on the roof; about rhinestone suits, guitars, and the country music business. Or what used to be

known as hillbilly music—sad songs about absent sweethearts, train wrecks, Jesus, long nights in a jail cell, and cheatin' hearts: real songs, written by real people who used to be poor for fans who still are. The radio boom of the 1920s nurtured country music and, through a series of regional barn dance programs, spread it thickly across the South. The most famous country show of all time was and is the Grand Ole Opry, broadcast on Saturday nights from Nashville, Tennessee, over the powerful, clear-channel station WSM.

Almost from the beginning, in 1925, the Grand Ole Opry defined itself by what it wasn't: tasteful classical music, high culture, or grand opera. The Carnegie Hall of this unclassical Southern vaudeville with commercials was the columnless Ryman Auditorium, just off Broadway, sometimes called the Mother Church of Country Music. Built especially for religious revivals, the Ryman resembled a Protestant church of the old school on the outside, all foursquare brick and righteousness, punctuated by squat Gothic windows without an ounce of grace or classical charm. When Elvis Presley saw the building for the first time, he didn't believe his eyes. "You mean *this* is what I've been dreaming about all these years?" he cried. The Ryman looked a lot more beautiful on the radio.

Inside, in the 1940s, Opry audiences sat in hard oak church pews, as uncompromising and rigid as the rules governing the kind of music fit to be heard in the Ryman. No drums. Nothing too far from the formula of heartbreak, old-time religion, and utter sincerity. And decorum, please. In 1951 Little Jimmie Dickens became the first performer to wear a rhinestone-studded suit from Nudie of Hollywood on Opry night and was almost hooted off the stage. The great Hank Williams was summarily fired in August 1952 for tardiness, unruly behavior, and slipping down the back alley to Tootsie's Orchid Lounge during station breaks for a glass of sweet joy and inspiration.

Hank Williams was one of Elvis Presley's boyhood heroes:

Elvis had sung his songs, with their cheeky, almost-rock lyrics, and he had pondered the lessons of the Williams story. The humble origins, the rise to fame and fortune, the movie contract, the Nudie suits. The big blue Cadillac that drifted through Centennial Park, around and around the Parthenon, on warm summer days. The one-story mansion in the southern suburbs of Nashville with a wrought-iron fence in the shape of the opening bars of "Lovesick Blues." Gold-flecked paint and white velvet walls in the bedroom.

But the saga of Hank Williams was also the sad story of life

on the road, and of a lonely death in the back seat of a Cadillac, on the highway outside Oak Hill, West Virginia, on New Year's night, 1953. It was a cautionary tale about the price of fame, paid on a thousand miles of back road in the currency of feel-good pills, go-to-sleep pills, waker-uppers, morphine, and liquor. On the afternoon of his big Opry debut, Sam Phillips of Sun Records took the nineteen-year-old Elvis Presley to Tootsie's or one of the other Williams hangouts behind the Ryman to check out a promising act. But Elvis wouldn't sit down. His mama, he said, wouldn't want him in such a place. He waited out on the sidewalk and thought about fame and the Opry and Hank.

Years after the fact, Elvis told Hank Williams, Jr., that when he walked out on the Ryman stage for the first and only time in September 1954, all he could think about was Hank, Sr. Jim Denny, who used to pat down old Hank for booze, had been reluctant to book Presley on the Opry in the first place, hit record or no hit record. At an audition a month earlier, he had made snide remarks about the singer's appearance. The night of the show—the quarter-hour sponsored by Kellogg's cereals and hosted by Hank Snow—he flatly refused to let Elvis sing the number he had rehearsed. "Good Rockin' Tonight" was too much for the Opry in 1954. And so was somebody called Elvis Presley. Backstage, Snow made fun of his name. When he sang, the audience of Opry regulars sat on its hands in stony disapproval. And afterwards Jim Denny suggested that Elvis go back to driving a truck.

Kindly Ernest Tubb, who produced an after-hours radio show at his record store on Commerce Street, stayed late at the Ryman that night and tried to console the boy who had finally reached hillbilly heaven only to be turned away at the music-note gates. Elvis cried all the way home. He rode up front in the Cadillac, with Sam; Bill Black and Scotty Moore, the Blue Moon Boys, were in the second car, with the instruments. On the

outskirts of Nashville they stopped for gas. Elvis went to the washroom, changed out of his stage clothes, and stumbled back to the car. By the time he remembered that he'd left his good clothes and his suitcase at the filling station, they were almost back in Memphis. It was just another hazard of life on the road for a would-be country star. The lyrics of the music told all about the heartbreak, the hard driving, and the sense of aching loss.

Elvis eventually went back to Nashville in triumph, although never as the headliner at the Grand Ole Opry. Later in 1954 he was spotted in a Nashville club his mama would not have liked, looking for a chance to sing. In 1955, when his records began to show up regularly on the *Billboard* country charts, he dropped in on a disk jockeys' convention there (and then drove 600 miles straight through to Texas for a show). In 1956, after Sam peddled his contract to RCA, he began to record in Studio B, on what would become Music Row, in the heart of the nascent Nashville music industry. At first nobody noticed, even at RCA, with the possible exception of Chet Atkins, ace guitarist and future inventor of the "Nashville Sound," who remained suspicious of a boy he said had turned up at the Opry wearing eye shadow.

Later, in the 1960s, RCA had to hire police to keep fans from invading Studio B during his sessions. The Tennessee legislature summoned its native son to the State House with the columns on top and made him an honorary colonel. Elvis took to coming up from Memphis in a posh chartered bus, with a retinue of worshipful acolytes. But at first, back in the 1950s, Elvis drove to Nashville with his band in whatever car had not recently died in a ditch or caught fire somewhere in Arkansas, and then hit the road again, back to the circuit of bandshells and movie theaters and one-night stands in Texas. He played country music jamborees and jubilees and tent shows all across the South with Mother Maybelle Carter and her daughters,

Jimmie Rodgers was the Father of Country Music and Hank Williams's idol. The first of the live-fast-die-young country blues heroes, he toured hard all over the South in a big, cloth-top touring car with wire-spoke wheels. In 1929 he became Hollywood's first hillbilly movie star with a fifteen-minute short, "The Singing Brakeman." At the height of his fame, Rodgers built himself a $50,000 mansion in Kerrville, Texas, close to the TB sanitarium where he was being treated. He called his mansion Blue Yodeler's Paradise, but was too restless to stay put for long. He died at the age of thirty-five in a room at the Taft Hotel in New York City, still out on the road.

Gladys Presley was a Jimmie Rodgers fan. Gladys and her husband were fond of singing "Corinna, Corinna" with Vernon's brother, Vester. Elvis cut his teeth on Jimmie Rodgers songs. In May 1953, a week before his high school graduation, Elvis told Gladys he was going down to Tupelo to invite the relatives to the ceremony in person. Instead, he drove on through to Meridian, Mississippi, 240 miles from home, and checked into the Lamar Hotel. Jimmie Rodgers had stayed there during a course of treatment for his illness; there was a life-size statue of him in the square down the street.

Wearing a cowboy shirt and a string tie, Elvis had come to enter the all-Mississippi talent contest that was a highlight of the first annual Jimmie Rodgers Memorial Festival. The organizers of the festival presented a guitar once owned by Rodgers to the winner, Hank Snow's son. Elvis Presley sang a Red Foley number and won second prize, a brand-new guitar. The Jimmie Rodgers Memorial Festival was country music at the taproot and Elvis's first professional outing.

In 1955 he was invited to play Meridian during the festival, alongside Slim Whitman and Ernest Tubb. This time, traditionalists in the audience took vocal offense at his rendition of "Baby, Let's Play House." There was a smattering of boos when he rode in the festival parade. They voted him the Jimmie Rodgers Achievement Award a year later, but Elvis refused to acknowledge the honor.

Ferlin Husky, Faron Young, and the terrible Hank Snow. He was a real hillbilly singer, hell bent for glory and a solid gold Cadillac.

At the Country Music Hall of Fame on Music Row, Elvis Presley is not a major presence. Nashville still has reservations about a country singer whose audiences screamed and fainted and didn't give a damn about mandolins and another whiny chorus of "Wildwood Flower" or "The Little Rosewood Casket." The museum looks for signs of an unbroken musical heritage, leading from Jimmie Rodgers and the Carters and the singing cowboys and the Opry through Hank Williams, honky-tonk, and bluegrass straight to Garth Brooks. It is a brisk, no-nonsense march of progress, one that does not readily accommodate deviations from the norm. As a musician, Elvis is slotted into a rockabilly category, for purposes of classification, as though what he did alongside Hank Snow and the others in those tent shows of the 1950s was just a little dip in the highway of country musical history, like the introduction of celluloid guitar picks. In a grudging concession to tourism, however, the museum does display, under a bank of spotlights in a red velvet niche, one of Elvis Presley's Cadillacs, a sure crowd-pleaser with a roof that raises and lowers at intervals as if by magic.

The car is a 1960 tail-fin Cadillac limousine, customized for Elvis by George Barris of North Hollywood, the Cellini of star vehicles. Ever since the film business moved to Hollywood, movie stars had been enhancing standard models with identifying touches: Tom Mix and the other horse-opera cowboys favored Western motifs. For movie stars, the custom car was simple vanity. But for the country music star on tour, it was a basic component of the image, a sign of the poor boy made good, still working the byways to pay the bills and please the fans. The car was the visual symbol that announced the arrival of an eminence at some dusty crossroads south of Nashville or west of the Appalachians.

Nudie, the Hollywood tailor, the father of country flash, owned

two white Pontiac convertibles with inlaid silver dollars on the interiors, gearshift levers made from six-shooters (pull the trigger for overdrive), and bull horns on the front bumpers. Webb Pierce had a silver dollar car, too, and Hank Williams's widow bought one from Nudie for her young son in 1966 to boost his singing career. The gaudier, the better. Ostentation was the key to the aesthetic of country music. Although the songs spoke of feelings that everybody shared, rich or poor, Nudie Cohen thought the entertainer owed it to his fans to dress up and to look as different from the audience as possible. The star in the rhinestone suit with the block-long Cadillac car proved that the all-American dream could still come true.

The Solid Gold Cadillac took the operative fantasy to a grandiose extreme. The body glowed with forty coats of hand-rubbed pearlized finish made of crushed diamonds and fish scales from the Orient. The bumpers and the hand-spun hubcaps were plated in 14-karat gold, as were the swank interior accessories: the shoe buffer, electric clippers, record changer, bar, swivel-mounted TV set, and dual phones. The back seat had gold lamé drapes. The roof was studded with real gold records. It was a theme car, honoring gold records and Elvis Presley hits. And it was also, as experience soon proved, undrivable. Traffic stopped whenever the Elvismobile appeared. Mobs surrounded the car. It couldn't be left unattended for a minute. Every time a fan got close enough to touch a bumper, Barris presented a bill for several thousand dollars worth of repairs. Disgusted, Elvis shut the Cadillac up in the garage at Graceland.

Toward the end of 1966, with his client's movie career tailing off into something worse than mediocrity and record sales on the wane, Colonel Parker talked RCA into buying the car for $24,000 and sending it on tour as a kind of surrogate for Elvis Presley, who hadn't made a live appearance in years. So the Cadillac opened shopping centers and allowed itself to be ad-

mired in the parking lots of theaters where smaller-than-usual crowds were expected to turn out for the star's latest film epic, the turgid *Frankie and Johnny*. The car tour was a great success. In Houston, 40,000 came to take a look and take home a free "Elvis Presley's Gold Car" postcard. In Atlanta, the car was the guest of honor at a dinner for 250 dignitaries.

At the nerve center of gape-at-the-stars Nashville, within a thousand yards of the intersection of Division and Music Square East, the Hall of Fame, and the Elvis Cadillac, stand the Car Collector's Hall of Fame with a Webb Pierce silver-dollar car and the Hank Williams Jr. Family Tradition Museum with the blue death car on exhibit for $4 a peek. The abiding interest in star automobiles speaks to much of what country music is about. The loneliness, the restlessness, the dangers and rewards of life on the road. The existential condition of the American hero driving toward the horizon with a Hank Williams song on the radio and hope glimmering fitfully on the center line, just up ahead.

The assemblage of vehicles on Music Row also describes the changing status of the car in the country music business. In the 1940s, when Hank Williams first rolled out of Montgomery to keep a date at a honky-tonk on the ragged edge of nowhere, his auto was a tool of the trade: it was altogether fitting, somehow, that the famous Williams Cadillac would carry its owner off to meet his destiny one cold winter night in 1953. But Elvis Presley's gold Cadillac was a motionless symbol of that long, hard journey. Nobody ever made the treacherous, four-hour drive from Nashville to Memphis behind the gold-flecked wheel. The 14-karat Cadillac existed mainly to conjure up the memory of Hank Williams on the road to Canton, Ohio—or to heaven—in the back seat of his big blue car.

Until he went off to Hollywood (and intermittently thereafter), Elvis Presley clung to the emerging conventions of the country-

western business. He celebrated stardom by buying loaded luxury cars, including a pink Cadillac for his mother, who couldn't drive. He wore clothes as rich and high as the Lansky Brothers could find. And in 1957 he was measured by Nudie himself for a metallic gold and rhinestone tux. Elvis's agent told the papers that the gold suit—much too stiff and heavy for comfortable wear—cost $10,000. The real price tag was closer to $500, but the publicity value made up the difference. The suit was a whole show in itself, like one of Hank Williams's two-tone outfits garnished with music notes on the sleeves, laced-up pockets shaped like arrows (called "Frankenstein" pockets after the movie monster's stitched-closed scars), lightning bolts on the toes of the high-heeled boots, and shiny sequins everywhere else. Elvis wore a gold suit and cut a record of "Your Cheatin' Heart," one of Hank's greatest hits. For years, beginning in 1957, the Hollywood rumor mill periodically coughed up reports that Elvis had been signed to play Hank Williams in a new biopic, for staggering sums of money.

Initially, Hollywood saw Elvis Presley as a deep-fried Southern type, a hillbilly like Hank Williams before him. His early on-screen roles closely matched that reading of his biography. In his first movie, Elvis was a Southern farm boy, left behind when his brothers went off to fight the Civil War. For *Loving You* (1957), the second release, scriptwriter Hal Kanter went along with Elvis on a road trip to Shreveport, Louisiana, for his final contractual appearance on Louisiana Hayride, the Opry's chief competitor.

The Hayride was less dogmatic than the Grand Ole Opry about rules of dress and musicianship. As a result, the show earned the title of "Cradle of the Stars" for hiring unknowns—Webb Pierce in his days as a Sears salesman, Kitty Wells, Johnny Cash, and Hank Williams—later judged seasoned enough for Nashville and the big time. The Hayride hired Elvis as a regular a month after the debacle at the Ryman. He did

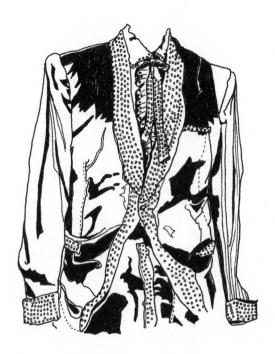

singing commercials for Southern Made Donuts every Saturday evening and rode the schoolhouse circuit with the rest of the radio gang between broadcasts.

On this last trip to Shreveport, Elvis squired Kanter around in a white Lincoln Continental limo, leaving the band to limp along behind in a mere Cadillac. The resulting screenplay was a thinly disguised version of Elvis's adventures on tour, sketched broadly and boldly enough to summon up the story of any boy with big dreams, a big car, a splashy Western get-up, and a guitar. In *Loving You,* the car was a red convertible. The red-and-white satin cowboy shirts, designed by Edith Head, doyenne of the studio costumers, parodied the flower-strewn embroidery patterns Nathan Turk, the cowboy outfitter, had dreamed up for Rose Maddox and her brothers in 1939, when they set off on tour in five matching black Cadillacs. Hollywood never did make much of a distinction between hillbilly and

*T*he night his first record was introduced on Memphis radio, a nervous Elvis Presley sequestered himself in the darkness of the Suzore Theater #2. On the top of the double bill was a Red Skelton picture. The second feature was a singing western, Goldtown Ghost Riders, starring Gene Autry and Slim Pickens.

It is no accident that Elvis Presley's own first film was a western. Music had been an intrinsic part of the genre from the 1930s through the early '50s, and the cowboy movies of the period were often the only way for lovers of country music to see the stars they heard every week on the Grand Ole Opry. The term "hillbilly" carried negative connotations of sectional backwardness, but Wild West plots in movies starring Nashville personalities neutralized the mainly Southern character of the music. Ads for *Feudin' Rhythm*, a country-hillbilly-western of 1949, promised moviegoers a chance to "see and hear the famous radio and recording favorite," Eddy Arnold.

Most of these formula films were built around the recording star, who played him- or herself—an entertainer—in flimsy plots culminating in on-screen jamborees. That was the format of Roy Acuff's *Grand Old Opry* of 1940 and the 1958 *Country Music Holiday* with Ferlin Husky, June Carter, and Faron Young. In the 1950s, when Elvis began making movies constructed around album cuts and fan magazine stories, they followed the same recipe.

The guiding geniuses behind these various productions overlapped. Sam Katzman, the so-called King of the Quickies, had made *Hootenanny Hoot* (1963) in eight and a half days and *Your Cheatin' Heart* (1964), the life of Hank Williams, in a week and a day. Under Katzman, work on the hillbilly-themed *Kissin' Cousins* kept Elvis on the set for just over two weeks in October 1963. The point wasn't the intrinsic quality of the film; the movie was a small part of a total entertainment package of songs, TV shows, photos, and merchandise, all focused on the star.

Studio insiders described Gene Autry films to one another strictly by number: Autry #7, Autry #8, and so on. *Kissin' Cousins* was Elvis #14.

western wear, between generic Southerners and Gene Autry singing trail songs astride Champion, his wonder horse. And neither, in fact, did Nashville's up-and-coming crop of rhinestone cowboys. A gold suit was the logical consequence of a cowboy suit encrusted with silvery sparkles.

Like most of his early movies, *Loving You* tried to make Elvis acceptable to the widest possible audience by accounting for the star's most glaring idiosyncrasies: his Southern background, his hankering for big cars and strange clothes, and his abiding interest in making a decent home for himself. The tension between home and the road dominates the film. As the orphaned Deke Rivers, Elvis aspires to have his own place some day, some fixed spot at the end of the next road trip. "How can a person who's got no home be homesick?" he asks his best girl. In real life, Elvis had just shown Hal Kanter the ranch house on Audubon Drive he'd bought for his parents (who appear in *Loving You* watching an Elvis/Deke jamboree in some anonymous town midway through a long tour). A bought-and-paid-for home meant security, stability, and love. The road meant bad food and bar fights, sleepless nights, loose women, and bald tires. A little flim-flam and not much cash.

Elvis knew all about it. To let off steam after a show, he patronized traveling carnivals and won stuffed animals by the gross; his mother filled the spare bedroom with plunder, from floor to ceiling. He bought outlandish lamps for the new house whenever he saw one in a store window somewhere. Mrs. Presley told a friend she wished he'd quit the business, come home, and open a furniture store: it was clear he had a good eye for lamps. Photographs taken in seedy motel rooms along his trajectory to the top show a pale, hollow-eyed creature, bloated from a steady diet of hamburgers, nuzzling a succession of predatory proto-groupies. Johnny Cash says Elvis was out to see how many girls he could get. "He did OK," Cash thinks.

In their family act, June Carter Cash also tells a couple of

good stories from her early days on tour with Elvis, including one about a whole troupe of Carters and Tubbses and Snows stuck in the mud up to the fenders of his "almost not used, two shades of pink Cadillac" looking for a shortcut to Hope, Arkansas, en route to a radio interview and a bandshell show. And then there's her Nashville story. Nashville, sometime in 1955. If you're ever in the neighborhood, drop in, she tells Elvis at the end of a swing through Alabama, Georgia, and points South. So he does, hungry and weary and broke, passing through Nashville on his way to another date. There's nobody home. Elvis breaks into her spanking new house, melts her copper skillets trying to fry eggs, and falls asleep in her bed, like Goldilocks with sideburns. Enter the husband, with a shotgun. Nashville, 1955: country music and a would-be star asleep in a strange bed. Life on the road wasn't all it was cracked up to be.

New frontiers: the Las Vegas strip

In legend, anyway, the gangster "Bugsy" Siegel is the Davy Crockett of Las Vegas, the pioneer who blazed a trail into the cactus-strewn waste where Sophie Tucker would one day open her show at the Last Frontier Hotel wearing spangled chaps and a cowgirl hat. Siegel's Flamingo Hotel wasn't the first watering hole in the desert east of L.A., but it was a model of its kind. A glitzy hotel, a gambling casino, and a showroom full of big-name acts all under one roof—and a strong, sweet whiff of something illicit by the standards prevailing in normal cities where people could neither get married, buy a new Cadillac, nor order champagne cocktails at 3 A.M.

In the 1950s the new electric sign outside the Flamingo was one of the wonders of the Strip, an effervescent cylinder of neon rings that fizzed and bubbled against the nighttime sky like an eight-story champagne cocktail. Ben Siegel, alas, never saw the sign. The Flamingo opened in 1946, with much fanfare, and with Jimmy Durante and Xavier Cougat as headliners; six months later Bugsy was rubbed out by the mob. The desert is an elemental place. Birth. Death. Rebirth in a halo of pink neon lights.

The Last Frontier predated the coming of Bugsy Siegel. Built in 1942, the second resort on the main highway between Salt Lake City and Los Angeles soon to be called the Strip, it was a dude ranch with a difference, a seductive mixture of wagon wheels, natural logs, and neon. "The Early West in Modern Splendor," the ads read. Swimming pools. Individual garages. Steer horns everywhere. And real covered wagons that picked up guests at the airport. The desk clerks and the waiters wore embroidered cowboy shirts and bolo ties. Old Wild West buildings shipped to the site for added atmosphere included the Little Chapel of the West, where tourists could get hitched cowboy style, any hour of the day or night. In 1963, when the script called for them to be married in the last reel of *Viva Las Vegas*, Elvis Presley and Ann-Margret tied the knot there, in the chapel at the casino's Frontier Village. The frontier had always been the land of fresh starts, new beginnings, and bright dreams.

In real life, Elvis married Priscilla Beaulieu at the new Aladdin Hotel just down the street from the Frontier in May 1967. The Aladdin typified the fantasy architecture of Las Vegas, where daydreams materialized in neon overnight and any fantasy seemed possible. In 1962 the Aladdin was the Tally Ho, all half-timber, stained glass, and Robin Hood–moderne à la Errol Flynn. One of the only local resorts built without a casino, the Tally Ho flopped under its own name and then again as the King's Crown, until it was reopened in 1966 by Milton Prell, an ex-jeweler and front man for the Chicago underworld, who had been one of the original partners in the vaguely Near Eastern Sahara Hotel. At Prell's Aladdin, the Tudor guest rooms remained intact but the canopy over the drive-in entry and the $750,000 free-standing sign cavorted in a riot of Moorish arches, magic lamps, and pseudo-orientalisms of typeface and color. Half Olde English with a facade out of the *Arabian Nights*, the Aladdin looked as though the neon genie atop the sign had

been stopped in mid-Alacazam! before his work at the oasis was through. The Aladdin was caught forever in an act of self-transformation and change.

The notion that Las Vegas was such a place, a new place for starting over, for change and turns of luck, made it the ideal venue for beginning or ending a marriage. Nevada divorce laws were liberal, a benefit the nearby movie colony appreciated. Clark Gable was among the first of the Hollywood stars to shed a wife within sight of a Las Vegas casino. Weddings could also be performed without blood tests and other annoying waits

calculated to dissuade the passion-stricken. No questions were asked, no eyebrows raised. The past-his-prime Frank Sinatra, with several trips down the aisle already to his credit, married a much-too-young Mia Farrow there in July 1966, at the home of the owner of the Sands Hotel. It happened with blinding speed and without much in the way of tearful relatives or flower girls. The groom already had a tux suitable for the occasion: the black dinner jacket was the costume of choice for all aging Vegas headliners. The greatest draw on the Strip, Sinatra virtually owned the main stage at the Sands in the 1960s.

Elvis, on the other hand, did not own a tuxedo. When whispers began to circulate among his inner circle that the boss was finally going to marry the girl who had lived with him at Graceland since she was fourteen years old, a friend did a rough sketch of an appropriate three-piece suit and had it made up by Lambert Marks, the MGM studio tailor, in deepest secrecy. Faded now to an unappealing chocolate brown in its glass case in the Graceland Trophy Room, Elvis's wedding garment was a parody of the standard Frank Sinatra–Dean Martin–Sammy Davis, Jr. on-stage tux, the plain black suit that stood for the class Las Vegas craved almost as much as it doted on neon and high rollers with big bankrolls. Pants, vest, coat and all, it was made of stiff brocade, with a woven-in paisley pattern of curlicues reminiscent of the neon twisting across the facade of the Aladdin Hotel. The satin lapels gleamed like the fenders of a black Cadillac limousine. The coat was tight and peculiar-looking by conventional menswear norms of the day, cut high and open in the front, exposing the trousers to the waistline. It wasn't sexy, exactly. Odd, perhaps. Distinctive. It wasn't like any other getting-married, singing-at-the-Sands suit on earth. But as a piece of costuming, it was also profoundly wrong for the conventional character of the event at hand, the expression of an emotional discomfort manifest in the writhing Maharishi

patterns and in a jacket pirated from the wardrobe trunks of the Beatles.

Priscilla's dress came straight off a bridal salon rack in the style highly touted by magazines for the newly engaged in the spring of 1967. The gown was white, of course, and full length, a satin sheath underpinning a spill of white chiffon in the latest Empire, almost-pregnant line (their daughter *was* born precisely nine months later). It was plain to a fault, a fashion error Elvis noted and disliked. The only adornment consisted of seed pearls and bugle beads scattered across the see-through sleeves and shoulders. There was a train and a full veil, held in place by a little tiara that perched atop a tower of back-combed hair, hair dyed as black as a desert night to match Priscilla's mascara and the groom's own glistening bouffant. "She looked like she had about eight people living in her hair," said one of the two best men, the amateur designer of Elvis's startling black-on-black tuxedo. Those twin poufs of Clairol-black hair set the tenor for the whole ceremony: dark, glittery, theatrical, and strange, like Las Vegas at 3 A.M.

Which was the hour when Elvis, Priscilla, and their fourteen guests furtively touched down in Vegas after a week of James Bond code words and diversionary feints. Vernon Presley, for example, had slipped into San Bernardino by train from Memphis to catch the chartered jet out of Palm Springs. A jeweler who had just flown in from Memphis raced to the plane with the rings. RCA brass were instructed to go to L.A. International, await further instructions, and speak to no one. At 3:30, the happy couple picked up the license: he was thirty-two, according to documents filed with the clerk that morning; she had turned twenty-one almost a year before. Her last birthday may have been the reason for the joyless tenor of the wedding flight. Elvis had met the future Mrs. Presley, stepdaughter of a serviceman, during his army hitch in Germany. She had barely

Thanks to his own fly-by-night nuptials at the Aladdin Hotel, Elvis has become the patron saint of the quickie wedding. Couples who have done it all before, and are therefore apt to approach the whole business in light-hearted fashion, are especially prone to being married by justices of the peace in jumpsuits or flying to Las Vegas for the $250 special at the Graceland Wedding Chapel. Since serious weddings so often seem to lead to ridiculous marriages, why not reverse the sequence?

The Graceland Chapel, a white clapboard mini-church on the Strip with no architectural similarities to the Presley estate in Tennessee, caters to the previously wed. The fee includes wedding pictures, bits of wedding finery, and an appearance by the King, in the person of the establishment's clerk and caretaker. This Elvis doesn't do the actual marrying but he does sing, in a variety of jumpsuits matched to the tastes and interests of the bride and groom. One couple, for example, opted for a "Jailhouse Rock" ceremony complete with striped jailbird outfits, a ball and chain to exchange, and an Elvis, all in black, crooning their theme song.

Jon Bon Jovi, a rabid Elvis fan, got married there in May 1989.

entered her teens, and the understanding that allowed her to move to Memphis as his live-in Lolita apparently entailed making an honest woman out of her when she reached her majority.

But in May 1966, when she turned twenty-one, Elvis had shown no such inclination. Widely rumored to be in love with Ann-Margret, he left Priscilla back home at Graceland reading movie magazines and lingered on in California, unhappy and confused. He gained weight. He chased starlets. He popped pills. She settled for rare visits to the movie set. Early in 1967, during the filming of *Clambake,* he was found unconscious on the floor

of his rented mansion in Bel Air. The press was told that he had tripped over the cord on a TV set, but his manager suspected the worst. Citing stories that Hollywood's most eligible bachelor was gay, and painting an equally grim picture of what would happen if Priscilla's family told the world he had seduced a minor child, Colonel Parker seems to have engineered a proposal. Married life would settle his boy down. It was Parker who went to Las Vegas every weekend that spring to set the wheels in motion with his pals at the Aladdin and Parker who delighted in the cloak-and-dagger tactics that guaranteed a publicity coup of epic proportions by catching the gossip columnists and the fan magazines flatfooted. Thanks to the Colonel, the Elvis Presley nuptials on the Strip were a dazzling surprise to everybody, including the participants.

The couple exchanged vows in Milton Prell's private suite on the second floor of the hotel, before a justice of the Nevada Supreme Court and a handful of sleepy friends and relatives. The hurt feelings of those who had been excluded would poison Elvis's personal relationships for years afterward. In truth, however, they hadn't missed much. The ritual lasted for just under eight minutes. He said "I do." She did not promise to obey. At 9:41 A.M. it was over. And the press conference began. The record and movie executives Parker had sequestered in a smaller hotel during the ceremony were trotted out to meet a hastily summoned press corps, alongside the bride and groom. Pictures were taken. Elvis managed to give the impression that he had scarcely seen Priscilla since his army days. Then the company repaired to a vast banquet hall—the Camelot Room—at the rear of the hotel for a $100,000 wedding breakfast.

Elvis disliked the so-called breakfast almost as much as he did his wife's gown. Apart from fried chicken and ham and eggs, the food was the kind of fancy Vegas stuff served during the eight o'clock dinner show to impress the marks: roast suckling

pig, Oysters Rockefeller, Clams Casino, and poached salmon candied for good measure. The reporters were provided with menus but got nowhere near the buffet table. Twenty waiters in white gloves guarded the salmon and steered the crowd toward a five-foot-tall, six-tiered wedding cake, festooned with pink-and-red frosting roses, silver leaves, and 478 silver dragées that glowed like faux pearls. The layers were supported by free-standing Grecian columns, and on the one just below the top, spelled out in red confectioner's gel, were the names of the newlyweds: "Priscilla-Elvis" or "Elvis-Priscilla," depending where the photographer stood during the obligatory shot of her feeding him a slice of cake. In the pictures they both look uncomfortable, tired, and only slightly pleased to be there.

Later in the month they put on their wedding outfits one more time for a big reception in Memphis, in the Blue Room at Graceland where the gold records now hang. The party was a pseudo-wedding, an admission that this was the way it should have been done in the first place—at home, with all the kinfolk (Grandma Minnie Mae Presley was the guest of honor) and a mile-long procession of limousines with tin cans tied to the fenders. As it was, the Aladdin wedding felt sleazy, no-class, inauthentic. But it had delivered a complex message all the same. On the one hand, Elvis Presley was a married man now, solid and respectable. But he was still a swinger, like Sinatra and his Rat Pack, still attractive to the chicks, sexy forever, as he prowled the neon underground of Las Vegas, sniffing the night for the attar of unwedded bliss.

The Vegas nuptials distantly echoed the sideshow rites that united Hank Williams with his second wife, the nineteen-year-old Billie Jean, in the New Orleans Municipal Auditorium in 1952. The bride wore white. The groom wore cowboy glitter. The numerous guests—14,000 by some counts—all paid to get in. Seats down front, in the area usually reserved for the family,

cost $2.80. General admission was $1. And to accommodate an overflow crowd, the couple got married twice, once at 3 P.M. and again at 7. The first ceremony, the grand finale of Hank's regular show, was actually a rehearsal, but that fact was not publicized. Local businesses were persuaded to cough up merchandise as wedding gifts. Appliances, clothing, and gift certificates poured in. Billie was especially thrilled with a brand new sewing machine, and she greeted the press at the couple's hotel after the second round of vows wearing a negligee that was part of the booty.

Hank Williams played Las Vegas that year, too, as the feature act at the Last Frontier Hotel. Despite its shoot-'em-up motif, however, the Frontier was not entirely comfortable with booking a country star. Along the Silver Circuit, the chain of lounges that ran through the casinos of Vegas and Reno and Lake Tahoe, country music was generally regarded as poison. Whereas the entertainment was supposed to please, to lull the sensibilities, and to serve as a pleasant backdrop for lavish dining and gambling, Hank Williams fans weren't big spenders apt to feed thousands into the slot machines a nickel at a time. They were poor rubes who took the unsettling emotionalism of his music seriously, listened to the lyrics, and went home after the last plaintive note had been sung. Whether or not Hank stayed drunk most of the time he played there, as the industry grapevine hinted, his engagement at the Last Frontier was not a happy one. Vegas preferred Sophie Tucker in sequined chaps. Vegas liked old, familiar acts undressed—or all dressed up in spangles, rhinestones, and gold lamé.

When Elvis headlined at the new 2,000-seat showroom of the new International Hotel in 1969, he was a vision in gold and pearls and familiarity. For his first stint, in April and May, he sang his old hits of the 1950s before packed houses of the faithful, anxious to catch a glimpse of an idol who had not

performed in public in eight long years. He looked great, fit and lean, in slim black tunics adapted from the *gis* he wore for karate practice. But the music was the thing. Memory Lane. Just what the fans wanted. During anxious weeks of rehearsal in L.A., he worked at crafting an "Elvis Presley Stage Show," as though he and Elvis were two separate entities. An Elvis Show was what the fans expected. But for his second date, in July and August, and for years thereafter, the costume was the thing: the clothes, the poses, the spotlights, the look. ELVIS, as huge and sparkly as the electric letters on the marquee of the International Hotel. Sophie Tucker with Clairol-black hair. Frank Sinatra in a jumpsuit. The Elvis Show quickly became a ritual, like a wedding. By 1970, said *Variety,* it had become "the essence of Kabuki drama."

The sheer grandiosity of it all matched the flamboyant style of the International. This was the $60 million hotel built by Kirk Kerkorian, former MGM movie mogul, on the scale of a biblical epic in Cinemascope. With 1,519 rooms, including an Imperial Suite on the penthouse floor designed and appointed according to Elvis's wishes, it was the largest resort in Vegas. Unlike the ranch-style competition, it was a thirty-story skyscraper, the tallest building in Nevada. The swimming pool on the roof was the second-largest man-made body of water in the state, after Lake Mead. The carpeting was ordered by the mile. There were 1,000 slot machines.

The International had whole theme floors, in keeping with the name of the hotel. But the most extravagant decor was reserved for the cavernous, multi-level Showroom International downstairs. It, too, was haute Imperial in flavor, with cloth-of-gold curtains, ersatz classical columns of plastic caressed by chiffon clouds, backdrops showing Greco-Roman ruins, and *putti* or some other airborne godlings suspended from the ceiling. After the second song in the Elvis Show, the star pointed toward the

heavens and greeted the cheering multitudes. "Welcome to the big, freaky International Hotel, with those . . . funky angels on the ceiling," he said. "And man, you ain't seen nothin' until you've seen a funky angel."

On stage, Elvis often played at being a Roman gladiator, fist raised in salute, knee bent in mock humility as he finished a number, or the *Discus Thrower*, arms akimbo, a perfect Grecian profile silhouetted against painted ruins washed in golden spotlights from the wings. As a tribute to the moon landing of 1969, when Elvis appeared the band blared out "Also Spake Zarathustra," the theme song of the movie *2001: A Space Odyssey*. It made Elvis seem cosmic, otherworldly, like an angel from outer space. An epiphany from the thrones of heaven. *Rolling Stone* called the act "supernatural, his own resurrection" from a dec-

ade of bad movies. He was legendary, biblical, gorgeous, godlike, a mortal man transfigured by the radiance of a pure white jumpsuit swathed in pearls and ropes of gold.

The jumpsuit is a strange, special, quasi-liturgical garment, like a wedding gown, a spacesuit, or the coronation robes of some monarch in a history book. Guys in greasepits wear jumpsuits, but there's nothing of the terrestrial in these stage clothes. Developed in the late 1960s especially for his new Las Vegas career, Elvis's gilded jumpsuits are sometimes explained on the basis of practical comfort: no tight waistbands, no buttons to come loose, no shirttail to pull out in the middle of a karate kick. And that may well have been the inspiration behind the soft black pants and unstructured jackets Hollywood designer Bill Belew initially made for Elvis as he prepared to return to the concert tour. But between the black pants of 1969 and the white one-piece costumes of 1970 lies a gap that comfort cannot bridge. Jeweled, studded, fringed, and laced (or unlaced), the jumpsuit Elvis is a different creature, the Vegas Elvis, a legend armored in a carapace of sheer, radiant glory.

The belts got bigger after the hotel gave Elvis the kind of World Champeenship buckle that boxers win for setting a house attendance record. The collars got higher and more Napoleonic after Elvis took to reading mystical tracts about a race of spiritual masters pictured wearing such attire. The pantlegs got wider and funkier in the wake of bellbottomed Woodstock. Made of wool gabardine from Milan and lined in silk, some of the outfits came to weigh thirty pounds or more, without the matching belts and the capes once worn exclusively by superheroes and Confederate officers. They even had names, these suits of his. The Mad Tiger. The Prehistoric Bird. The Mexican Sundial. The American Eagle. They were theme clothes, with a message, like the Tudor wings of the Aladdin Hotel or the Imperial Suite atop the International (later the Hilton). Elvis the Icon was

cosmic, mysterious, all-American, untouchable, as old as time. Gold-plated Elvis. Vulgar and magnificent, he ruled Las Vegas like a modern-day Caesar, or Sinatra in his prime.

Everybody wants a piece of the jumpsuit. Manuel of Nashville, the Dior of country music and Nudie's ex-son-in-law, has claimed authorship. So did Tony Alamo of Hollywood, before his arrest for using child labor to wardrobe the stars. But the squabble over Belew's singular stroke of genius seems less important than the effect of the jumpsuit on the audience and the man who wore it. The former is easy to establish: in the realm of impersonators, Halloween costumes, and pictorial souvenirs, Elvis and his outfit are one. Increasingly, the off-stage Elvis began to dress like the apparition on the album covers, too. He favored Nehru jackets and Edwardian suits in opulent, offbeat fabrics, accompanied by rings, chains, and huge belts. On his infamous visit to the Oval Office in 1970, he wore a black velvet suit with a caped jacket, a belt as wide as his too-big collar, flared pants, and giant cufflinks, which Nixon examined in stunned disbelief at the invitation of his guest. "I've been performing a lot in Las Vegas," Elvis told him, apropos of the moment. "Quite a place." If the Elvis Show was a kind of heroic disguise, a capacious alter ego in which the once-upon-a-time poor boy from Tupelo and the would-be Nashville hillbilly, the rocker and the washed-up movie star, could all hide themselves away, then so was the jumpsuit made, it seemed, of razzle-dazzle and stardust and every bright light on the Las Vegas Strip.

During the early 1970s Liberace, perpetually at the Riviera, was more famous for his costumes than for anything he did in them. In displays of wizardlike stagecraft, he zoomed into view wearing rings on every finger and a 135-pound black mink cape lined with rhinestones. His customized cars often appeared on stage with him, as part of a glutton's banquet for the eyes; Liberace was the person who introduced Elvis to George Barris

$\bigcirc\!\!\!/\!\!\!/$**iva Las Vegas** was shot on location on the Strip. The Stardust, the Tropicana, the Sands, the Flamingo, and the Sahara all figure in the musical number at the beginning of the film. At the end of the 1965 movie *Harum Scarum*, the cast inexplicably winds up there, too, with Elvis playing a movie star who does a mean lounge act. Completed in eighteen days, everything about *Harum Scarum* was borrowed. The scimitar Elvis carried had been used by Robert Taylor in another sweat-and-sand epic. The costumes were recycled from two successive versions of *Kismet* (1944 and 1955). The main set had been built by Cecil B. De Mille for his *King of Kings* in 1927. It could be argued that Elvis's Las Vegas career was a second-hand thing, too, borrowed from the life and times of Frank Sinatra.

In the early '60s, it was Sinatra who needed Elvis. Frank's daughter Nancy Sinatra met Elvis as he walked off the plane from Germany bearing a peace offering from her father, a box of shirts made by his own Hollywood tailor, Sy Devore. Welcome back to civilian life and cool clothes! Elvis returned the favor by taking the train to Miami for Frank's TV special, taped in the Grand Ballroom of the Fontainebleau Hotel. All along the route, kids stood beside the tracks hoping for a glimpse of their hero. It was better than a presidential whistle-stop campaign. Sinatra realized that Elvis fans could prop up his precarious ratings. And, for the first and last time, he coaxed Elvis into a bona fide Frank Sinatra–Las Vegas tux for the occasion (the joke was that Frank showed up in casual attire).

When Elvis closed at the International Showroom in 1969, Nancy opened there the next night. Elvis took full-page ads of congratulation in the local papers and attended the lavish party hosted in her honor by the old man. When Elvis got married in Vegas, Frank offered to send his private jet to whisk the happy couple away to their honeymoon retreat. Las Vegas made Elvis the New Sinatra of the 1970s. It may have been the elephant's graveyard of the entertainment industry, the place where old elephants went to sell their yellowed tusks. But Elvis and Frank gave Vegas a curious, gaudy legitimacy by hanging on so long.

and the joys of gold Cadillacs with built-in, gold-plated TV sets. When Elvis was growing up in the Memphis projects, Liberace was a TV star and the boys used to tell Liberace jokes, based on his outré sense of style. But Elvis reserved judgment, even then. "Man, if I could ever get people to talk about me the way they talk about Liberace, I would really have it made," he sighed. In November 1956 Elvis posed for a news photo with Liberace backstage at the Riviera. Lee wore Elvis's alarming striped sportcoat and brandished his guitar. Elvis wore Liberace's velvet smoking jacket and held his trademark candelabrum. After the picture-taking was over, Liberace told Elvis to change his image. The messy hair, the pimples, and the old Lansky Brothers' Beale Street flash wouldn't play on the Strip. The successful Las Vegas showman had to dress to please his audience.

When he dropped in on Liberace in November 1956, Elvis Presley had thus far conspicuously failed to do so, although he did have a wonderful time in Las Vegas, romancing showgirls, going to cowboy-movie matinees, taking in the other lounge acts—he may have heard "Hound Dog" for the first time while checking out the competition—and speeding down the Strip in a hot car with his cool friends, doing a passable imitation of a junior Rat Packer. It was April 1956, and he was playing the Venus Room at the New Frontier. His name was up in lights: "The Atomic-Powered Singer," the "Extra Added Attraction" in the twice-nightly review called "Musical Fantasy." Clearly visible in *Hollywood or Bust*, the Martin and Lewis comedy then being shot around town, a twenty-four-foot cardboard Elvis stood in the parking lot along the hotel's highway frontage.

The New Frontier was the Last Frontier with a space age facelift. Cynics note that John F. Kennedy used to frequent the nearby Sands in the mid '50s, when the wagon-wheel chandeliers came down at the Frontier and the asteroid lighting fixtures and spinning planets went up instead in the Cloud 9 cocktail lounge. Magenta and lilac, violet and torrid pink, the New Fron-

tier was modern to a fault, and the choice of the wildest new act to hit show business in a generation confirmed the dramatic change of identity. Elvis, the Atomic-Powered Singer, was the crowning touch in a multimillion-dollar remodeling project. In 1952 the billionaire Howard Hughes, who was dabbling in Nevada hotels while living in luxury in the penthouse of the Desert Inn, made *The Las Vegas Story* on the Strip, with the pneumatic Jane Russell and Victor Mature. The hotel in the film is called the Fabulous. It could just as well have been the New Frontier.

According to most versions of the Elvis Presley legend, the New Frontier episode was a rare defeat in a lifetime of triumphs. Booked to play the Venus Room for a month, he flopped. His name quickly slid down the lighted billboard from the tippy-top to a position of ignominy at the bottom, below the orchestra and a Borscht Belt comedian. In the beginning, he ended the show: the big finish. But as the days wore on, they decided to put Elvis on first, where he could do the least damage. After a week (some say two), he was unceremoniously replaced by a girl singer who kept her distance from the Starlets, the chorus girls stationed behind the featured act. The middle-aged Eisenhower Republicans who went to Vegas—and ran the place—weren't ready for rock 'n' roll.

He was dumped by the Last Frontier and dumped on by reporters just itching to take another hillbilly down a peg or two. *Newsweek* compared Elvis to a "jug of corn liquor at a champagne party." "For the teenagers he's a whiz; for the average Vegas spender, he's a fizz," said *Variety*. In sheer frustration, Elvis told the diners placidly chewing on steaks in the front row that their lack of emotion was "pitiful." In the legend of St. Elvis, it is only against the depths of this 1956 humiliation that the heights of his miraculous return to Vegas in 1969 can be fully appreciated. Some eyewitnesses recall big crowds and celebrities, like Bing Crosby, predicting a rosy future for the kid with the guitar, but adversity makes a better story.

Whatever the truth may be—and Elvis seems to have signed and fulfilled a two-week contract at the New Frontier—his early exposure to Las Vegas shaped his vision of what showbiz was all about. Glitter. Glamour. Something transitory and temporary, like an overnight stop on the highway from Salt Lake City to L.A. Stay up late and party. Eat, drink, and be merry. Big money: when Colonel Parker told him he'd be getting $17,500 a week, Elvis could only swallow hard and mutter, "Good Lord." Big stars in the dark desert sky. Five weeks before he took the stage at the New Frontier, Elvis was still singing in movie theaters in the South, between the halves of the double feature; the closest he got to his boyhood idol, Tony Curtis, when their names appeared together on the marquee of the Fox in downtown Atlanta, was when he slipped into a seat and watched the film. In the '70s, everybody who was anybody vied for opening night seats at the Elvis Show: Cary Grant, Pat Boone, Yul Brynner, Sammy Davis and the Sinatra crowd, and his other boyhood idol, Dean Martin, for whom he sang a special chorus of "Everybody Loves Somebody" from the stage of the International. In 1956 Elvis did all the rubbernecking, learning how a headline act was supposed to work, and getting Liberace's autograph for his mama, back home in Memphis.

Compared to Memphis, Tennessee, Las Vegas could have been the dark side of the moon. You went to Vegas and did pretty much what you wanted and then you went home. You took the money and went home. Elvis took the train. And two days later he bought his mother the house she'd always wanted, in a quiet part of Memphis full of trees and grass and $40,000 ranch houses with three little bedrooms apiece. It wasn't any Imperial Suite. The neon and the glitter seemed very far away. The stars that twinkled over Audubon Drive were the ones God himself had hung there in the heavens, and the lamps in the picture windows took 60-watt incandescent bulbs.

Route 66:

Hollywood to home

Route 66 began in cold, windy Chicago, at Grant Park, and ran 2,400 miles south and west from there to the Pacific Ocean. On the last leg of its journey to the sea, the highway coursed through Hollywood and Beverly Hills, where the movie stars gamboled in unimaginable luxury. Old Route 66 had been chartered back in 1926, the year Rudolph Valentino died.

Black-haired, sexy, and ready for silver-screen immortality, Elvis Presley—the next Valentino—first joined the torrent of humanity spilling into California in 1956: he sailed up Hollywood Boulevard with his band in the long, chrome-trimmed Cadillac limo they'd driven out from Memphis, hooting at all the pretty girls and getting his fans to chase the car. Until 1967, when the trip began to bore him, he drove back and forth to Tennessee several times a year on Route 66 in a convoy of Cadillacs, customized Greyhound buses, station wagons, and mobile homes, an entourage fit for a star of stars. Elvis rarely stopped along the way, except sometimes to nap at one of the Holiday Inns, a Memphis-owned motel chain. Travel was strictly a matter of destinations. Graceland at one end of the road.

Hollywood at the other. Elvis was not a tourist, a traveler intrigued by roadside oddities or the prospect of adventure.

In all the years they made the trip together, his companions could think of only a handful of stops that weren't strictly for sleeping, or changing a tire, or grabbing a burger on the dusty outskirts of Williams, Arizona. Early in 1965, heading to L.A. from Memphis, he saw a vision in the wilderness, where Route 66 nears the south rim of the Grand Canyon, and pulled over, convinced that the face of the Almighty had appeared to him in the clouds above the center line. It seemed providential, then, that the bus should have caught fire a little farther up the road, in the Mojave Desert near Needles; God wanted Elvis to think twice about going back to Hollywood. But that was Divine Providence. The only incidence of out-and-out tourism came just before his marriage. Like an aged art-lover determined to see Paris and die, Elvis took the eighty-mile detour to the edge of the Grand Canyon, got out of the car, and contemplated the void. Then he pushed on to Bel Air, secret plans, and his fateful rendezvous with matrimony. God and nullity lurked alongside Route 66 and they were both fearsome things.

The act of going places was inherently terrifying. The terror, the loneliness, the sense of aching loss is what makes Elvis's 1955 version of "Mystery Train" haunt the ear like the wail of a

soul in torment. "Train I riiide. Sixteen coaches long." The long black train that's gone in the night, carrying with it love and hope and solace. And comfort for the spirit. Speed is no antidote for the pain of being no place at all. Not safe at home, at Graceland. Not yet in the Promised Land of dreams come true.

Route 66 was the main river of the American West during the age of the automobile: half the population of rural Iowa, it seemed, had already floated along to the warm beaches at Santa Monica and Venice to retire, and the rest of the nation quickly followed after Disneyland opened in 1955. Route 66 was a river of dreams and illusions and visions. Out in Anaheim, in Disney's world of make-believe, you could take a jungle cruise through all the rivers of the world in ten minutes flat, fending off plastic crocodiles and hippos en route. California: a Fool's Paradise where the streets were paved with tinsel and glitter instead of gold and the rivers all had center lines. Out in Hollywood, too, nothing was quite as it seemed.

Elvis first came out to Hollywood on April Fool's Day, 1956. Hal Wallis, producer of *Casablanca,* had seen him on TV and set up a special Sunday morning screen test at Paramount. The aspiring movie star, who had been a theater usher in a one-size-fits-all uniform as recently as six years before, was due in San Diego, home of the Pacific Fleet, where Milton Berle planned to broadcast his weekly show from the deck of the *U.S.S. Hancock* for dramatic effect. Hence the Sunday audition. Elvis wore a satin cowboy shirt and sang "Blue Suede Shoes" and strummed a guitar without strings. So far, so good.

Then Elvis and the character actor Frank Faylen did a scene from *The Rainmaker.* Elvis played Jimmy Curry; he had shown up at the studio in bluejeans (which he never wore otherwise) in order to look just right—and because James Dean and Marlon Brando wore them. He knew all the lines, his and Faylen's both. He was nervous and very polite. Faylen had to tell him to

forget his manners. In the finished movie, a prestige picture with Burt Lancaster and Katherine Hepburn, Earl Holliman was Curry not because Elvis was bad but because he was too expensive for anything but a lead role. He was a big star before he ever spoke a word of dialogue to a camera.

Elvis didn't think he'd done very well and begged for a second chance. On Monday morning they did it again, with an actress, this time, coaching her charge through his scene. And then he tore off to San Diego and the opprobrium of critics who had suddenly discovered that a twenty-one-year-old hillbilly was in danger of becoming a major Hollywood somebody. He had "no discernible singing ability," wrote one prominent TV-watcher; he was nowhere near as talented as Frank Sinatra back in the latter's days as a bobby-sox idol. All in all, it was a tough introduction to movieland.

There's a pathos about Elvis in Hollywood that April, shy, eager to please, untrained and raw. Needful. Hank Williams had signed an MGM contract in 1952 and then got scared when he saw a script as thick as a big-city phone book. And he didn't want to be a redneck or a cowboy either, to suit the preconceptions of a big shot behind a desk, who looked at ol' Hank and saw the perfect rube. So he put his cold feet up on the boss's desk and got sent home, never to co-star with the likes of Esther Williams and Jane Powell. Hank Williams fled but Elvis stayed and tried, through twelve long years and thirty terrible motion pictures, three a year at the peak, all just alike, full of dreadful songs, pretty girls, and exotic scenery usually shot by a second unit while the star lip-synched and emoted on a back lot in Culver City and fooled around with the guys who'd driven out to Hollywood from Memphis with him.

This was the Memphis Mafia, El's Angels. The paid hangers-on, the old high school buddies, the dullards, the yes-men, and the shirt-tail relatives, forty or fifty of them over the years, who

\mathcal{M}ost of the reviews of *Love Me Tender* were pretty good. Critics seemed pleasantly surprised that Elvis could stand up on his two feet and speak, much less act. And it was clear that his fans would buy tickets no matter what their elders concluded.

The few awful reviews were *really* awful, however. "Is it a sausage?" asked *Time*. "It is certainly smooth and damp looking, but who ever heard of a 172-lb. sausage 6 ft. tall?" Janet Winn, writing in the *New Republic*, wrote her review in a quasi-literate mock-Southern dialect. Elvis, she said, played "a nice Southern boy who helps his mother around the house, and does bumps and grinds to raise money for the new school, and then all of a sudden goes insane with jealousy." When Marilyn Monroe did *The Brothers Karamazov*, Winn suggested, she ought to look up Elvis for the male lead.

Hal Wallis anticipated the hostility that would greet a controversial singer trying to make the transition to the screen and, in an internal memo to Paramount's chiefs, recalled the case of Frank Sinatra, playing a lounge singer in *Las Vegas Nights* of 1940. The picture didn't do well because Sinatra's followers didn't get the word. Elvis pictures, Wallis thought, should be marketed as such, to take advantage of his following.

So, although no Elvis Presley movie plumbed the depths of, say, *Las Vegas Hillbillies* of 1960 (with Jayne Mansfield and Ferlin Husky), the strategy of keeping the singer's name above the title and gearing the stories to what the fans already knew about him as a person helped to produce Elvis movies that could have had numbers instead of names. Nor did the master plan encourage much acting.

drove out to the Coast with Elvis in groups of a dozen or so and, as their leader put it, took care of business. One kept the vehicles gassed up and ready for a run back down Route 66. Another tended to matters of wardrobe: whether the moment's obsession was tailor-made suits or motorcycle gear, Elvis was often seized by the notion that he and his hometown friends should dress identically, as a sign of kinship.

The Mafia picked up girls, hung out, and acted cool, like Sinatra's older Rat Pack. They lived with Elvis at the Hollywood Knickerbocker Hotel and the Beverly Wilshire, until the management tossed them out for rowdiness. A dozen guys pummeling one another, playing touch football on the wall-to-wall carpet, and sending out for junk food quickly wore out their welcome. The Knickerbocker switchboard was overwhelmed one afternoon by a record 237 calls from tittering fans. By 1961 the Presley menage was installed in the first of a succession of rented mansions in Bel Air with a hand-tinted photo of Gladys and Vernon over the fireplace du jour but otherwise decorated like cut-rate boys' camps. Pinball machines, a juke box, lots of TVs and hi-fi sets, stuffed animals, card tables, and a pool table or two: Welcome to Graceland West.

The actor Bill Bixby, who was featured in several Elvis epics, thought the guys themselves were Elvis's traveling Graceland, his roots personified. Hollywood conspired to make Elvis somebody else—a Civil War–era farm boy, a cowboy singer, a jailbird—but the cadence of Southern speech kept him firmly tethered to home. The plot lines of Presley movies were almost always distorted versions of his real-life biography, but the process of making a movie meant a strange, unreal environment: California, Clark Gable's old dressing room, backlots, and make-believe. The only cures for the illness of illusion were going back to Memphis whenever there was a lull in the shooting

schedule and keeping friends from home close by when he couldn't.

The few journalists who got inside Club Presley long enough to write a story were puzzled by the fly-by-night quality of life with Elvis in Hollywood. He seemed always on the point of leaving and utterly detached from the people he worked with in the film industry. Hal Wallis, in his memoirs, makes special note of the fact that he was never invited to his star's house. Books by good ole boys who lived there make it clear that visitors like Tuesday Weld were the exception. Much is made of the night in 1965 when the Beatles called on Elvis at the big, Mediterranean-style place on Perugia Way because such occasions were so rare.

Some chalked it up to arrested development, a Peter Pan complex. Elvis hung out with the guys, living like a teenager whose parents aren't home, because he was a lout without the good sense to grow up and become a force in the picture business. As it was, he was a commodity, an ELVIS, trotted out two or three times a year to perform simple routines his pet chimp could have mastered. The bad movies existed mainly to sell bad albums. Quality was not a consideration. Neither was acting, craft, or pride in one's work. Or maturity. Alienated from home at the far-away end of Route 66, Elvis Presley also found him-

self separated from ELVIS, the alien being who had become a movie star.

His curious passivity has been blamed on the crassness of Colonel Parker, who preferred cash to art and made his movie deals accordingly. On the Memphis Mafia, whose own best interests lay in discouraging Elvis from making new Hollywood friends and thinking new thoughts. On Elvis himself, who believed that his fame had condemned him to a nocturnal existence behind the gates of rented houses and a circle of hired companions trapped inside with him. But the Elvis who auditioned for Paramount in 1956 had harbored no such suspicions. He yoo-hooed at pretty girls on Hollywood Boulevard and was deadly serious about a career as an actor. He told the press he didn't want to sing in the movies. His heroes were Gary Cooper and Tony Curtis, Kirk Douglas and Victor Mature, Marlon Brando and James Dean. He didn't want to smile a lot in the movies because, during all those Saturday afternoons in the dark at the old Suzore's #2 near the projects back in Memphis, he'd noticed that the best actors hardly ever did. "James Dean," he told the columnist Hy Gardner, "was a genius in acting." So Elvis had memorized every line of his dialogue in *Rebel Without a Cause.*

In the beginning, until the moguls added songs to *Love Me Tender* to pander to record buyers, his prospects looked bright. Everybody agreed that he looked great on film and had lots of natural ability. But no Stella Adler ever came along to show Elvis how to do it. Perhaps he thought that if you looked the part, if you wore the proper comma curl on your forehead the way Tony Curtis did, then you were a pirate. The consummate moviegoer, Elvis told the Jaycees in 1971 that he used to sit in the dark and yearn to be up there on the screen someday, alongside Tony and the Coop. "I saw movies and I was the hero of the movie," he confessed, with more regret and puzzlement

than joy. "So every dream that I ever dreamed has come true a hundred times."

James Dean died the same year Elvis made his first picture. Armed only with memories of watching *Rebel Without a Cause* in Memphis and dreaming about being a star, the newcomer was forced to compete with a martyr/legend. He made friends with Dean's friends, the alienated young rebels of Beverly Hills. Nick Adams. Sal Mineo. Natalie Wood. Maybe something would rub off. The minute he got serious about Natalie Wood, however, he shipped her home to Memphis to stay with the folks and ride her motorcycle through Audubon Park. Talk of a wedding sent her straight back to Hollywood to work on her career. She wasn't ready for that much Southern comfort.

To Elvis in the 1950s, the South was not so far away. The studio commissary learned to serve up down-home meals like Mama's. Lunch often consisted of bowls of mashed potatoes and gravy and a platter of crisp-fried bacon washed down with a quart of milk. The elder Presleys came out to Hollywood to visit, too. During the filming of *Loving You*, in which Elvis played a country singer ("But I'm a *hillbilly* singer!" he protested in vain) accused of depravity for wiggling when he sang (a charge that deeply offended Gladys), his parents were extras in the climactic "big show" scene, as justice triumphs and hip-twitching gets the moralists' seal of approval.

Vernon loved the bright lights and the movie stars. He would have been content to stay forever, Gladys confided to a Memphis newspaper in ill-disguised horror. Elvis, meanwhile, had been driving around, looking at stars' houses, using the maps for sale at the corner of Hollywood and Vine. He took Gladys and Vernon on a tour that left them goggle-eyed at the long driveways full of big cars, the tall columns, and the mansions that looked for all the world like movie sets. Both of them revised their thinking on what the home of a Hollywood hero ought to look like, but

Gladys thought such a place might be found in the vicinity of Memphis and was happy to board the train bound for home, sure that her son would shortly follow. Hollywood was a temporary aberration, a wisp of stardust borne upon an ill wind. Memphis was home.

Afterwards, Elvis was in Hollywood but never quite *of* Hollywood, despite the huge contracts and his name on the marquee of every drive-in in America. His early pictures weren't low-budget B-movies, either, bad from the start, as is sometimes charged. The evocative sets for *Love Me Tender* were done by art director Lyle Wheeler, the man who brought the Old South to life in *Gone With the Wind*. The satin, Nudie-style cowboy outfits in *Loving You* came from Edith Head, the best costume designer in the business. The imaginative choreography of *Jailhouse Rock* was largely Elvis's own invention, worked out with the support and encouragement of the director. And *King Creole*, shot on location in the French Quarter, was adapted from a pricey novel by Harold Robbins. Hollywood was making an effort for Elvis. Elvis, for his part, thought that by the time he finished with the army and the draft, rock 'n' roll might be gone and he'd have to be a full-time actor. Yet there was always some inner core of reserve and separation. The Southern boys. The bowls of mashed potatoes. The hotel suites and the rented houses strewn with suitcases, ready to be packed. The cars, gassed up and waiting to head back down the road that led back to Tennessee.

Elvis's first trips to Hollywood were by plane. Photographs of the spontaneous welcome arranged by the Colonel in the summer of 1956, as production on *Love Me Tender* moved into high gear, show Elvis nuzzling uniformed stewardesses and signing autographs at the L.A. airport. But the logistics for *King Creole*, shot eighteen months later, were a nightmare of slow trains and boredom. First, he went out to the Coast from Memphis on the

"Southern Steamer" with a party of twelve in a private car. There were some diversions on the westbound trip. People lined the tracks, day and night, eager for one last look at Elvis, who was slated to report for basic training the minute the picture was done. Then came Hollywood and the Paramount lot. Wardrobe, makeup, still pictures, and interiors. Another train to New Orleans, with all the guys, Nick Adams, and the cast. And back to L.A. You could feel the rumble of the wheels for weeks afterward. Finally, off to Memphis, on the frigging train. By the time they got to Dallas, everybody was squirrely. Elvis led his entourage to the nearest rental agency, leased a bunch of Cadillacs, and drove the rest of the way home.

There are any number of incidents that might account for Elvis's sudden aversion to airplanes: icing on the wings on a flight out of La Guardia; engine trouble over Texas, inbound to Memphis, with the passengers instructed to drop sharp objects and pray. But the byproduct of his fear was an old-fashioned, grinding awareness of the distances commercial aviation had otherwise dispensed with. The gulf between Memphis and Hol-

lywood widened in a physical sense, when the trip could take five whole days of flat tires, boiling radiators, and Holiday Inns. In the early '60s, after Elvis got out of the army, the journey became a two-or-three-times-a-year rite of passage from the wickedness of L.A. to the wholesomeness of Memphis, from stardom to the persona of a Southern boy who never got above his raisin'. Elvis drove all the way. In transit, if not in Hollywood, he alone was in control.

They started with a convoy of Cadillacs and station wagons, crammed with luggage. Later Elvis bought a Dodge motorhome, especially for the trek across Route 66. And in the end he graduated to a forty-foot, double-decker Greyhound bus, customized by George Barris. Priscilla was visiting from Germany, still a schoolgirl, when the bus was delivered. Like one of the pedal-to-the-metal types he played, Elvis put on his yachting cap and drove her to Las Vegas that very night in his rolling Graceland: they parked at the Sahara and hit every show on the Strip. On the way back they fiddled with the stereo and the built-in TV, tried out the velvet sofas, and went upstairs to the King's Suite, done up in purple velvet and lilac patent leather, with tufted ceilings and a full kitchen for frying crispy bacon as the desert night rolled by outside the portholes. The bus had three engines, for durability and speed, and lead sheets under the carpeting to seal out the noise. On those long trips back to Memphis, it coursed on ahead, like a shark out of water, with a school of cars shimmying along in its wake.

In 1967 the seasonal migrations ended abruptly. Elvis seemed directionless, more and more reluctant to leave whatever end of the highway he found himself on. He'd procrastinate until the only way to meet the schedule was to take a plane. The bus was put up for sale. It was a time of economies and changes. He would fly to Las Vegas to be married that year. Hollywood was no place for a married man. Besides, except for the documen-

taries, the string of Elvis films had just about played itself out. Two Westerns, a couple of chase-the-girls musicals, and an unconvincing turn as an inner city doctor in love with a nun—and it was over. Hollywood was over. It had never really been Graceland West, any more than the bus with the crimson sky lounge and the stash of get-away money under the floorboards was Graceland On Wheels. Hollywood wasn't Memphis or Graceland or home.

All aboard

the Mystery Train:

New York to Memphis

July 3, 1956: a Tuesday. Almost midnight, in the cavernous gloom of old Penn Station in New York. Varnished wooden benches, hard and shiny. Elvis, his band, a cousin, his manager, a gofer, and a photographer with a bag full of black-and-white film. The shooter, Al Wertheimer, has been hired by RCA records to follow their boy around with a camera. But RCA isn't sure if Elvis is the real thing or a passing fad so they won't pay for color processing. In the quasi-darkness of the concourse, dimly lit by pools of hard, flat light puddled around the tall brass lampstands, black-and-white film seems just right anyway. It's a black-and-white kind of place, New York, when it's late and you're waiting for the night train to Chattanooga.

It's been a black-and-white couple of days, a TV week. This group has spent a lot of it in train stations. Manhattan on the 29th, for rehearsals at the Hudson Theater. Penn Station again that night: the 10:50 to Richmond, Virginia, for two live shows. Arrive back in New York on Sunday morning, early; a taxi from the station to the Warwick Hotel. That night, a guest spot on the Steve Allen Show at NBC at eight o'clock. Elvis, on the

black-and-white screen of his parents' new console-model TV back in Memphis, singing "Hound Dog" to a real live pooch. A white-tie affair: the dog sports a bow tie and Elvis wears a black tail suit and hardly moves a muscle.

Allen means to prove that there are still standards left in the world. Good and bad. Black and white. Elvis Presley in a formal suit is not, perhaps, the Antichrist after all, the dark angel who portends the fall of Western Civilization. De-twitched and properly garbed, he's a kid who helps the ratings. The proof is right there, in black and white: Allen and NBC, with a 55.3 percent share of the audience, have finally creamed arch rival Ed Sullivan, over at CBS.

Thus far, however, the Allen Show has not been entirely to the

liking of the fastidious host. The network is fixated on bumping off Sullivan. The weapon is big names, bigger than Ed's names. This is the second week of the season. For the first show, the lineup included Kim Novak, the reclusive movie bombshell, Wally Cox, from the *Mr. Peepers* sitcom, and the spooky Vincent Price. It wasn't enough. Time to bring on Elvis Presley, the most controversial act in show business in 1956. "The fact that someone with so little ability became the most popular singer in history," Allen would be quoted as saying, "says something significant about our cultural standards." But ratings counted, too.

Elvis had already done a fair amount of network TV. Between January and March of 1956 he made six appearances on the half-hour *Stage Show* fronted by Tommy and Jimmy Dorsey and produced by Jackie Gleason as a lead-in to his weekly comedy sketch. Gleason was of two minds about Elvis Presley. On the one hand, he characterized Elvis as a kind of singing Brando, worth using for the novelty value. On the other hand, he resisted pressure to put Presley in specials or programs on which he might be forced to perform the introductions in person. Although he later boasted of giving Elvis national exposure before Ed Sullivan did, Jackie Gleason was not entirely comfortable around the wild boy with the Southern accent. Elvis had that effect on Broadway. By New York standards, hillbilly wasn't show-biz.

Elvis's drummer D. J. Fontana remembered driving up Broadway to CBS's Studio 50 for the first Dorsey rehearsal: "We were scared to death—a bunch of hillbillies going to New York." The show itself was the antithesis of rock 'n' roll. World War II–era music, heavy on the strings and the schmaltz; middle-aged men wearing tuxes; and women—the June Taylor Dancers, in ancient Rockette routines—wearing very little. The Dorseys liked it that way, blander than Vegas. They threatened to walk out if

udubon Drive turned out not to be the home of the Presleys' dreams. The neighbors were snooty, the fans impossible to control, and the place too small to hold the spoils of stardom. One whole room had to be used just for lamps and stuffed animals and extra stage clothes.

When Elvis bought Graceland in 1957 he got a huge attic, a virtually fan-proof front yard, with the mansion set atop a steep hill overlooking all points of access, and no close-by neighbors except a shopping plaza.

But what should be done with the old place on Audubon? Charles Cobb, a candy and gum manufacturer with offices in downtown Memphis, offered a fabulous price for the house. He proposed to chop it into little pieces and give a hunk to anyone who mailed in five gum wrappers.

The deal sounded good to Vernon, just what the neighbors deserved. When he called Colonel Parker for an okay, however, he learned that another candymaker already held the rights to Elvis products.

Elvis was disappointed. "It was a cute little gimmick," he told the Memphis *Press-Scimitar.*

Later RCA bought some of his movie clothes and packaged swatches in record albums. Like a sliver of the True Cross, a relic of Elvis was a little piece of heaven.

Elvis stayed. But he lasted long enough to be noticed. Hal Wallis watched the Dorsey show and was fascinated by the contrasts: the tuxes, the violins, the slick patter, and then Elvis, in a too-big sportcoat and too-tight pants, wailing "Heartbreak Hotel" as though the future of the human race depended on it. He seemed so alive. The show seemed all but dead.

And Milton Berle, over at ABC, noticed. Mr. Television, the uncrowned king of the small screen, was in trouble. His demo-

graphics were awful. Kids didn't laugh at his transvestite routines and his mugging the way their parents did. In despair, he hired Elvis to salvage his career. Berle was still a prime-time somebody. People noticed. *Variety* dated the full-blown Elvis Presley mania of 1956 to the Berle shows that spring. In April it was "Shake, Rattle and Roll" from the deck of a Navy ship in San Diego. In June it was "Hound Dog" and a comedy routine in which girls screamed when Elvis appeared (including Debra Paget, his current movie co-star). Berle was canceled but the first massive wave of alarm and disgust over Elvis began to build. Berle's show came from L.A., where standards tended to be more relaxed. But live TV was still a New York business, and in New York, it was fashionable to worry about class, culture, and civilization. Or what hillbillies seemed not to have much of.

Because nobody had ever seen anything like Elvis on TV before, national magazines dispatched teams of writers and photographers to explain the phenomenon. Why did he wiggle and shake his leg and sneer? Why did the girls scream? The answer was always the same: sex, vulgarity, and—yes—degeneracy. He appealed to some primitive streak in the young, to something that hadn't been civilized out of them yet by parents and pastors and principals. Because he was a hillbilly from the South, the next thing to Piltdown Man in blue suede shoes. It was kind of amazing that Elvis and his sort actually wore shoes or had families and houses and high school diplomas.

Life's first Elvis coverage was careful to avoid any hint that he might be something like a regular teenager. *Collier's* ran a stacked contrast between Elvis and his rival, Pat Boone. Boone was portrayed as a family man, popular in East Coast nightclubs, a regular on Arthur Godfrey's show because of his appeal to all ages and tastes. And then there was Elvis, rockin' and rollin' and kissin' girls backstage, a Godfrey reject, and no darling of the Eastern establishment.

Although Berle walked on the sides of his feet and made hurtful jokes about being "Melvin Presley," Elvis's long-lost twin, his crude shtick was ok. But "Hound Dog" was taken as a sign of Southernness and hillbilly barbarism, unacceptable on prime-time TV. To Gladys Presley's dismay, ministers (including Hank Snow's musician-turned-seminarian son, with whom her son had toured amicably enough) gave hellfire sermons attributing the nation's new low in spiritual degradation to Elvis and his hip-swiveling, kissy-face, long-haired ways. Ed Sullivan, the arbiter of sound middle-American taste, pledged that he wouldn't have Elvis "on any show at any price." He was uncouth. Deplorable. Bad. Until Steve Allen signed him up for a hot Sunday night in July, opposite ol' Ed, that is.

In some ways, Allen's show wasn't much better than Berle's or Gleason's. Milton Berle was one of his guest stars that fateful night, in fact. Instead of the Dorseys, "Steverino" had Skitch Henderson's orchestra. Steve Lawrence and Eydie Gorme sang. Steve and Eydie were Allen regulars, a pair of cool, urban, finger-snapping quasi-hipsters in evening dress. They were sophisticates, in other words, and Elvis was not—and from the start of rehearsals, the theme of the program was precisely that. Introduced as the "new" Elvis, the young Presley slouched on stage in an ill-fitting tail suit, stood on a set strewn with classical columns, and sang "Hound Dog" to a motionless basset hound perched upon a pedestal, like a canine version of a Roman vestal. The context was high cultural, the content consisted of the raucous lyrics of rock music, and the result was utterly predictable. Elvis looked like a jerk, and a sullen jerk at that. His music was made to look as tawdry and stupid as the critics had charged. "Well, they said you was high class," Elvis sang to the dog. But that was a lie.

The worst was yet to come. The hillbilly skit, a dead-on parody of the *Opry* or *Louisiana Hayride*, with Allen, Elvis, Imogene

Coca, and Andy Griffith, the latter a professional Southerner trading on the funny accent and supposed naïveté of his kind. The segment was called "Range Roundup." The background was a standard, barn-dance set. In a motley assortment of cowboy outfits and moonshiners' hats, the company interrupted their patter just long enough to deliver homespun commercials for dubious products, in broad accents culled from somewhere west of the Hudson and south of Bayonne. Elvis pitched a "Tonto" brand candy bar made in Ptomaine, Texas, the same way he used to push donuts on the Hayride. Allen cast knowing, sidelong glances at the camera and sniggered. The kid was a jerk, but what did you expect? This country stuff was trash.

Allen the composer/author/raconteur/actor/wit didn't quite get away with it, though. Teenagers picketed the studio—"Give us the Real Elvis!"—and wrote nasty letters to the sponsors. John Lardner, in a *Newsweek* editorial, took Allen to task for imposing his own elitist understanding of American culture on the audience, at the expense of Elvis, hillbillies, cowboys, teenagers, and traditions that were deeply meaningful to viewers who neither read the *New York Times* nor bought Steve Allen albums. "Presley was distraught," Lardner wrote, with a shrewd sense of where that alternative tradition came from, "like Huckleberry Finn when the widow put him in a store suit and told him not to gape or scratch." But Huck Finn had his revenge. The day after the show, at two in the afternoon, Elvis turned up the RCA studios on East 24th Street and sang "Hound Dog" into the big silver microphone. He sold six million records before the year was out.

And Ed Sullivan ate crow shortly thereafter. First thing Monday morning, after he saw the ratings, Sullivan called Colonel Parker and agreed to terms: $50,000 for three appearances, the highest fee ever paid for a TV performance by anybody. Suddenly, Ed changed his tune about bad taste and moral turpi-

tude, too. He had watched a kinescope of one of the Dorsey shows, he said, and detected nothing objectionable in it. But he never came to terms with Elvis, or why half-hysterical girls were shrieking in his balcony. After the second Presley appearance, in October—and a spirited, take-that-Steve-Allen rendition of "Hound Dog"—Sullivan accused the kid of attaching a big cardboard tube to his penis and using well-timed thrusts of the apparatus to reduce the galleries to hormone-flavored Jell-O.

Elvis sang "Peace in the Valley" on the shot-from-the-waist-up January show, to prove he wasn't a monster, and Sullivan was forced into a parting testimonial. Elvis was a " real decent, fine boy," he told the audience, as if to say that this was mighty hard to believe. In a late-night TV interview right after the Allen show, a tired and sulky Elvis was asked if he had shot his mother, as if such happenings were commonplace in families like his. To the designated culture barons of uptown Manhattan, Elvis remained a sloe-eyed barbarian from Dixie with something dangerous stuffed in his pants.

In a grudging concession to his popularity, *Look* revealed that he had just bought his parents a $40,000 air-conditioned home with a swimming pool. Maybe he *was* an all-American kid with a heart of gold. The news of his normality was undercut somewhat by the photos, however. There on the living room sofa of the new house sat Elvis, side by side with an old party from Tupelo quoted as saying that Miz Presley's son was "a fine boy," shore 'nuff. Always had been. The Mississippi elder sat there clutching his cane, ramrod straight, with his hat on indoors, and big, wide suspenders buckled over an old workshirt, the perfect hillbilly. One more living Southern stereotype.

When Elvis left Penn Station after the Allen show and the hillbilly sketch, he was headed toward the new house, the air conditioning, and the two-toned sofa with the tumbling fern pattern picked out in cut pile on the free-form back cushions.

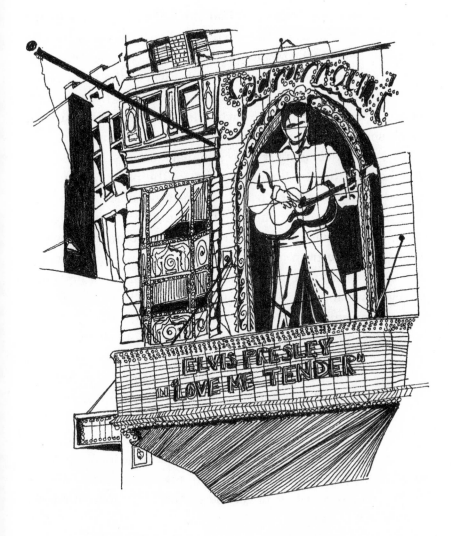

He ate breakfast in the Chattanooga station at 7 A.M. on the Fourth of July and boarded the eight o'clock local for Memphis. The train was due at the downtown depot in midafternoon. There was almost sure to be a crowd waiting there; it was a holiday and Elvis was slated to do a benefit concert in town that night. In May Elvis had tried to take a taxi from the station when

he got in from Las Vegas and had almost been trampled by the waiting fans. More and more often lately, the fervor of the "El-fans"—especially the Memphis contingent—led to desperate deceptions. The conductor would stash Elvis in the baggage car and let him slip away down the platform while the teenagers charged the coaches. Or he'd wire his father to meet him up the track somewhere, a town or two before Central Station.

This time, the engineer agrees to make an unscheduled stop just east of the city limits. The rest of the party will face the crowd downtown while Elvis makes his way home in peace. The Colonel tells him to say hello to his mama and be good.

Wertheimer has his camera ready as the young man swings down from the train all alone, clutching the records he's just cut in New York. He wants his mama to hear them first. In a fancy new suit and white knit tie, he slowly picks his way through an empty field of burrs and foxtails and yellowing grass and asks directions to Audubon Park from a black woman on the sidewalk at the edge of the frame. The signpost reads "White," in tarnished letters. The rest is missing. White Station: the far eastern edge of a city that shrinks eastward nowadays, away from Main and Beale and the projects and the poor folks, black and white, toward the countryside. Elvis Presley is a suburbanite now. He lives in a brand new house in a brand new neighborhood in the classiest part of town, a house so new he hardly remembers how to get there. And he is going home for the Fourth of July.

Audubon Drive, a curvy asphalt lane south of the new park and the golf course, has a country club air about it. Broad, meandering streets. Cul de sacs. Trees. Big back yards, where Elvis added a pool just like the one at the New Frontier Hotel as soon as he got back from Vegas. The house at number 1034 is pastel green and low to the ground. A ranch-style with nine rooms, all on the one floor. Black shutters. Brick trim. A gray

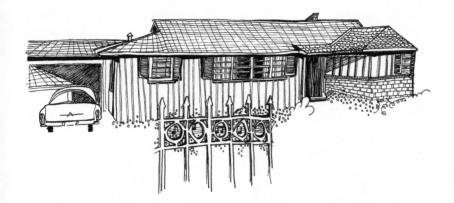

tile roof. A pool and a carport and a patio out back. Despite their size, and the depth of the lots, the houses are not very far apart on Audubon, separated by mere strips of well-tended grass. Beverly Hills houses are arranged in such well-bred proximity, without walls or fences. It gives the place a neighborly feeling, like Old Saltillo Road in Tupelo. But unlike Tupelo, there are no front porches for visiting back and forth. When Wertheimer finally arrives at Audubon Drive from decoy duty, they let him in through the side door in the carport that opens on the kitchen. This is a neighborhood that likes its privacy. Front doors are seldom used. Entrances and exits occur in private, via the garage.

The inside is a study in comfort and consumerism. Unused to $40,000 houses and a rich son, Gladys tried to move in with all her old things. Friends talked her out of it, so the detritus of a lifetime of poverty is piled up in the den, along with the lamps Elvis brought back from road trips as souvenirs. There's one ceramic lamp in the living room that came from his travels: knobby, gold-painted excrescences over canary-colored glaze, and a split-level shade. Bought in a town he wouldn't see twice, the lamp was a tacit admission of his longing for home, stability, and the good things of life. In anxious moments, as she watches

the Allen show on a console TV in the wood-paneled living room of her gorgeous new house, Gladys wishes Elvis would come home for good, give it up—the things they say about the boy bother her—and sink his earnings into a furniture store. He loves furniture. Lamps and all the new tables and couches and chairs that fill the house, from the unused front door to the dream kitchen in the back, with its two deluxe Mixmasters, one at each end of the built-in counters, so Mama doesn't have to walk too far.

The house is crammed with multiple TV sets. Berle and Allen and Ed Sullivan are never farther away than the length of a nubby sofa. There are two in the living room alone, the console and one of the new carry-around models. From the outside, the house looks like a sitcom on weeknight TV, the sort of place the Ozzie Nelsons might have lived in. The perfect $40,000 house says that the Presleys have joined the ranks of happy TV families with money to spend on all the wonderful things shown in the commercials. Hotpoint electric ranges. Linoleum. Couches that turn into beds with the flick of a wrist. The decorating magazines would probably call the style of the appointments "contemporary," meaning vaguely oriental, given to glitter, and modern but not hard-edged—intricate and cushy rather than austere. Comfortable and colorful.

Wertheimer peeked into Elvis's own Technicolor bedroom while he was getting ready for the show that night. It was a teen dream, plucked item by item from *Father Knows Best* and *Leave It to Beaver* and ads aimed at the new youth market. Twin beds with flouncy pink spreads, decorative plaques of wire and plaster in far-out shapes, yellow wallpaper speckled in orange and blue, and plush pink hound dogs cuddled up against the headboards. Oh, and an extension phone in *color.* Bright red with rhinestones. The rest of the house was a cornucopia of spanking new stuff that looked every bit as posh and wonderful as the

bedroom ensemble. Formica. Venetian blinds. Hi-fi sets. Feature walls painted in colors that didn't match the rest of the room. Huge chairs with woven-in boomerangs and palm fronds spread lavishly across broad, splayed-out arms and backs. Two-tone cocktail tables and cabinets with canted legs that tapered down to sharp brass tips. Standing ashtrays. Short white drapes with blotches of outer-space tracery. Gigantic yellow lamps of eccentric shape. Color everywhere, set off against dark wood walls. Never-seen-before new. The house looked just like

Elvis's wardrobe. If the Lansky Brothers had sold furniture, this would have been it.

And whatever else it may have been—bright, a little too happy, perhaps, for a subdivision of pricey, prestigious homes in subdued pastels—the Audubon Drive house was altogether in keeping with mainstream taste in the 1950s. The furniture came from good stores in Memphis, bought at retail. If the Presleys's blond-on-blond, bi-level, saber-legged end tables had not been featured in the "How To" section of last month's *House Beautiful*, they certainly had been pictured in the ads in back. Decorators accustomed to dealing with old-money Memphis might have counseled against paneling almost everything and avoiding neutrals when painting the rest, but the interiors depicted in advertisements for manufacturers of wall coverings showcased rooms that looked just like Gladys's living room. All the color pictures in the magazines lacked, in fact, was one of her Mississippi relatives ensconced at the end of the overstuffed sofa with his hat on, stubbing out butts in a standing ashtray made of brass.

The relatives from Tupelo were the first bone of contention with the neighbors. The Smiths and the Presleys and the Loves drove up by the carload to share in the family's good fortune and try out the furniture. They couldn't sit on the front porch because there wasn't one. But you knew they were there. They didn't drive Cadillacs, for one thing, and by the time the clan had gathered on a Sunday afternoon, Audubon Drive resembled a used car lot overrun by hillbillies in suspenders and hats that seemed to have been riveted in position at birth. There was a serious class problem in the socially select precincts of the east side where Memphians not far removed themselves from country roots were mortified by the sight of the white trash congregating at 1034 Audubon. Why, the woman who lived there—that singer's mother—hung her wash out in the back yard every Monday morning. Can you believe it? Well I *do* declare.

The fans were something else. When Elvis was home, they came by the hundreds, at all hours of the day and night. Vernon never had to mow the lawn. The girls plucked it out, blade by blade, for their scrapbooks. They tiptoed up the driveway when nobody was looking and pressed their ears to the green siding, hoping to hear a snatch of "Hound Dog" through the walls. Elvis put up a fence, a low brick wall with wrought-iron spikes on top interrupted by a pattern of circles, each bubble holding a staff and a few musical notes. Something on the order of Hank Williams's music fence in Nashville. But the fence didn't keep anybody out. If anything, the notes made it easier to find the house. Vendors sold hot dogs and popcorn in the street. The city posted signs. "NO PARKING, LOITERING, OR STANDING."

The fans ignored the signs. When Elvis wasn't home, they yoo-hooed out by the fence until Mrs. Presley came down to visit. Could she rub Elvis's Cadillac with this Kleenex, please? Would she take this paper cup and dip some Elvis water out of the swimming pool? Could we stand in the carport if we're real quiet? The family treated the invaders with grave country courtesy. When Elvis came home for the Fourth of July in 1956, there were Elfans in the carport and the driveway, fans out by the fence, fans cruising down the street, honking and waving and taking pictures. Fans in the bushes with their noses flattened against the windows, watching him talking on his bright red phone and getting ready for the evening. Elvis was bringing a date to his concert. Elvis and his girlfriend sat in the living room and cuddled his stuffed animals and listened to his new records. Al Wertheimer took pictures. And the fans watched in rapture and squealed in delight when he emerged from the house and sped off down Audubon Drive, pursued by a block-long train of admirers, honking and yelling like fools.

The hillbillies had taken over Audubon Drive. The neighbors were beside themselves. Pledges were secured: would the Presleys kindly sell the house to the neighborhood association

and move away? Would the neighbors, Elvis asked, like to name a price for *their* houses? The standoff lasted for more than a year of dirty looks and nuisance suits. The judge found out that Elvis was the only resident of Audubon Drive to own his house free and clear, and threw the aggrieved petitioners out of court.

Going home wasn't an easy thing to do. Memphis was starting to feel like New York City. Do this. Don't do that. Good taste. High standards. High toned. Be just like everybody else. It wasn't enough to have a house like Ozzie and Harriet's. You had to act like them and sound like them. You couldn't be a hillbilly in the suburbs.

\mathcal{U}.S. 51 South

Long stretches of Elvis Presley Boulevard look like Sarajevo on the 6 o'clock news. A curbless street riddled with the kinds of craters that appear after direct hits from heavy artillery. Actual rubble. Shapeless lumps of concrete, bits of brick, lengths of wire and hose and ancient rebar lie sullenly on sidewalks rapidly devolving into footpaths through pustules of litter cast off by traffic headed elsewhere. Angry curls of tire tread. Fast food wrappers, their chipper logos erased by friction with the battered pavement. Urban gemstones: shards of brown glass and green glass, necks of bottles, twisted paper bags weighted down by bottle fragments hidden deep inside. Just past a giant milk bottle bleeding rusty tears down the side of an abandoned dairy, the center line lurches suddenly, and plunges under a railroad viaduct into reeking darkness: the road to hell is surely better paved than this.

This road is also U.S. Highway 51 South and it runs from Memphis down to Jackson, Mississippi, and on to New Orleans. Wander off into the warren of little streets to the east or the west of the main stem, and you might as well be deep in rural Mis-

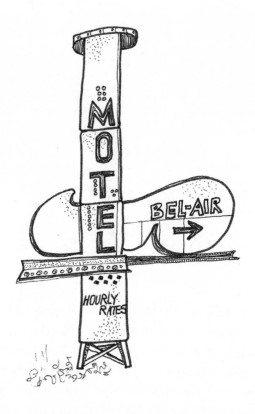

sissippi. Block after block of shotgun shacks, unpainted, un-
loved, and poor, squatting in dirt yards. Tupelo without the
chickens. Imagined from the vantage point of Tupelo in the
1940s and '50s, Memphis was all bright lights and careless
ease. "Goin' up to the Big Shelby," people said when they headed
up Highway 51 toward Shelby County, Tennessee, and the glow
in the sky, never dreaming that South Memphis might look just
like Mississippi.

It looked better then, of course, back when the whole in-town
section of 51 that joined the tangled arteries of downtown Mem-
phis with the countryside was still known as Bellevue Boule-
vard. The Bel Air Motel and Club, just past Forest Hill Cemetery,
out where Memphis stopped and the unincorporated township

of Whitehaven began, must have been a much more savory place when Elvis sang there with the Starlight Wranglers in 1954. The motel wing is still in business, furtively, beyond a privacy fence designed to conceal the guests from the scrutiny of sharp-eyed motorists. The peeling sign out front offers hourly rates. The business end of the electric arrow that used to point back over the fence is missing.

Bellevue Boulevard must have looked better once. On the downtown end, before it jogs west through a no-man's land of tall city hospitals stranded in parking lots ringed by arrows flashing for trauma and dire emergency, there is a neighborhood of big old houses, stone, some of them, with wooden trim, large enough to have been the homes of people of substance. On the Bellevue side, the Central Gardens district is pretty seedy. Old stone walls have been stained with cheap, streaky paint. It's hard to say if things are getting better or worse. The Bellevue Baptist Church, at number 70, once led the struggle to maintain a certain tone. The congregation protested the renaming of the street in 1971. They didn't want to be the Elvis Presley Baptist Church.

Except for one spit-and-polish McDonald's, nobody cares how the thoroughfare now looks for most of its twelve-mile flight toward the Mississippi line. Or has the wherewithal to imagine something better. Besides, at night, in the dark, Bellevue looks just fine: bright lights, headlights, lots of action, fried fish and bottles dispensed from empty gas stations with homemade signs. The S in fish is always backward, and it writhes and twists in the fitful light of passing traffic like a fat, bottom-feeding Mississippi catfish on a hook.

Vacant-eyed young black men in flashy clothes sit on stoops and see the signs, block-long Cadillacs, and visions of things that never were in this part of town. They stumble through minefields of trash, muttering softly to themselves. The lights of

police cars flash blue and yellow and angry red. The sirens wail. South Memphis is a drug dealer's paradise. When the city fathers had their official ceremony in January 1972 and put the signs for Elvis Presley Boulevard up over the old Bellevue markers, Vernon Presley proudly lent a hand. "Man," said Elvis, when he read the crime reports in the paper that day, "they're gonna think *I'm* doin' that stuff." Elvis Presley: robbery. Elvis Presley: assault. Elvis Presley: murder. Eight full miles of mayhem, misery, and death, all the way to Graceland.

Or almost all the way. Things change at the off-ramp for the interstate, where the road toward the airport cuts off to the east in a welter of stoplights and traffic arrows. Suddenly, after the turn for the airport, suburbia begins. A commercial strip, a forest of poles for wires and signs, and parking lots. The buildings date from the late '50s and '60s and most of them, for the next few blocks, have seen better days. Lots of vacancies, broken windows, plywood sheets. Striped lines in parking lots fading in the sun. TO LEASE. The maps say Graceland is just up the road. How could a restaurant, how could a drive-in *anything* fail on Elvis Presley Boulevard, within sight of the second-most-visited private home in America (after the White House, of course)? It's enough to try one's faith in the American Dream. And in Memphis, with its skeletal downtown, its sanitized, let's-pretend Beale Street, and its deserted suburbs. A city slowly dying, ready to consign its weary bones to a new thirty-story, $62 million, stainless steel Egyptoid pyramid built along the river to charm a better class of tourists disinclined to pick their way through the remains of Bellevue to Elvis Presley Boulevard.

But there's Graceland! Finally! Up ahead, off to the left, on a hilltop set in a grove of oaks and magnolias on a lawn so green that it seems to be a lovely dream of nature and cool forests, dreamt by a tourist stuck at a traffic light on Elvis Presley Boulevard in front of a derelict carpet-by-the-yard outlet that

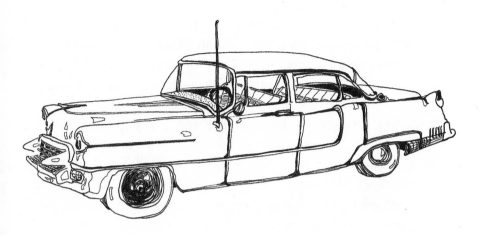

used to be a frozen custard joint. Five o'clock on a steamy afternoon in late July. The light-up signs, the parking lots, the show windows, the one-story, built-in-a-week businesses stop for the length of the stone wall out in front of Graceland—and then begin again. Krispy Kreme Donuts. Exxon. Cookie-cutter apartments with aristocratic names. A gated subdivision where the lawns have gone to seed and paint is a forgotten luxury. The Piccadilly Cafeteria. All the way out to what remains of White-haven Plaza, two long blocks south of Graceland, on the corner of the five-hundred-acre farm that once surrounded the house. One Hour Martinizing. Rainbo Coin Laundry Services. U-Can-Rent. Royal Furniture. Walgreens. Wig Garden.

The Plaza has fallen on hard times, like most of its pre-mall, space-age counterparts. In the spring of 1957 Gladys and Vernon Presley made an appointment with a real estate agent to go and look at houses, better ones, bigger ones, with bigger lots for privacy. The rendezvous spot was Whitehaven Plaza, selected, no doubt, as much for its social cachet as for its location. The Plaza was the last word in retail modernity, stores for the comfortably-off and the choosy set in vast, free-parking lots that gave the shopper the kind of easy access downtowns never quite

achieved. It was the place to be seen, as Mrs. Presley was that afternoon, emerging from a white Lincoln Continental, purchased by a famous, loving, movie-star son.

Virginia Grant, the realtor, took one look at the car and pegged the retail price at $11,650. At Whitehaven Plaza, a nose for prices was a must, for shopping was a crucial social drama of class, status, and mobility. Mobility in two dimensions. There was lateral movement, making the long drive out from town on Highway 51. And a steep vertical climb, too. People who shopped at Whitehaven Plaza were on their way up. Mrs. Grant understood what the expensive car and the shops scattered like shimmering gems across a carpet of fresh, velvety asphalt really meant. She told the Presleys to look sharp for the beautiful estate on "51 as you approach Whitehaven Plaza." That was the house—the mansion high up on the hill—they were going to see.

Visitors never fail to be shocked by the sight of the hill and the trees and the big white mansion stranded in an endless strip mall, a hundred yards from a fume-choked six-lane highway which has not been appreciably gentrified by being called a boulevard. "I never dreamed that a man of his stature could live on such a street," says one fan who speaks for many. Graceland. 3764 Elvis Presley Boulevard. Stand under the tall columns at the front door and look down the hill. Wilson World Hotel and Campgrounds. Shoney's: Big Breakfast Bar. Gas. A little pink stucco mall-ette. Memories of Elvis Gifts and Souvenirs. Graceland Plaza, where the tourists board the buses for the trip across the highway and up the hill to the front door. If you can't beat 'em join 'em: Elvis Presley's heirs own the Plaza with its neon lights, fast food, and gift shops. Snapshots of Elvis riding his horse on the lawn in front of Graceland in the summer of 1969 show trucks and buses and cars in the background, toxic clouds of exhaust hanging gray and heavy in the air, and gas stations and a sign-crazed rib emporium right across the street.

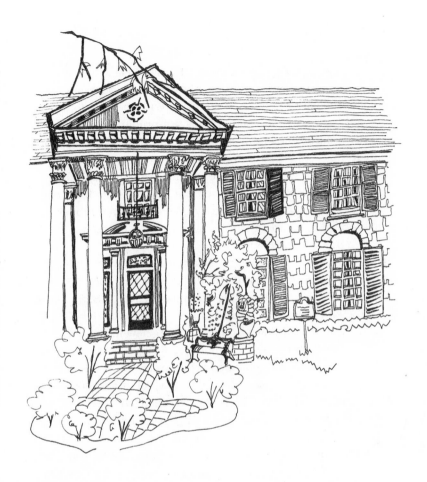

A huge electric sign shaped like a grinning pig. BAR-B-Q. bar-b-q. BAR-B-Q.

Relatives who worked on the grounds claim that Graceland was a pastoral Garden of Eden, way out in the country, until 1963 or –4, when houses and businesses sprouted up all around it and the cows disappeared. But it just isn't so. Most of the farmland around the house had already been sold off by the owner, surveyed, and subdivided (a "Graceland" community was on the drawing boards) by the time the Presleys came calling, including a lake promptly drained for more housing

he Automobile Museum in Graceland Plaza on the other side of the street honors Elvis Presley's obsession with mobility. His cars are there in quantity. With their custom paint jobs and elaborate accessories, they are primarily symbols and only secondarily means of transportation. Like the 1955 pink Cadillac that Gladys could not drive, these were vehicles of desire, symbols of wealth and the freedom to go absolutely anywhere. The fact that Elvis himself did not stray far from home may say more about the capacity of chrome and rubber and hand-rubbed paint to satisfy his desires than it does about the isolation bred by stardom.

The museum acknowledges that going places for Elvis often meant driving from Memphis to Mississippi and back. The displays are laid out on either side of a make-believe U.S. 51 South. It's dark, of course. The neon lights are ablaze at the HWY 51 DRIVE-IN movie (sit down and watch the show in the back seat of a '57 Chevy) and 51 GAS. A diorama of Graceland, behind the pink Cadillac, shows the house in the winter, muffled in a crisp, white blanket of peace, serenity, and snow. All up and down Elvis Presley Boulevard—which Elvis always called "51"—everything is perfect: fresh, new, spic-and-span. Highway 51 seen through the starry eyes of a kid who has just bought himself a mansion.

The real Highway 51 is not quite so idyllic. The Wilson World Hotel, at 3677 Elvis Presley Boulevard, adjoins the Graceland parking lot via a private gate. It's pink, with a 24-hour all-Elvis channel on the in-house TV and two genuine hand-painted Elvis pictures with little brass lights over them in the lobby. The jumpsuit Elvis to the right of the registration desk dissolves in clouds from the knees down. A Legendary Elvis. In the pool-and-popcorn room, immediately behind the art display, there are usually several Elvis widows, with or without little Elvis, Jrs., "showin' out" whenever there's a lull in the action at the pinball machines. They weep and babble and inspect caches of dog-eared papers held with rubber bands. In the parking lot outside, big black cars roar back and forth all night long.

sites. Whitehaven Plaza was open. Before World War II, ads for building lots off Highway 51 and Palmer in Whitehaven, well south of Graceland, were already appearing in Memphis newspapers: five acres for $1,500. The Memphis City Council began discussing the possible annexation of Whitehaven as early as 1953 because the area had a reputation for swank, for forward thinking, and for breakneck development. With 15,000 residents, its own water system, and ready access to the airport, Whitehaven was the suburb of tomorrow, the place where the trend-setters would go next when the east side got too crowded.

It was a half-way kind of place in 1957. Mrs. Ruth Moore, who sold Graceland to Elvis, could remember the flocks of wild turkeys that used to eat the early jonquils from the garden in the 1940s, shortly after she, her husband, and her daughter moved to the country property that had been in her family since the Civil War. The Presleys would keep chickens, horses, dogs, an evil-tempered monkey, a herd of donkeys in the swimming pool, briefly, and peacocks on the lawn until they pecked the finish off a new Rolls Royce on proud display at the end of the three-quarter-mile driveway. The turkeys were gone, though, even then, and the taco stands, the discount carpet outlets, and the power mowers were only a whisper away.

In 1957 Graceland stood at an important boundary. On one side—a couple of miles south—was Mississippi and the slow, rural ways of the Old South. On the other, the bustling, entrepreneurial New South: Whitehaven Plaza, gas stations on every other corner, airplanes swinging low over ranch-house suburbs on the glide path into Memphis, blinking arrows, and motels. Memphis was a city of roadside bustle. The drive-in movie first appeared in Memphis. The supermarket was invented there in 1916, the Piggly-Wiggly, with shopping carts to wheel down aisles of shelving the way a car might steer down Highway 51 in search of ribs. Kemmons Wilson created the first Holiday Inn on Summer Avenue in 1952 out of a big green-and-

yellow boomerang sign flashing on the curb and a stack of standardized rooms cowering behind it.

From the beginning, Elvis Presley's Graceland was another roadside attraction, with a strong presence at the shoulder of the highway, where the border between private life and public celebrity was marked off in arabesques of wrought iron and Alabama fieldstone. One of the reasons the family moved out to Whitehaven was to escape the crowds of devotees always waiting for Elvis in the carport on Audubon Drive. Already, Vernon's brother Vester, Gladys's brother Travis, and some of the other relations who camped out in the living room made up an informal security force devoted to polite forms of fan control. The 13.8 acres on which the Graceland mansion stood included a long uphill swath of trees and parkland in front of the house—a buffer against invasion—and the first additions to the layout were a substantial stone wall around the property and a pair of 250-pound gates across the driveway. But far from masking the identity of the occupant, the gates were a kind of Presley coat of arms for the uncrowned King of Rock 'n' Roll, treating Highway 51 to the sight of larger-than-life, twin Elvi with guitars rampant upon a field of rippling music. As for the $65,000 wall, it became a do-it-yourself billboard on which passersby advertised their devotion to its owner in chalk and crayon.

The gates and the "Wall of Love" were Graceland's equivalent of Kemmons Wilson's neon boomerangs. Look! There it is! There's Elvis's house! The mansion remained physically aloof on its hilltop, but the symbols deployed along the curb had quite the opposite effect. They located Elvis firmly in geographic space and invited fans to share something of his life, if only a glimpse through the filigree of the gates. They drew a line in the asphalt, too: Elvis in the shade of the trees, you and me out on the sizzling curb—stardom and unimaginable luxury inside; pocket change and a bus ticket back to Monroe, Louisiana, on the

outside. The frontage on Highway 51 articulated the imaginary social line between rich and poor, between those who belonged and those who didn't. But the see-through gate and the not-too-tall parapet never quite constituted the Southern equivalent of the Berlin Wall. The effect was more like the sheer chiffon curtain that swishes open by magic when the movie starts. Pro forma signs of withdrawal and exclusion only served to enhance the drama of the big white mansion and the pleasure of anticipating the next appearance of the star.

And there was more. How many private homes guard their anonymity by installing a battery of blue-and-gold spotlights, trained on the facade, that make the whole structure glow in the darkness like a radioactive baked Alaska? How many recluses outline their pediment and the downspouts on their gutters in forty-watt bulbs? "Motorists driving along Highway 51 can plainly see the home now at night," a headline article in a Memphis paper dryly noted. While the renovations were in progress, Elvis was back in California making a movie. He called his father long distance and told him to string blue lights along the edges of the driveway, all the way from U.S. 51 to the front door: Red Skelton had a mile's worth of them, and he had the nicest house in Hollywood. Vernon obliged under protest. It made the approach to Graceland look just like the main runway out at the airport, he said. At Christmas time—from Thanksgiving until well after Elvis's birthday on January 8—the voltage increased: life-size nativity scenes, trees with presents, Santas and reindeer, giant greeting cards signed by Elvis, all over the lawn, all lit up as bright as day.

While the parts of Graceland closest to the road used the traditional keep-out imagery of mystery and power, the electronic presentation of house and hilltop to the highway was borrowed from the movie marquee, the Las Vegas strip, the spotlights at a Hollywood premiere. The Holiday Inn on Summer

Graceland was not a farm in 1957, however much the sales pitch for the house waxed poetic about wild turkeys and the purebred Herefords that used to graze the pastures where Graceland Estates were soon to arise. But something in Elvis—he was good in cowboy parts—came alive at the thought of farms and ranches and wide open spaces. In 1967 he bought 163 acres ten miles south of Graceland, just off Highway 51, across the Mississippi line in De Soto county. He called the place the Flying G Ranch, after Graceland.

He went on a spending spree of unequaled ferocity. Horses, tackle, house trailers and pick-ups for everybody. Guys. Wives. Cousins. He moved into a trailer there himself, ate Priscilla's cooking, and got fat. The dream was to create a kind of commune. This was the 1960s. Vaguely, he seems to have believed that being out in the country air, getting back to basics, everybody with a horse and a pick-up, would make for a better world. Lots better than his movie career.

From that part of Mississippi you could see the lights up the river plain as day. And the lights up the road to Memphis. Maybe it was too close to home. But things went sour in a hurry.

The Flying G cost a fortune. Like other utopians before him, Elvis forgot to provide for some steady source of community income. He was it, and his days in Hollywood were numbered. Under pressure from Vernon, he sold the ranch in 1969.

A Memphis promoter eventually acquired the spread and tried to make his fortune by selling seven-inch segments of the board fence, each one with a signed certificate of authenticity from Elvis's cousin Billy Smith, Travis's boy.

Avenue. Come on in! Public property! Everybody welcome! Gladys Presley often brought a lawn chair down to the gates in the afternoons to sit and chat. Before her death in 1958, she'd pose for pictures, show off the downstairs—her new silver service for 100 was a favorite—when the spirit moved her, and make lunch for fan clubs. The gatekeeper-uncles were always as much tourguides as guards. Everybody carried notes up the hill, if asked politely. Travis collected cameras down along the wall, took them up the drive, and snapped pictures of the house, click after click. Vester had a little pink Jeep. When he met especially nice gawkers, or folks from faraway places, he ran them up to mansion in person, regaling them with Elvis stories. "Be good to all my fans," Elvis told the security detail at the outset. "They are the ones who put me on the hill."

During Elvis's hitch in the service, Vernon put a sign on the fence of their rented house in Germany, advising that autographs would be signed from 7:30 to 8 P.M. *only*. Afterward, after the army, a kind of rough schedule worked itself out at Graceland, too. If Elvis was away, the gates were usually left open from dawn 'til dusk. Provided they behaved themselves, fans could stroll around at will, look in the windows, inspect the cars, and take snapshots to their hearts' content. "I'd let them all come into the house at Graceland if it were possible," Elvis said. "But there just isn't that much room."

When the master of the house was in residence, the gates were kept locked, except for his madcap dashes down Highway 51. After warning his uncles to get ready, he'd zip down the drive at high speed in an 18-carat-gold-trimmed Stutz, wave to the crowd, beep the horn, gun the engine, and tear off down the highway, laughing and calling out the window, with carloads of the faithful in hot pursuit. Every so often he'd pick a face out of the crowd and bring the chosen one home to dinner. Although the exact hour changed over the years, he usually came down

to the wall once a day to sign autographs and have his picture taken on a tree stump, from which he was clearly visible to those on the sidewalk. They made a game of it. Fans would fling papers, pencils, shirts, their shoes over the wall. And Elvis would sign his name and toss 'em back. His worst nightmare was that one afternoon they wouldn't be there. He woke up in a cold sweat, trembling, sometimes: "All the money was gone, the Colonel was gone, the girls at the fence—everything."

On the day of his nephew's death, Vester Presley had escorted more than 1,500 guests up to the house for picture-taking. For all practical purposes, the estate was open to the public. Anyone who didn't pee in the driveway (as one matron in party dress did whenever she managed to get by the guards) could walk right into Graceland like a relative or a personal friend. Every time the wall-to-wall carpeting was replaced, the uncles let their charges take pieces of the old stuff home for souvenirs. Despite the make-believe hauteur of gates and wall, Graceland really was a part of the highway culture that tooted and wheezed by on 51. Elvis had always loved Main Street in the dark for the sheer promise of the bright lights, the plate glass windows full of things to buy, and the moving traffic, going somewhere magical and new. Stretches of Highway 51 felt just like downtown.

One of the best-known photographs of Elvis was taken in 1958, during a leave from the army. All in white, from his buckskin cat boots to the turned-up collar of his shirt, he heads down the driveway, joined to Graceland by the snowy white walls and columns at his back, but drawn to the world outside and the murmur of his waiting fans. "It's after eight and the night's pretty outside," he told a journalist come to do an interview at Graceland one evening in 1965. "The sun's down and the moon's pretty. It's time to ramble." Down the driveway, past the gateposts, out into the moonlit night along the boulevard. Sometimes, in 1957 and 1958, he drove all the way downtown and sat in his car in the parking lot of the Hotel Chisca and

waited to see what would happen. Sometimes he went to Whitehaven Plaza with a wad of $100 bills in his pocket and shopped for Christmas presents.

The car chases, the rolls of bills, the fans at the gates often mortified the same civic leaders who annexed Whitehaven in 1969 and renamed Highway 51 South in his honor only after every other large feature of the Memphis landscape was ruled out for being a little too noticeable. Having Elvis Presley as the most prominent citizen of Memphis was a mixed blessing at best. He wasn't Andy Williams or Perry Como. The landing lights on the driveway and the giant Christmas cards on the lawn were serious breaches of the well-mannered good taste expected of people who could afford to live in Memphis mansions. If Graceland was his glow-in-the-dark castle, then Elvis was the King of the rednecks who stood outside and gaped.

When his mother died, Elvis wanted to hold the funeral at home, in the traditional Southern way, because she loved those fans at the foot of the hill. Colonel Parker scotched the idea of a public viewing in the Music Room at Graceland, but others—members of the press, dignitaries, celebrity hounds—sweet-talked the uncles and pestered Elvis and Vernon during the period of mourning. At the end of the week, Elvis's dentist got a call asking him to come to the mansion. After Lester Hofman and his wife arrived, a troubled Elvis gave them the grand tour. "The newspapers have made my house so laughable," he told Mrs. Hofman. "They have made it sound so laughable, I would love to have your opinion." His mother's home was beautiful, the Hofmans replied. Just beautiful.

There's a moral to this sad little story. The gates of Graceland that were supposed to separate Elvis from the fans never really worked that way. Despite the newfound wealth on display under the colored spotlights, Elvis remained in spirit a part of the have-not group on the other side of the wall. The lights were all for their benefit. And, as the years went by, it was they who were

most likely to ride up the driveway in the pink jeep, or stay for supper, or inspect the fancy cars at close range: fans, old high school friends, folks from Tupelo, cops, dentists, tradesmen, relatives, and relatives of the cooks and groundskeepers. Reporters, society folk, Old Memphis money, politicians, professors—the highly educated, the middle class, the members in good standing of the New South establishment—almost never got inside. But while Elvis's guests were not inclined to publish florid accounts of what they saw there (during his lifetime, at least), those who hadn't seen a thing came to regard Graceland as a challenge, a bastion of hillbilly piss-elegance locked away from critical scrutiny behind those ghastly gates on Highway 51. A laughable house.

But it was a house of awful sorrow, too. Mrs. Presley, lying in state in her brand new house in a pretty blue dress. The funeral cortege of white Cadillacs and Lincolns driving slowly back toward Memphis, three miles north along Bellevue to the Forest Hill Cemetery, not once, but twice. First for Gladys in 1958. Then, in 1977, for her son. At four o'clock in the morning of August 18, the fans who hadn't made it up the driveway and into the foyer to see Elvis in his casket in his new white suit were still lined up at the bottom of the hill, keeping vigil, waiting for morning. Suddenly, a '63 Ford Fairlane, a white one, came roaring down Elvis Presley Boulevard out of nowhere, weaving, doing 55 in a 40-mile-an-hour zone, and plowed into the crowd. Two teenage girls from Monroe, Louisiana, were killed on the spot. But the trucks from the florists' shops kept coming, until the whole hill was massed with sprays and wreaths: every flower in Tennessee was blooming that morning on the hill above Elvis Presley Boulevard. And in the street outside the gates, Elvis Presley memorial t-shirts sold for $5 apiece.

\mathcal{T}he Southern mansion

The movie version of Tennessee Williams's *A Streetcar Named Desire* appeared in 1951, starring Vivien Leigh as Blanche DuBois. Leigh had made her name in Hollywood in 1939 playing a Civil War–era Southern belle in *Gone With the Wind*. This new role was an updated version of the same part. Blanche is a modern-day belle, a little the worse for wear. Unlike Scarlett O'Hara, who held onto her backlot plantation house against all odds, Blanche has lost Belle Reve, "a great big place with white columns" somewhere in Mississippi, and has washed up in New Orleans, sharing close quarters with her sister Stella and Stella's working-class husband, Stanley.

Stanley is obsessed with beer, bowling, and Belle Reve. The house, which he has seen in family snapshots, represents wealth, social standing, gentility—everything that he is not. And yet he delights in having plucked himself a marital prize from that genteel world of cavaliers and ladies. "I pulled you down off the columns," he reminds his wife, "and how you loved it." Blanche angers Stanley because she will not surrender the illusions that go with white columns and wisteria. Her airs, he

\mathcal{G}one With the Wind—the movie—has spawned a cottage industry in collectibles: dolls, commemorative plates, posters. The latest is a 3 1/4" sculpted Tara, with add-on pieces representing the summer kitchen and the spring house. These arrive at two-month intervals (for only $29.90 each, plus shipping and handling), beginning with the main house, a tree, climbing vines, a section of driveway, and some grass. And, absolutely free, the site plan of the property drawn up for Selznick in 1939 by the Atlanta artist/historian Wilbur Kurtz (aka Walter Klurtz).

Miniature houses have the appeal of the dollhouse or the playhouse: the small scale fosters the illusion of control. In this version of Gone With the Wind, Rhett won't necessarily walk out on Scarlett. The Civil War might never have happened. But reproduced at palm-of-the-hand size, Tara also descends into cuteness. With pillars the height of a matchbook, it can hardly be imposing, despite the ad's plummy invocation of the "sweeping grandeur of an authentic Southern plantation." Cozy, perhaps. Romantic. Domestic: just right for corner of the coffee table. Never grand.

There are small Gracelands on the market, too, less detailed than Tara (the carport, Vernon's office, the racquetball court, and the Meditation Garden are not included). They make nice souvenirs. They confirm that Elvis is as closely identified with his home as Washington with Mount Vernon, another famous Southern mansion. They live in an eternal present, a state of grace in which mothers and sons never die and the families inside are happy forever.

The finishing touch to the Tara set, the valuable FREE bonus for those who stay the course and buy the other sections, is a gateway covered with climbing roses the size of cabbages and inscribed with the name Tara in Art Nouveau script, circa 1890. It could be the pseudo-gateway to a 1990s subdivision: Tara Heights or Rhettland. It could be Scarlett's version of the Music Gates at Graceland.

complains, have turned his apartment "into Egypt and you are the Queen of the Nile!" But in the South beautiful dreams die hard, and the Belle Reves of the antebellum past were never really lost. In the 1940s and '50s they merely moved to the New South suburbs of Memphis and rose again, column by column, as if to fulfill old Pharaoh's dream of the good years to come.

Tucked in among the week's society news in late October 1940, Ida Clemens's article on the year-old "manor" house of Dr. and Mrs. Thomas D. Moore in suburban Whitehaven was not her usual Sunday real estate feature (on topics such as sewer extensions and revolutionary plans for drive-in restaurants with glass block walls), although she described the Georgian Colonial structure in the kind of lush detail calculated to make potential buyers eager to sign on the dotted line. It was, she told readers of the Memphis *Commercial Appeal,* positively palatial: a huge, green-shuttered home built of white stone from Tishomingo County, Mississippi, specially shipped in for the Moores.

Outside, four two-story columns supported a pediment over the front door. Inside, there were decorative walls of glass brick and several picture windows, very modern for 1939, as well as a more traditional white marble fireplace. Downstairs, across the front, ran a sequence of oyster-white formal rooms—reception hall, dining room, parlor, solarium—large enough to seat five hundred people when the daughter of the family, a promising music student, played her harp for company. As she most surely would, for the Moores enjoyed high social standing in the community. Miss Clemens divined their status in the architectural character and setting of Graceland, their new country abode.

"As you roll up the drive, you sense its fine heritage of the past in its general feeling of aristocratic kindliness and tranquility," she rhapsodized. A subtle, burnished elegance that matched the bloodlines of Mrs. Moore, née Brown, a Toof on her

mother's side. The Toofs had owned the rise overlooking Highway 51, with its grove of towering oaks, for almost a century. The land had been named Graceland after Grace Toof, Mrs. Moore's aunt. The furnishings of the new house, also called Graceland, were Toof heirlooms for the most part, imported from the ancestral manse at Linden and Lauderdale in the heart of Memphis: a six-foot Chinese vase purchased at the 1893 Columbian Exposition in Chicago, a gold-bronze chandelier with crystal prisms, and lots of pier mirrors framed in antique gold leaf. A symphony in oyster-white and blue, a cantata of images refracted in polished glass. "Colonial courtliness." "Majestic columns." "Subtle luxury." A house fit for demigods, antebellum planters, or kings.

Furbringer and Ehrman drew up the preliminary plans for Graceland in 1938. Theirs was a relatively new firm, established three years before. But Max H. Furbringer, the senior partner, had been in Memphis since completing his architectural apprenticeship at the Pan-American Exposition in Buffalo in 1901. With a taste for the bold and the picturesque, he had left the exposition, bound for Texas and a great Western adventure, only to be diverted by lurid reports of a yellow-fever epidemic that had wiped out the professional class in Memphis. He stopped overnight, noted the absence of public buildings of distinction, smelled opportunity, and settled in. In 1904 he formed a thirty-year partnership with Walk C. Jones that produced some of the most impressive architecture in the region. Jones and Furbringer built churches, courthouses, and schools.

They were best known, however, for homes in the grand, Georgian mode, awash in classical ornamentation and the heritage of the glorious past. For the first major Colonial Revival residence in Memphis, the sumptuous C. Hunter Raine House of 1904–1906, Jones and Furbringer served as associates to the

Louisville architect W. J. Dodd. Thereafter, the grammar of giant porticoes, dentilation, and dark shutters set against brick or stone became their own. An early picture portfolio of works by the pair emphasized the residential side of their practice; Furbringer's only substantive discourse on architectural theory came in a 1919 treatise entitled *Domestic Architecture.*

In that little book, Furbringer presented the rudiments of what the etiquette expert Emily Post and others would later call "personality," or the imperative to reflect the character of the owner in the arrangement and, more particularly, the decoration of the house. A revivalist by conviction, Furbringer aimed to express "the tastes and refinement" of his clients in the period details of his residential projects. "People are no longer content with a house," he wrote. "They demand that environment which creates the atmosphere of 'home'"—or houses like Graceland, imbued with built-in sentiment, meaning, and status. A full-blown Colonial Revival would sweep Memphis in the 1940s and '50s. So Graceland stands at the beginning of a new wave of architecture premised on the postwar triumph of American values. But Graceland can also be seen as the last of the great antebellum mansions of the planter aristocracy of Memphis, or a splendid example of the Tara craze of the 1930s.

Gone With the Wind, Margaret Mitchell's epic Civil War novel of 1936, helped to create a positive image of the New South in the '30s, when national opinion on the region was overwhelmingly negative. Whereas the Southern stereotype ran to pellagra, sharecroppers, poverty, racism, and the conservative congressmen Franklin Roosevelt tried unsuccessfully to purge in 1938, Mitchell's bestseller featured a plucky heroine whose story centered on her efforts to save the family home—Tara—and the gracious way of life being trampled by the advancing Yankees. Nonetheless, Peggy Mitchell had nothing but scorn for the moonlight-on-the-magnolia tradition that would idealize a

make-believe, bygone South as a retreat from unpleasant realities of the Depression era. And she waged a running battle with producer David O. Selznick to prevent the movie version of her book from prettifying the raw, red-clay Georgia where Rhett and Scarlett played out their tempestuous romance.

In the end, the struggle resolved itself into a contest of wills over architecture. The American public had already decided that Clark Gable *was* the dashing Rhett Butler. The technical side of filmmaking was clearly Hollywood's business. But Mitchell saw the great plantation houses of her story—Scarlett's "clumsy, sprawling" Tara, which survives the war, and the lovely Twelve Oaks, which does not—as the symbolic essence of *Gone With the Wind* and rightly feared that moviedom would give the settings the grandeur and scale of "the Grand Central Station," if that's what it took to sell tickets. It all came down to columns.

Selznick, whose production company was headquartered in the colonnaded majesty of a white antebellum mansion, circa 1924, originally built as movie set, liked 'em. Columns were classy. Tasteful. Although the office building's nearest neighbors were the bars and seedy residence hotels of Culver City, California, he used a tightly cropped picture of its green-shuttered facade as the on-screen trademark for Selznick Pictures, along with the slogan "In the Tradition of Quality." Columns suggested tradition *and* quality, the wealth and elegance swept away by the Civil War. Through allies planted among Selznick's historical consultants and advisers, Mitchell waged a successful rear-guard action to limit the Greek Revival columns on Twelve Oaks to the facade only and to keep round ones off Tara altogether—although it would, to her eternal chagrin, sport tall brick pillars along with Selznick's green shutters.

Authenticity mattered to Mitchell. Everyone else preferred "authentic" Southern atmosphere. Beginning in 1936, auto

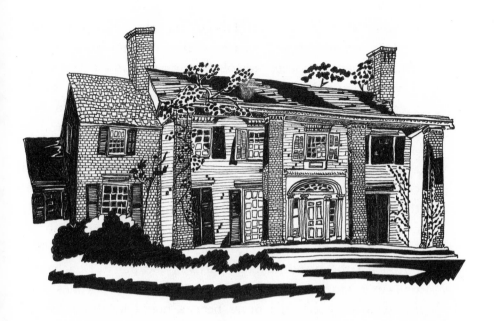

tourists rolled into Atlanta, expecting to see the fictional Tara in the round and sorely disappointed when they were shown real but columnless houses of the 1840s and '50s. Magazines ran features on historic houses in Mississippi and Louisiana that looked more satisfactory, thanks to a plethora of flutes and capitals. *House and Garden*, in November 1939, published a sneak preview of the movie in the form of Kodachrome views of the Tara set exuding Southernness in the foothills of the Santa Monica mountains. "To most of us," the editors confessed, "the South in all its romantic splendor and unfading charm is summed up forever in the stately plantation house with tall columns . . . set in the midst of rolling green fields." They quoted Margaret Mitchell (who was still smarting from the indignity of seeing piers affixed to Scarlett's beloved home): "There was an air of solidness, of stability and permanence about Tara."

Preliminary drawings for the filmic Tara could have been Fur-

bringer's sketches for Graceland. A central pediment perched on four tall supports. Green shutters. A symmetrical facade, with two bays on either side of the front door. A curving driveway. A rough-textured wall surface, in witty contrast to the taut precision of the detail. This first movie Tara began life as a nice, new, 1938-vintage suburban home, and that was the trouble with it. It lacked the opulence necessary to take the curse off the sharecropper South, the sparkle and splendor required of celluloid dreams. Hence the second Tara's ennobling piers and the wedding-cake frosting of classical frou-frou spread thickly over Twelve Oaks. Fearing the worst, Mitchell's spies from Atlanta winced wherever an exterior shot was in the offing. The outdoor barbecue scene (done partly on location at Busch Gardens in Pasadena) made the Old South look like Versailles, they complained. There had never been a house in all of Georgia remotely like the Hollywood/Twelve Oaks that threatened to disappear into its own forest of ornate columns. But director Victor Fleming, who agreed with them in principle, understood the forces working to create the Selznick Colonial style: "Maybe the po' white trash will like it because they can say it is just like Grandpa's [mansion] that Sherman burned down."

Freestanding outdoor sets like Tara and its outbuildings were expensive to build: the budget ultimately kept Selznick from going hog wild on columns. The interiors, constructed on a sound stage, were another story. Here, where unspeakable luxury could be conjured up from a handful of rented props, *Gone With the Wind* moved into a new dimension of domestic grandiosity. Its appeal was obvious to advertisers. Cookbooks, bedspreads, candy boxes, and other products sold themselves on the basis of pictorial associations with the movie and the life of easeful comfort it ultimately celebrated. Mitchell often used such details in an ironic way, exposing Scarlett's carpetbagger failures of good taste by lingering over the wall-to-wall carpet

and the red velvet portieres in her Atlanta mansion. There is no such irony in the decoration of the movie sets, however. Everything is drop-dead gorgeous, on a scale calculated to seduce both buyers of rugs and draperies and the arbiters of household taste who told them what to buy.

Joseph Platt, a New York decorator and *House and Garden* consultant, wrote the text for the magazine's *Gone With the Wind* layout (and managed to imply that he had been responsible for the art direction of the film). Later, Platt would assert that the published photo of Aunt Pittypat's knickknack-strewn parlor had launched a revival of Victorian clutter in furniture departments all across the nation. As for the decor of Scarlett's millionaire mansion, which one discerning visitor to the set said was so terrible as to be "almost beautiful," the mirrors and the gilding, the prisms and the elaborate chandeliers seem to fall midway between Mrs. Moore's Tooficized Graceland and the Hillbilly Hilton effect achieved there in the 1950s and '60s, according to scoffers, by Elvis Presley.

Graceland was a timely and evocative copy of the historic architecture of the Middle South. The doorway, with its sidelights and miniature order of engaged columns, could have come straight from publicity stills for *Gone With the Wind*. More likely, however, it came from Clanlo, a surviving Memphis plantation house of the 1850s fronted by a four-column portico of exceedingly slender proportions and Corinthian capitals bearing flattened acanthus leaves. These details, also found on the 1852 Pillow-McIntyre House, constitute a kind of antebellum Memphis style, formulated when the Toofs and the Browns were the new first families of the American Nile.

It may well be that this peculiar handling of the acanthus motif alludes to the lotus plant and to the city's exotic Egyptian name. In any case, the Memphian columns and capitals of Graceland give the generic plantation tradition a strong regional

The only real, board-and-shingle Tara languished for years on the MGM back lot. From time to time it was seen in other movies—*The Kentuckian,* for one—thinly disguised and growing seedier by the year. By 1959, when the carcass was finally crated up and sold to an Atlanta promoter, the mansion was a ruin. The California sun poked its way between chinks in the boards that masqueraded as whitewashed brick. The whole structure had developed a marked list to starboard.

Georgia rejoiced when Tara arrived in Atlanta in pieces. The governor issued a proclamation from the front steps of the Capitol. But plans to put the set to some profitable use soon foundered. Tara languished in a warehouse until Betty Talmadge, ex-wife of Georgia's senior senator and a professional party-giver, acquired the remains in 1979. Mrs. Talmadge already owned the *real* Tara, the home of Margaret Mitchell's great-grandparents, and the real Twelve Oaks (although rival claimants had appeared in Covington by then). She used the cluster of houses as the setting for wedding receptions, corporate bashes, and gala "Magnolia Suppers," at $50 a head, with a Rent-A-Belle service extra (Confederate officers, their ladies, and fieldhands, to add that special finishing touch).

The Hollywood Tara was meant to round out the set, but there were problems. Mitchell's heirs objected to the use of Tara in a money-making venture. Important bits were missing, including the upstairs window from which Mammy called down to Scarlett about wearing her shawl. Talmadge bought back the window at a ruinous price. Restoration of the front door for a 1989 party Ted Turner (who owns the movie) threw in honor of Jane Fonda ran to $8,000. And all the while the IRS was threatening to seize Tara for back taxes.

For reasons of security, Mrs. Talmadge had hidden the crates in undisclosed locations south of Atlanta. "I can't spend the rest of my life looking after Tara," she said. Pie-in-the-sky plans called for rebuilding Tara in a *Gone With the Wind* theme park in the suburbs in time for the 1996 Olympics. If it wasn't too far gone, that is.

flavor. If the good Doctor Moore, with his hobby herd of purebred Herefords, was playing Ol' Massah or Rhett Butler in his imposing white manse on the hill, Mrs. Moore's sterling local lineage (she belonged to the Colonial Dames of the Seventeenth Century) was also subtly acknowledged in the iconographic program. And there was a little pergola in the back, too, built of columns rescued from an old Memphis manor house. "The pergola may be simply a decorative adjunct or it may serve a useful purpose as an outdoor retreat," wrote Furbringer. Graceland was big, showy, see-it-from-the-road, old-lace-and-honeysuckle, pseudo-plantation Southern—a thoroughly modern house, in other words—but it was also a genteel retreat from the hucksterism of a culture in which *Gone With the Wind* opened all across the Cotton Belt in 1939 and 1940 in movie houses adorned with cardboard columns.

The column fad began in Atlanta, at Loew's Grand downtown. The Grand covered itself in three-story Doric columns for a gala premier at which Selznick, Mitchell, Leigh, and Gable all appeared, as did Martin Luther King, Sr., and his church choir, dressed as field hands and Aunt Jemimas, singing Negro spirituals. The false fronts soon spread to Georgia stores and, finally, to private homes. The Memphis of Max Furbringer and Merrill Ehrman caught Scarlett fever early, in 1938, when the fashionable Peabody Hotel added a roof garden with a to-die-for Tara motif. The annual Memphis Cotton Carnival for 1940, attended by tourists from twenty-two states, featured an all-day plantation tour, with mules, authentic barbecue, Negro work songs, and hastily erected columns. But while Furbringer continued to accept commissions from carnival dignitaries and the Peabody crowd for Taras of their very own, his interests came increasingly to center on the social effects of public housing for the poor.

He was named chairman of the newly created Memphis Municipal Housing Administration in 1935 and eventually super-

vised construction of two major housing complexes for black residents. He dragged prominent citizens to bleak inner-city slums and made movies illustrating the alternative—two-story brick projects with attenuated Georgian details in which tidy apartments rented for as little as $4 a month. In 1956, a year before Furbringer succumbed to a heart attack at the age of seventy-seven, the Housing Authority's annual report described its properties as clean, healthful, and elevating of taste. They were temporary accommodations, way stations on the road to middle-class respectability. Why, in the past five years alone, one in seven resident families had purchased houses of their own. "A typical example of this rapid turnover," the document concluded, "is the case of Mr. and Mrs. Vernon Presley and their now-famous son, Elvis," formerly of Lauderdale Courts, in the heart of the Memphis projects. By the time the report appeared, the twenty-two-year-old rock 'n' roll star had bought Graceland for $100,000.

So the Presley family bought Tara, and everything *Gone With the Wind* had come to signify in its many gala rereleases. By 1957 the movie had become *the* national epic, the most popular American film ever made. It entered the language as a shorthand way of saying that something was big, beautiful, and just about perfect: "Every one of those sessions was like I was filming *Gone With the Wind*," said Sam Phillips, describing how he recorded Elvis's first hits at Sun Records. Reissued three times during the war and again in 1947, *Gone With the Wind* was one easy answer to the question of what American boys had fought for overseas. Tara. Home. A house on a hill. Upward mobility at the end of a blacktop driveway. Status and class. And white columns.

In 1954, on the occasion of the studio's thirtieth anniversary, MGM converted *Gone With the Wind* to a dazzling, wide-screen format in order to compete with TV. The columns got taller in

the process and the houses got bigger. And as if to show home viewers what they were missing in terms of scale, Ed Sullivan devoted two successive Sunday-night shows to clips and reminiscences. Tara and Twelve Oaks and their architectural descendants in affluent, old-money suburbs from Memphis to Maine stood for the natural order of things, for how things ought to be, a state of prelapsarian innocence that could be found again wherever columns rose over the green lawns of Eden. The pillared mansion was the American dream come true.

Ever since the turn of the century, big-city tourists from up north had come to the resort hotels of the South seeking refuge from the killing pace of business under a sheltering portico of antebellum columns. The Greenbrier in White Sulphur Springs, West Virginia, built around 1910, needed only to circulate pictures of its columns and manicured lawns to conjure up visions of leisured ease, contentment, and peace. Thomas Jefferson, sitting on a block of Roman marble in the south of France a century earlier, had gone into raptures at the sight of the columns of the "Maison Quarrée" for the same reason. They were perfect, like the classicized mansions his generation would scatter with prodigal abandon all across the American South. They were perfect, like Tara, Twelve Oaks, and Graceland.

In Margaret Mitchell's novel, architecture is the dress society wears. She never quite recovered from the indignities visited upon her mansions by Hollywood. Houses are Mitchell characters, like Rhett and Scarlett. Her Tara has a plain, uncolumned facade to affirm the fact that Scarlett is a country girl. The Wilkeses of Twelve Oaks are allowed a few well-placed columns to allude to their Virginia origins and their bookish idealism. Scarlett O'Hara's rise in the world is charted by a growing excess of decoration, but the point is lost in the movie because everything is uniformly lush. The difference between money and breeding blurs. No wonder Mitchell, in 1942, became the presi-

dent and charter member of an Association of Southerners Whose Grandpappies Did Not Live in Houses with White Columns.

By the time the war was over, though, the moral of Peggy Mitchell's story had ceased to matter much. Mrs. Moore, née Brown, a Toof on her mother's side, divorced the doctor and sold her Southern mansion to the Presleys from the projects. And came to have tea one afternoon shortly thereafter with Mrs. Gladys Presley, née Smith, formerly of Tupelo, Mississippi, in what had once been her formal parlor, done in oyster-white and delicate pastels, with ancestral mirrors on either side of the marble fireplace. There was wall-to-wall carpet now, of a deep claret red—just like what Scarlett O'Hara had in her terrible Atlanta mansion. Deep-blue walls, gold-painted moldings just below the ceiling, and brand new custom-made furniture from Goldsmith's Department Store, built along the lines of the Cinemascope version of *Gone With the Wind.* Big stuff: a fifteen-foot sofa and a cocktail table to match. Portieres with fringed edges. The ladies enjoyed each other's company. Mrs. Presley, bursting with pride in her new home, gave Mrs. Moore the grand tour after tea. Mrs. Moore especially admired the fully equipped soda fountain and the jukebox in the basement.

ℋeavenly mansions

The end of March was sunny and warm in 1957, but still cool enough for Elvis Presley to wear his favorite Lansky Brothers' striped wool sportcoat with the velvet collar turned up around his ears. He kept his hands deep in the pockets in the damp of the unheated foyer as he ushered two local reporters into Graceland.

He had redecorating on his mind. The mansion had stood empty for some time now and signs of neglect were everywhere. When Vernon and Gladys had first seen the house ten days earlier, they had had to sit out in the car and wait for a Sunday school class to finish up. A nearby church sometimes used the downstairs rooms on Sundays, pending sale of the property. For hymn-singing, there was a beat-up piano in the big room to the left of the front door. Lost in plans and dreams, Elvis ran his fingers absently over the dusty keyboard and told all of Memphis about the changes he planned on making.

He wanted a blue bedroom at the top of the staircase, "the darkest blue there is," dark as the nighttime sky, with a wall of mirrors, black furniture trimmed in white leather, and a white

carpet underfoot. A midnight chamber, dark and mysterious in the glow of comet trails of white—his mama was already calling it the King's Room. In the entrance hall, another sky effect: clouds painted on the ceiling for daytime and little lights that twinkled for the stars at night. His home would be a mirror of the cosmos, a house of heaven. Like some Renaissance prince he never knew existed, Elvis saw Graceland as a grand model of the firmament, of space and time, the heavens here on earth. The stars would twinkle overhead just for his enjoyment. Bearing sweet dreams of morning, Morpheus would steal across the nocturnal sky over Memphis, Tennessee, wearing the cloak of slumber in "the darkest blue there is."

Graceland was mystical, celestial, beginning with the name. Grace was somebody's old aunt, sad to tell, but the word still conjured up heaven's gate, Elysian Fields, and grassy pastures dotted with the angel host in wings and halos. No wonder Elfan legend says the house was a full-fledged church when the Presleys came to stay there. Although Mrs. Presley talked him out of the electric stars and the trompe l'oeil clouds found in old Southern movie theaters of the 1920s, the aura of cosmic potency lingered along with the name. Graceland. The chandelier Elvis eventually hung in the cloudless foyer in the 1960s was made of long glass tubes with flame bulbs at the ends, like tiny shooting stars.

Who was to say how close to heaven the stars were, anyway? The popular fascination with outer space—with far-off planets, moons, and stars—had a solemn, theological dimension in the days when Elvis played a Vegas resort with a dining room that revolved like the solar system under flying-saucer chandeliers. Was somebody up there, among the UFOs? The man in the moon? Or God? Or William Shakespeare? In *Forbidden Planet*, the wide-screen sci-fi sensation of 1956, space travelers encounter the cast of *The Tempest* (with Caliban played by Robby

the Robot) on the distant edge of the galaxy, where the language spoken is that fruity Old Vic–King James English also used by Hollywood for God and Roman gladiators and the decor resembles the New Frontier Hotel in Las Vegas. If the stars were not the chandeliers that hung from the ceiling of the Father's heavenly mansion, they dangled nonetheless in a dark blue realm of mystery, possibility, and exaltation, very close to glory. Graceland needed stars in the foyer. They were a sign of grace.

Now Grace Toof wasn't Elvis Presley's aunt. Nor was the name of the farm inextricably attached to the house when Elvis bought it. It was just the big place out on Highway 51. There wasn't any family feeling between the Presleys and Grace's great-niece, the seller. Matters of price and terms were discussed through agents. Years later, a family member claimed that Mrs. Moore had liked Elvis's music, but the story rings hollow, a colorful anecdote told about a spunky old woman who was upper-crust Memphis to the bone and not likely to be impressed by the Presleys' kind. But Elvis kept the name and made it one with the mansion. A house called Graceland gave the inhabitants a corner on piety, long before a covey of marble Jesuses alighted in the garden. The name sounded like the way Elvis felt as he drove up the hill and saw the tall white pillars for the first time and remembered a little house in Tupelo that could have fit in the downstairs foyer with plenty of room left over. Amazing. A gift from God. "Amazing grace," cried the words of the old hymn. God himself had put Elvis Presley up on this hill as a mark of election—the same God who built the inky firmament and hung the silvery stars.

To Elvis and the family from Mississippi, going to Graceland always meant going "up the hill." That was the phrase they used, in awe of the prodigious climb from rags to riches, in awe of the flash of grace in which the mansion had materialized like some sweet vision of heaven floating above the dusty plains of woe. Coming home from the army, Elvis made an album of gospel songs, released in 1961: "I've got a mansion, just over the hilltop," he sang with a quaver of real emotion in his voice. Home was heaven and the mansion a sign that God's benevolent grace had not deserted him. In his homecoming press conference, held in Vernon's little office out by the garage, the only thing he was sure about was his abiding need for this place. "I'm going to hold on to Graceland just as long as I possibly can,"

he said. For gifts of grace that come without human sweat and sinew can vanish as quickly as they appear. There was always something a little precarious about his status at Graceland. The mansion stood upon a grassy hill that needed to be climbed again and again.

Like the Tower of Babel in the Old Testament, like the hairdo of a country-western singer ("The taller the hair, the closer to God!"), the height of the hill put Graceland nearer to heaven in the first place. Physically aloof from the road below, the house had even more private and secret zones inside, determined solely by elevation. Friends hung out in the basement and played pool. Visitors were entertained on the main floor. But the staircase to the second floor was always a kind of Jacob's Ladder, often contemplated, seldom climbed. The King's Room was at the top, at the apex of the mystery, behind a pair of golden doors. The blue walls went, eventually; a dark blue toilet was sold at public auction. The necromantic darkness up there prevailed until the end, however, if stories about blocked-up windows, black suede walls and smoky mirrors, a black quilted headboard, and a picture of Jesus on an easel next to the bed are to be believed.

The whole upstairs is closed to tourists now, including the bathroom suite adjacent to the bedroom, the bathroom where Elvis died. But every eye is fixed upon the staircase all the same, wondering, imagining. Four, five, six steps into the foyer and then the stairs rise all white and gold to a landing, curtained off, that curves to the right and disappears. In death, Elvis lay right here, at the foot of the stairs, under the chandelier, to say goodbye to his fans before he disappeared forever into the final mystery that lingers over Graceland still, like a stormcloud above the earthly Jerusalem, confounding understanding.

In their book on Elvisiana, Jane and Michael Stern reproduce without comment or caption a collage (by a fan?) called *Welcome*

I̶n 1987 Paul Simon won a Grammy for his album *Graceland*. In the title song, Elvis Presley's house is a symbol of redemption and reconciliation. Everybody can come. Pilgrims: believers. Poorboys. Young and old—the singer, divorced, and the nine-year-old son of his first marriage. Families and broken families.

In this place, conflict is resolved. The song is a litany of conflict and pain. The Civil War. The singer's past. Dead loves. Yet he senses that everybody will be received here, without a fuss. Everybody can come. There is something universal to be found at Graceland.

Of course everybody can come, you protest. That's what American tourism is all about. Just bring money. But there is no hint of cynicism in Simon. There really *is* something there for the pilgrims and the poorboys, the seekers and the watchers.

Elvis. At the bottom are the Music Gates, and right behind them, set off against a hovering crown and a midnight-blue sky full of shooting stars, a staircase rises into the celestial realm. Elvis, in a spangled jumpsuit, stands at the bottom, just starting his long climb, hesitant and unsure. But a few steps higher on the route to heaven, hand outstretched in welcome, Hank Williams appears, Stetsoned and befringed, all in white like Elvis. Come on, boy! Come on up! And at the top of the long red carpet to heaven, floating on a cloud, is Graceland. The shadowy figure of Gladys waits in the front yard to welcome her son home.

The staircase always winds upward, up the hill toward some final resolution. Toward death or glory, or the stars. After 1972 Elvis always came on stage in a blast of Strauss: "Also Sprach Zarathustra," the teasing is-there-life-out-there theme from Stanley Kubrick's 1968 film *2001: A Space Odyssey.* What *is*

up there, out there? What does it all mean? And he ended his concerts sometimes with "An American Trilogy," the "glory Hallelujahs" straining upward like a prayer, the intimations of his own death sinking like a pall over Graceland and the tinkling chorus of "Dixieland." Going up the hill took such an effort that he talked most often, in those final years, of coming down. Of giving everything away and walking down off that hill and out the gate. Elvis. Elvis and Vernon. Elvis alone. In a shirt and overalls, a poor Mississippi boy again, but free and happy. Fresh air and sunshine and happiness, in the terrestrial world, below the heights of Graceland. The thin, cool air up there, so high, so close to heaven, was sometimes hard to breathe.

Of all the awful things Priscilla Presley did to the family—and the first was leaving Elvis—the worst, in the estimation of the cousins and the uncles and the other kinfolk, was making them all buy tickets if they wanted to go up the hill again. Once Graceland became a tourist attraction in 1982, everybody paid. Uncles. The megafans who had hung around the gates so long they were almost like family. The nuts who stood outside the wall, peering at the house, and screaming that God himself had told them to go up to Graceland to find eternal peace. It was like being told they couldn't go to heaven without admission tickets. Even the relics were for sale. Slivers of wood from the trees around the house were embedded in the cases of pricey grandfather clocks like pieces of the True Cross.

And for all anyone knew, the True Cross and the Holy Grail had both been tucked away among the other lost treasures on the second floor of Graceland. Things were strange enough in Graceland toward the end to make a person wonder. There was Elvis, according to the rumor mill, sealed up in the King's Room in the dark, like King Tut in his tomb, surrounded by regal oddities to be puzzled over endlessly after his death. A white fur canopy with a built-in TV over a round fur bed, for instance, in

the second-floor dressing room. The inventory taken for probate listed 242 chairs, or thrones enough to furnish heaven. Half-formulated plans for marrying his last girlfriend included building a private movie theater in the house with a raised dais and a pair of thrones for the King and his Queen-to-be. As though Elvis were God the Father in a Flemish painting, awaiting the millennium enthroned in glory—or fake fur and velveteen.

Elvis himself was less interested in the Apocalypse, the Last Days, and the terrible visions of Judgment than he was in the mysticism of St. John and the mystery of the incarnation. The Word made Flesh. A loving Christ in human flesh. Toward the end he told a friend he was "tired of being Elvis Presley," as if there were other options, as if he had been sent from above, like Jesus, to inhabit a human frame for a little time. The fans at the bottom of the hill, he said, loved the Elvis with the sequins but not the real person that his daddy and his grandma did. They weren't the same. The real Elvis liked to read the other one's mail, as if the two were total strangers. He'd stop cold in the middle of a show, sometimes, and look down at his costume, and then out at the audience in disbelief: "Here I am in this Superman outfit," he'd say, as if the clothes had come by winged messenger from the Planet Krypton. When he spoke of coming down off the hill, the first step was always getting rid of the fringe, the jewelry, and the white fur beds. Luxury was the sad fate of gods in exile from Valhalla.

Even in the aesthetic climate of the 1970s, when style took twists and turns of amazing, hubba-hubba perversity, Elvis managed to look like a god from an undiscovered galaxy. He was an apparition. He simply materialized on stage in a wave of gasps, decked out "in a white suit of lights" and a golden cape, "gaudy, vulgar, magnificent." With the folds of his gossamer cloak swirling around him, the scarlet collar aglow in the spotlights, he looked like a Christmas angel that had just fluttered

down from Graceland, bearing tidings of great joy. He looked like Graceland, wreathed in colored lights, hovering over Memphis on the wings of a miracle.

To the Presleys, it always was. A miracle, that is, right out of the Bible. The reporters who walked through the empty rooms with Elvis called Graceland a house. With the exception of one photo caption that used the term "castle" for ironic effect, the local press treated it as a normal house, too, a little big, but a house nonetheless. By the time Elvis and his parents moved in, however, Graceland had become a mansion, and finally The Mansion, as if it had materialized out of the lyrics of an old gospel song. A place to stay, the word meant, but not just any place. A place of importance, stability, and meaning. There were governors' mansions (because palaces seemed undemocratic), ancestral mansions for the rich, and, best of all, the mansions of heaven. On his gilded piano in Graceland's Music Room, Elvis loved to play hymns that talked about home as heaven and the mansion as a mark of God's favor. "I've got a mansion just over the hilltop," he sang. "In my Father's house, there are many mansions." Jesus said it first, in the Book of John. And Elvis sang it, with a sob of homesick longing that hung in the still, cool air of Graceland like a prayer.

J. D. Sumner, the deep bass who was part of Elvis's backup group in Las Vegas, thought Elvis would have become a gospel singer had he lived another four or five years. To the annoyance of studio executives with schedules to keep, he often sang sacred music for hours before recording a secular song for a movie sound track. In Vegas he used to interrupt his own act, shhhh the audience, and step back to listen to Sumner and the others sing hymns. His apparitions took on the overtones of epiphanies, revealing Elvis to his fans as a prophet and a preacher. In a coda to a speech accepting an award from the Jaycees in 1971, he turned to the other recipients and said that "they might be

building the Kingdom of Heaven right here" in Memphis. "It's not too far-fetched to believe that." The line between the sacred and the profane was not much wider than the pathway of celestial blue light that coursed up the hill toward Graceland and redemption. "In my Father's house, there are many mansions": and after the speeches were done, Elvis brought the Jaycees there to celebrate with him in the Trophy Room, a dark blue room festooned with golden records, so many stars ablaze against a twilight sky.

In Graceland Mansion, among the indoor stars, the strangest things could happen. The ghost of Gladys Presley sat in the kitchen window, the one with the broken pane that Elvis wouldn't fix for months afterward because his mama had cracked it when she fell down in pain that last sad day. Gladys prowled the upstairs hallway, too, outside the King's Room, keeping watch, whispering a gospel song so softly that it could have been the whoosh of an angel's wing. The sweet voice sang its way down the staircase—"Like a King I may live in a palace so tall"—and the prisms of the chandelier tinkled when she wafted through the foyer where Elvis had once looked up and seen a vision of clouds and starlight. She flitted in and out of the blue lights strung along the driveway, carrying her ectoplasmic lawn chair down the hill to sit and visit with the fans camped just outside the gates of heaven.

The crowd outside the gates has always felt the magic, coursing down the hill into their own lives. On the night he died, one fan reported that her Elvis records had melted, for no earthly reason. Another woke up the next morning to find her Elvis statue in pieces. On the Graceland beat, the truth-seekers and the tourists and the weepers at the gates get lumped together by know-it-all reporters as so many moronic geeks who worship Elvis icons painted on black velvet the exact same color as the late master's Clairol hair dye. They're the ones who bear away

from the gift shops across the boulevard the trick photos of Elvis superimposed on a Holy Bible floating toward heaven on a cushion of clouds. They're the ones who hum "Take My Hand, Precious Lord" all the way to the cash register—the reverent idolaters, the unchurched, without much faith in dogma and collection envelopes, but full of hope for salvation and miracles and joy, in Elvis's name. They come looking for innocence at Graceland.

The Reverend Howard Finster of Summerville, Georgia, a noted folk artist, told of taking the Graceland tour in 1983. When he got home, still thinking about his trip up the hill, Elvis appeared to him in his own flower bed, standing next to one of Finster's haunting cutout portraits of a sweet little fellow from Tupelo staring out from under his hatbrim at the future in wonderment and apprehension. The Reverend knew better than to stare straight at a heavenly vision, so he turned away. But he wanted his guest to abide with him in the garden. "What about stayin' a while?" he asked. Can't do it, the haunt replied: "I have a tight schedule, Howard." And he was gone. Elvis, Reverend Finster decided, was a messenger from God, telling him to make more little Elvi and set them on stakes among the flowers. "Elvis at three / Is an angel to me," he inscribed on his outdoor altarpieces. Elvis is everywhere. And everywhere that Elvis is, so is Graceland—and the promise of God's holy grace.

ℋollywood houses

There's a nice scene in *Jailhouse Rock* where Elvis takes a bus tour of the stars' homes in Beverly Hills and Bel Air. The object is to get tips on the lifestyle appropriate for the soon-to-be-rich. His character—an ex-con, a singer—is about to make his first picture. But as the filming is subsequently portrayed, you're never sure whether any given scene is taking place on a sound stage or at the palatial new residence of Vince/Elvis. In star-land, reality and make believe are almost identical. Houses all have swimming pools, vast credenzas to complement fifteen-foot custom-built sofas, sunburst-shaped mirrors, and acres of wall-to-wall carpet, unified by decorative touches in the Atomic Rococo mode of contemporary too-muchness.

Although Elvis was a major Hollywood star by 1957, *Jailhouse Rock* was filmed in black and white, as a kind of rock 'n' roll *film noir* dominated by prison bars and the stripes of convicts' uniforms. It's a pity, since the domestic appointments, and the studio versions thereof, must have been a riot of turquoise and lime green, of red and pink. In the absence of color, opulence is suggested instead by pattern and texture. Everything, including

the attire of the star, is two-toned, nubby, fuzzy, velvety, or checkered.

Despite his own smoldering performance, Elvis is supposed to have disliked *Jailhouse Rock* because the movie cut a little too close to biographical fact: did everybody in Hollywood know that his daddy had served time in Parchman Prison? Yet it is most like Elvis in the details of costume and setting, in the greedy, lip-smacking appetite for all the stuff that comes with stardom. Vince and Elvis favor the same overblown wardrobes and stretch out in dramatic ease on the same long sofas. Vince stares out the window of that tour bus as if to make every detail of Jack Benny's house his own. Elvis had already parked at the foot of Red Skelton's driveway and checked off the features he wanted for his future mansion in Memphis.

Elvis took a lot of what he saw in the movie colony very much to heart. He saw Kim Novak shopping in a mink coat one day, for instance, and called Memphis, insisting that his mother get one, too. "We're not movie stars," said Gladys, but it became harder and harder to tell. In February 1957 Gladys and Vernon went out to California to visit their son on the set of *Loving You*. Sensing Mrs. Presley's dismay at the whole Hollywood ethos, the director tried to pacify her by putting the Presleys in the final scene as extras. A young singer maligned for being a bad influence on teenagers wins over an audience in which adults can judge the case for themselves. The Presleys cheered loudly and clapped on cue and then "went Hollywood" themselves. Gladys bought herself a poodle with a rhinestone collar and called him Duke, after John Wayne. Vernon began talking about how nice it would be to live out here, instead of in Memphis. The climate. The ocean. The palm trees. Blonde starlets. Movie star mansions.

The family went on a star tour of Elvis's own devising, to see the houses he liked best. In doing so, the Presleys were acting

\mathcal{T}he showman-pianist Liberace bought houses the way other people buy packs of gum. All of his gilt-on-white estates were crammed with functional objects tortured into piano shapes.

His first star home, on a prominent corner lot in Sherman Oaks, had a piano-shaped swimming pool with keys painted on the cement bottom. And it was a major tourist attraction, a local landmark. By 1959 it had been variously attacked by vandals and loved to death by fans. So Liberace moved his "happy-happies"—the knickknacks he collected on tour—to a twenty-eight-room place, up above Sunset Boulevard, near Ciro's. This house was less gimmicky, less fan-oriented, but no less lush. The front door was covered in gold leaf under plastic. There was gold wallpaper in the living room and white carpeting and crystal chandeliers everywhere, even in the kitchen.

In Sherman Oaks he always had a life-size outdoor crèche for Christmas and a mechanical Santa and reindeer that really flew. In the Hollywood Hills he scaled back the visible decorations that drew crowds but still trimmed no fewer than six indoor trees for the holidays and had them photographed for publicity purposes.

By 1978 Liberace owned ten houses, including several in Las Vegas, some of which functioned as virtual museums of the custom cars, mink coats, jewelry, and velvet suits he had begun displaying on stage in the '60s to compete with Elvis. Like the house in Sherman Oaks, Liberace's show had become a ritual display of the trappings of stardom.

like typical L.A. tourists. Anointed mayor of Beverly Hills in 1926, Will Rogers said his single most important duty was giving directions to Mary Pickford's house. By 1922 the tour buses were already rolling and star maps of Hollywood and nearby residential enclaves already traced the distinguished lineage of certain addresses that had passed from luminary to luminary with subtle shifts in filmgoers' mercurial passions. Kiosks at the corner of Hollywood and Vine sold linen-finish postcards with pictures of the huge half-timber Tudor cottages and electrified haciendas of the stars. Cards guaranteed to make the neighbors back in Memphis or Des Moines turn lime green or turquoise with envy.

Elvis's personal favorite was the Red Skelton place in Bel Air. The Georgian estate was dignified and refined, one of Hollywood's true showplaces. The grounds included an eleven-car garage and a driveway that meandered more than a mile through formal gardens to the vine-covered, red-brick manse on the crest of a hill. But in the details of his proper Georgian establishment, Skelton, one of the highest-paid TV comics of his era, betrayed a childlike sensibility not entirely foreign to the rest of Hollywood. He kept a stuffed gorilla in the shower room next to the 35,000-gallon swimming pool. The manicured 5.5-acre lawn was peppered with circus relics. The den had its own projection booth, plush seats, and a cache of old movies. And the owner often hinted at plans to line the drive (already lit up like an airport runway after dark) with life-size statues of saints.

It was all a monument to the rise of an ordinary Joe from poverty to affluence, from obscurity to stardom. Skelton's $750,000-a-year salary was cited in the papers with mingled envy and amazement: more than any distinguished actor of the day, this homely man, with his stock of sentimental, vulgar routines, symbolized the ascent of everyman in the prosperous

1950s. On the coffee table in the living room Skelton kept a doll representing a sad tramp (the character figured in one of better-known TV sketches) to remind him of just how far he had come. He loved sad clowns, too: in a pink art studio in the back garden he painted picture after picture of the father he had never known, a clown with the old Hagenbeck and Wallace Circus.

For all the retrospection, though, those invited to the Skelton house came away remembering the wild pink piano, the pranks, and the gorilla. It was great fun to be in a place that looked so staid and solemn and yet accommodated the zany antics of an overgrown kid who referred to his estate as "a Disneyland for adults." "This is going to be a lot nicer than Red Skelton's house when I get it like I want it," said Elvis on the day he bought Graceland. He never did put a stuffed gorilla out by *his* pool. But eventually he went Skelton one better. Elvis Presley had a whole Jungle Room tucked away behind the columns of his mansion in Memphis.

The prevailing architectural fantasy in Hollywood during the '30s and '40s was the Skelton Colonial, or an overscaled neo-classicism that veered from the austerity of the Greek Revival toward blowsy evocations of Mount Vernon and the antebellum South. The homes of the stars and the moguls sat on vast "estates" enclosing pools, golf courses, multiple garages and outbuildings, and even private gas stations. The dimensions of the lot constituted a major status symbol: ten acres (Jack Warner of Warner Brothers) were a great deal more than twice as prestigious as five and a half acres (Red Skelton). The houses chosen for reproduction on souvenir postcards often had ranks of lofty columns marshaled around the front door: an impressive entrance awed the humble guest by a sheer scale that bespoke the wealth and importance of the resident. Size equaled stature, and it was these big, pompous, column-laden, movie-

star facades that outsiders most often saw in the pages of fan magazines or through the windows of passing tour buses.

In the 1950s, faced by stiff competition from TV, some members of the film colony adopted a less regal, more suburban lifestyle to project an image in keeping with the imagined tastes of an audience that suddenly preferred small-screen domestic comedy and Red Skelton to Technicolor drama with popcorn and uniformed ushers. But for Elvis Presley, whose own days as a $12.75-a-week usher at Loew's State Theater were not far behind him, the big, sock-'em-in-the-eye, I'm-a-star house retained a potent allure. The same week in July 1954 in which his first record was being played on the radio in Memphis, Loew's was hosting the umpteenth re-release of *Gone With the Wind.* Elvis based his notions of the pomp and circumstance befitting a star on Tara and Twelve Oaks and the other gorgeous homes created in the imaginations of Hollywood art directors. And those illusions had also inspired most of the mansions built in Hollywood before the advent of television, when a star was still a star.

The proper movie-star house is the transatlantic equivalent to the European palace, the domain of an American royalty crowned at the box office. Such houses share a handful of elements. These include massive size; gates, guards, and long drives (signs of control and power); and blockbuster facades—all features that convey importance, like the credits running over bravura displays of cinematography at the beginning of a movie. They are meant to be looked at, desired, copied, and envied—the main point of stardom, after all. Thus movie-star mansions generally display a marked disparity between spacious suites of formal rooms on display near the entry and more exotic chambers in the back. That is, the initial impression of power and pomp gives way gradually to a rambling informality that puts guests admitted into the inner sanctum at their ease.

Rigid architectural propriety on the tour bus side. Unbuttoned lassitude in the backyard.

That contrast was not readily apparent to the average 1950s fan, however. Views of interiors provided to the press always showed resplendent front rooms decorated in a limited range of identifiable Hollywood conventions. Big, custom-made pieces, big enough to contain the sheer magnitude of a Clark Gable, for instance. White carpets, like Joan Crawford's, in need of constant attention from a bevy of live-in servants. Mirrors, like those that covered the walls of Jennifer Jones's living room, for checking the most flattering camera angles in idle moments. Elaborate, "stagy" treatment of draperies and lighting fixtures: the living room became a stage with spotlights and a velvet curtain about to rise on the life of Barbara Stanwyck.

So much for the kings and queens of the silver screen. What about the dukes and princesses? In 1956 and 1957 the *Ladies' Home Journal* ran a series of revealing picture spreads on the homes of Hollywood's younger couples. The object was to stress the wholesome, familial, just-folks side of Hollywood, but the rooms illustrated betray an ongoing fascination with old-fashioned, drop-dead glamour. Ann Blyth had a smallish house in unfashionable Toluca Lake, for example, but her living room contained a massive oil portrait of herself, huge crystal chandeliers, and ponderous valences over draperies tortured into folds that resembled nothing so much as the dusty old curtain in front of the screen at Loew's State. Electric drapes that whooshed open with the push of a button were a key star amenity of the 1950s: Tony Martin and Cyd Charisse had them in a living room of "super-Cineramic" length, along with the usual mirrors, candelabra, and lots of too-big overstuffed furniture. The Debbie Reynolds–Eddie Fisher "farm style" residence boasted the same kind of super-long mega-couches. Graceland was still a fantasy away when Elvis made his study

of movie-star architecture and decor, but against the Hollywood opulence apparent to the rankest outsider on the tour bus, the Presleys' brand new, pastel green, air-conditioned ranch house back in Memphis must have looked pretty ordinary.

The Hollywood style made everybody vaguely dissatisfied with their lot. Despite wall-to-wall carpeting, real wood paneling, a swimming pool, and a two-car garage—all of which the Presleys already had on Aubudon Drive—there was something missing. The trend seemed to be running away from ranch-house folksiness redolent of layaway plans and discount stores out on the highway toward what the women's magazines dubbed a "new formality." Noblesse oblige, huge sectionals, and Georgian pediments. "A new golden age"—an era of well-being, with glitter everywhere. Crystal chandeliers. Valences. Portieres, no less. Curving driveways long enough to put three or four cars on semi-permanent display. Plantation columns, all over again: in July 1957 *Good Housekeeping* selected MGM's deeply Southern *Raintree County* as its picture of the month and ran stills from the movie alongside a feature that taught Mr. and Mrs. America how to recognize the five basic column types at a glance.

The new formality was Doric-Ionic-Corinthian Bel Air à la Skelton, and there sat Elvis, transfixed by the spectacle. But when he had *really* made it in Hollywood, when he and the guys were lolling about in Clark Gable's old dressing room at MGM, he didn't opt to live in a classical movie-star mansion. The succession of houses he rented in California in the 1960s were certainly big enough to qualify. They were all in Bel Air. Several of them had a history: they were the ex-residences of Pat Boone, the Shah of Iran, and Rita Hayworth. And there were touches of star-caliber glitz. A built-in bowling alley here, an indoor waterfall there, a fireplace straight out of *Citizen Kane*, big enough to roast an ox in. But reporters and the handful of other visitors who got inside and cared to tell about it afterwards—like

the Beatles—described the Presley digs as dorms or army rec halls, furnished with pool tables, pinball machines, jukeboxes, card tables, TVs, and hi-fi equipment and decorated with stuffed animals.

In these son-of-*Playboy* bachelor pads, the household always seemed to be on the point of coming or going. Suitcases were always half-packed for a quick getaway. He had not invested much of himself in his hillside compounds overlooking Hollywood. The houses on Perugia Way, Bellagio Road, and Rocca Place were all but interchangeable, like so many Holiday Inns. They were places where Elvis marked time, watched TV, and got ready to face the cameras for another day, but they were never home. Not for a single Memphis minute.

The first glimmer of what home might look like did come straight from Hollywood. In the summer of 1956 Elvis was out in California making his first film, a Civil War costume piece for which he had been loaned to Twentieth Century–Fox. Some have suggested that the look of *Love Me Tender* reflects the industry's nervousness about the box office potential of a rock 'n' roll singer more famous for wiggling than for vocalizing: it was shot in black and white at a time when expensive color was still the best reason for turning off Red Skelton and going to the movies. But *Love Me Tender* was anything but a routine, low-budget production. The nineteenth-century costumes and settings were carefully researched, and the family farm to which three of the Reno boys return after the defeat of the Confederacy was noteworthy for its period charm.

In the story, Elvis plays the youngest Reno, left behind to help his mother, and the plot revolves around his marriage to a girl once betrothed to his eldest brother, absent and presumed dead. Like later Elvis films, in other words, this script contains muted echoes of the star's own life as the pampered son of a doting Southern mother. But what impressed Elvis most pro-

foundly was the set: the farm, with its land and rolling hills, and a commodious brick house chock-full of intriguing artifacts. He called his parents long distance from work shortly after the cameras began to roll and told them he wanted to move. He wanted a big farm just like the Reno spread, a place out in the Tennessee countryside. Spend $100,000 if you have to, he said. But start looking.

And there were more farms in Elvis Presley's immediate movie future. Early in 1957, as Vernon and Gladys continued to scour the greater Memphis area for a house that measured up to their son's fond memories of *Love Me Tender*, Elvis reported for work on *Loving You* at Paramount. Another reprise of his life story, *Loving You* traces the rise of a rootless young country singer with a red convertible. Deke/Elvis is an orphan whose offstage values are wholesome and touchingly simple. "Some day I'm goin' to have a place of my own, like a farm," he vows, with a dreamy look in his eyes. In an idyllic moment stolen from the pressures of his career, Deke runs away to his girlfriend's family farm for an afternoon picnic up behind the house and delights in the horses, the chickens, and the big brick barbecue. She stays behind when Deke rejoins the tour. "I'll always be here," she tells him. That what home's all about. "How can a person who's got no home be homesick?" he sadly replies.

Graceland was not a farm, of course, although it had been once and Elvis had a coop custom-built in the backyard for his mother's chickens. Memories of farm life lingered in the flock of ornery peacocks that pecked the cars in the driveway, in the old barn where horses would be stabled many years later, and in Vernon's short-lived effort to raise donkeys. But the Presleys had never been farmers and the animals amounted to rural props, like the front-porch rocking chair in *Love Me Tender*. Graceland was just about as rural as an afternoon at a movie in which the leading man pines for a country home with a

picturesque spatter of horses and chickens. It was a movie set improbably married to a movie-star palace in the Red Skelton manner. Columns and a self-important dignity out front, on the highway side. Chickens scratching and clucking in the back-yard.

It was a showplace from the beginning, too, like the Skelton estate—a house that existed to be shown and seen, a theorem in plaster and lathe about the good life and its meaning. From the moment the Presleys acquired Graceland, Uncle Vester sat down by the road and offered his own star tour of the property to those who came to read the story written in lawns and drive-ways and Hollywood columns. And it was a place where Holly-wood stars might be glimpsed through the music-note gates, doing whatever mysterious and glamorous things their kind were supposed to do. While the house was still being renovated, at Eastertime 1957, Elvis brought the starlet Yvonne Lime home from L.A. and posed for pictures with her on the lawn as if to show the local press corps that a little bit of Hollywood had descended on Memphis. Gladys's sister Lillian heard from one of the Graceland maids that Vernon had gotten a little too enthusiastic about giving the house-and-garden tour to an un-named blonde movie goddess who dropped by unexpectedly; his missus, the gossips said, never let him forget it. Graceland looked Hollywood, all right, but this was Memphis and there were chickens in the backyard and a flock of ducks in the movie-star swimming pool.

At Christmas 1968 Elvis's TV special—the so-called comeback special—aired opposite Red Skelton and killed him in the rat-ings. By then Skelton's Georgian estate had become a burden rather than a joy. His only son had died there of leukemia. Tormented by memories, Skelton lit up the driveway now be-cause he was afraid of the darkness. The tour buses no longer stopped so often. For Elvis, however, the Christmas show

marked a dramatic new beginning, a change of direction. Hollywood was over. He was going to be the King of Rock 'n' Roll again. After years of bad movies and critical indifference, 1968 marked a revival of interest in Elvis Presley and the life of gilded obscurity in which he had buried himself both in Memphis and in his rented Bel Air mansions. Although he lived in movie-star homes, with all the right here-I-am trappings, they had become houses of mystery occupied by a shadowy legend.

Esquire came calling at Graceland first, not overly impressed by an exterior that reminded the writer Stanley Booth of an "antebellum funeral parlor." Inside, Booth found the standard star amenities: "snowy drifts" of white carpet, a very long white couch, a gold couch, a gilded piano, gold records in frames, smoked mirrors around the fireplace. Red velvet draperies on an electric traverse rod, drapes that opened and closed at the touch of a button. But he also found a clutch of retainers, bored to the point of stupefaction, waiting for Elvis to get up, come

downstairs, and do something. As they waited, one girl opened and closed the red drapes. A boy, who had been lying on the gold sofa watching an old Joel McCrae movie on a gold-washed console TV, got up, sat down at the gold piano, and idly began to pick out a tune. Outside, near the gate, a gaggle of fans peered up toward the white columns and the big front door and imagined how wonderful it would be to be inside, with Elvis and his friends.

And then, showtime in Memphis. From the master suite at the top of the stairs, Elvis materialized, costumed all in black. The velvet draperies swished closed and open one last time. Everybody got up and trooped out to the yard, to watch the star play with a toy airplane and then light his cigar. On stage at Graceland, the performance, such as it was, had begun.

\mathcal{I}nside Graceland

June 1957. Elvis on the train back to Memphis. *Jailhouse Rock* was done. Graceland: would it be finished, too? The clouds on the ceiling? The dark blue bathtub upstairs, in his private domain? And downstairs, the purple walls, the white corduroy drapes, the gilded woodwork—as grand and exotic as the lobby of the biggest Loew's theater in the world? Were the painters' union still walking up and down the driveway with picket signs just because Daddy's friend Mr. Nichols was doing the inside work? And Mama. How was Mama doing with the decorators from Goldsmith's department store?

Was Graceland done? Elvis couldn't wait another minute to see the house. He got off the eastbound sleeper in Lafayette, Louisiana, rented a car, and drove home as fast as the law would allow. It was almost midnight when he bounced up the front steps, glanced up at the columns rising high above him, and strode into the foyer. Three, four, five, six, seven steps. On the precise spot where his casket would rest twenty years later, there stood his parents. "Welcome home, son."

All those years later, the mourners found themselves looking

down on Elvis, lying in state in a new white suit his daddy had bought him for Christmas. It seemed dreadfully wrong. Elvis was never still. He was larger than life. Best viewed from a distance, like a national monument. You never thought of actually seeing him up close like this, lying down, vulnerable, quiet, and small.

But there in the foyer on that long-ago night in June, Elvis stood up tall and stretched and preened and purred with joy. He looked up and saw the glint of gold around the ceiling, set off against the deep blue walls. He looked down and scuffed his toes deep into the wine plush carpet. In the pool of light at the bottom of the staircase, Graceland glowed just as it always had in his dreams. It looked the way he looked, or would look, standing someday in a spotlight on a huge stage in Las Vegas, Black Velvet hair by Clairol, milky white skin, diamonds glittering on his fingers, a red velvet jumpsuit or a white one ablaze with sparkles and caressed by dreams.

The shell was done. Things hadn't turned out quite the way he had imagined them, though. Mama understood that young people instinctively liked rich, dark colors. Purple, for instance. In a purple room, you knew you were inside and safe; there was never any question about where the walls were. Mama knew that purple was "cozy," but she painted the downstairs in a deep shade of Dresden blue with soft gray undertones. Pavilion blue. Calmer. A background color, like the blue of the twilight sky, gentler on the mind. And Mama knew her drapes, after all those years working in the curtain factory. White corduroy wasn't right. It didn't hang right. She'd ordered ivory brocade instead, edged in white satin tassels. Ivory for the summer. Blue for the cold weather months. Door draperies—portieres in the old Southern manner—and big valences over the windows.

The colors and the fabrics weren't the ones he'd had in mind when he left for the Coast, but the effect was just what he

wanted. Bold, full of energy, and mysterious, with hints of gold shimmering fitfully in the corners and a strong sense of enclosure: the claret red of the deep pile carpet defined the floor while the gilded dentilation of the crown molding showed exactly where the ceiling began. The stage was set. But it was bare. George Golden was coming in the morning with the final sketches for the scenery.

Golden had already worked for Sam Phillips. Earlier that year, with the profits from the sale of Elvis's recording contract, Sam had moved into a new house on the fashionable east side of Memphis and done it up in a lushly futuristic manner that few of his neighbors would have risked. Elvis admired the unrestrained originality of Sam's house and took down the name of his decorator, a former tea salesman known for a free-spirited eclecticism and a flair for advertising. Golden acquainted greater Memphis with his services by means of a roving flatbed truck that carried model rooms, complete down to the last detail of wallpaper and carpet. At night, a certain two-foot sofa covered in shiny chartreuse satin showed to especially good effect in the incandescent lights. In a three-foot room on the back of a truck, it took on the character of a Surrealist vision of the good life on planet Mars. All of Memphis gasped. And that was pretty much the reaction Elvis hoped for from Graceland, after the redecorating was finished.

What went on in Graceland that next day is anybody's guess. Gladys almost surely found out that Elvis was planning to leave again, for a vacation in Biloxi with the guys. She had hoped the house would keep him by her side, picking out every table and chair and savoring the choices. She had hoped the pleasures of domesticity would persuade him to quit while he was ahead and come home for good. Maybe go into the furniture business. But it was not to be. Elvis was in a fit of impatience to have Graceland done, right now, in a flash. Golden had sketches:

these things take time. Elvis had different ideas. When he specified what he wanted the downstairs to look like, the decorator flat out lied. Couldn't be done. Months and months of delay. Look at these swatches and samples instead. Quick service on this merchandise. Do it yesterday, said Elvis, discarding all but the most sumptuous possibilities. Do it. And then he was gone, leaving the petty details of the custom-built fifteen-foot sofa and the too-long coffee table and the white slubbed upholstery fabric and the black wood consoles and the tall lamps with abstract designs of rubbed gold on the shades to Mr. Golden, Goldsmith's, and his mother.

Ordered from Goldsmith's on Poplar Avenue, the furniture was of two basic types, both defiantly modern. The stock pieces, like the blond saber-legged chairs in the dining room, were attention-getting in their lines. The pieces customized by Don Johnson and his staff were large, simple forms in black, white, and gold, scaled to the proportions of Graceland's vast continuum of living space and assertive in their bulk. They filled the rooms like the soldiers of an occupying army, until it was no longer possible to imagine an end table or a sofa in any other position. Or an enormous matching piano. In July Elvis bought the white and gold Knabe grand piano for his Music Room right off the stage of Ellis Auditorium downtown, with the promise that he would replace it later. Decisive statements of taste or will, these were rooms that resisted casual changes by visitors intent on adjusting a chair or casting a bit more light on a page. This was Elvis's house. His things remained where he had put them. Although he had conjured up Graceland in a fever flash of wanting to be gone, it was wholly and forever his own. And Mama's, of course.

Dee Stanley Presley, who married Vernon in 1960, denies that she was ordered off the premises that June for trying to replace Gladys's living room drapes. She does say she just couldn't feel

comfortable living in a house that looked like a New Orleans brothel, "with its dark blue walls and garish red carpets." But to Elvis, those dramatic colors, those chairs and draperies, reminded him of Mama, and all their plans and dreams, and he was unwilling to change a stick of furniture for an interloper. Gladys had been laid out in a baby blue dress in the Dresden blue living room in 1958. It had been the worst day of Elvis's life. Would he get rid of Graceland, asked a reporter in an interview broadcast from his army base in Germany just after Gladys died? "It would be foolish to sell it now that I've got it completed," he replied. "And I don't think my mother would like it." She had always wanted him to stay home with her and tend to the changing of the draperies and the plumping of the sofa cushions.

Elvis's enormous white living room couch is the most visible legacy of the Graceland that existed once when dreams were new and Mama still thought her boy would stay there with her forever. Illustrated on every other page of every other decorating magazine, circa 1957, it was also the great white whale of trend-setting interior design. "The Long White Sofa," a 1957 story in the *Ladies' Home Journal,* describes the journalist Dorothy Thompson's horror at the extravagant wrong-headedness of her newly married adult child in furnishing a first apartment. The young couple have squandered most of their annual budget on one wildly impractical couch, "long, wide and low." Covered in a "nubbly white material," the couch is a veritable white elephant, too big for the flat and sure to attract ketchup stains. Why hadn't they bought a leggy little Hepplewhite settee? What was wrong with their taste? "We don't *want* old furniture!" the newlyweds shriek. "We want the apartment contemporary—modern." In the end, Mother swears off further meddling and admits that their white sofa looks quite handsome against a dark blue-green wall that could just as well have been found at Graceland.

Nothing stays modern forever, although the white sofa stayed in place longer than most of the other pieces in Graceland. Initially, Elvis discarded items selected during his mother's lifetime with extreme reluctance. Dee Stanley, with her cats and all her belongings, found herself out on the front lawn as a Goldsmith's truck zoomed up the driveway to repair her ravages. But by the mid-'60s the interior of the mansion was red and white throughout. The blues of the 1950s—including the blue tub in the master suite, later sold at auction—had been stripped away. Priscilla Beaulieu, who lived at Graceland for six years before marrying Elvis in 1967, admits that he was the one who made the decisions on color and style: "All I did was to change the drapes from season to season."

The interior of Graceland was no longer a showplace, either. Because Elvis was working in Hollywood, in the full glare of publicity, he thought of Memphis as a place to live a private life. He no longer talked about purple walls in front of microphones, nor did he invite reporters past the gates to take pictures for publication. In time, the unofficial blackout piqued interest. What was going on in those heavily draped chambers so far above the road? What did it look like? Finally, in 1960, *Photoplay* offered a $5,000 bounty to anyone who could insinuate him- or herself into Graceland and produce usable pictures of whatever unimaginable wonders lurked there. But the first pictures, when they were published at last, were a gift from the Memphis boy to his hometown paper.

The color photographs taken for the kickoff issue of the Memphis *Commercial Appeal*'s new Sunday magazine in March 1965 show a different Graceland—but not too different. There are deep red velvet drapes and portieres of a pattern identical to those in place in 1957, hanging from the same valences. A white ceramic elephant, a survivor from Elvis's first round of decorating, graces the twelve-foot cocktail table in front of the famous

living room sofa, now recovered in a glossy white-on-white fabric. But the overall effect is very different. Cruder, brighter, and harder.

The dentilation is still gilded, and the gold tone repeated in the pillows, occasional lamps, and other accessories resonates with the creamy ivory tint of the walls and carpeting. The Music Room, next to the living room, restates the color scheme in a gold leather couch of extruded dimensions, a gold table, an ivory piano (as her first anniversary gift to her husband, Priscilla would later have a smaller model covered in 24-karat gold for that spot), and a matching TV set. A gold-framed mirror brought along from the Audubon house seems right at home over the gold sofa. The 1960s make themselves felt in busy checked drapes, metallic floor cushions, a wire piano bench, and a chandelier composed of whimsical white glass bubbles suspended from wooden arms. In the dining room, over the walnut table and its suite of red velvet chairs, a hanging starburst fixture lends another touch of newness.

Everything is more tailored and geometric, including the man of the house. In the *Commercial Appeal* photographs, Elvis wears the kind of with-it, proto-Beatles costume MGM had concocted for his swinging bachelor role in *Viva Las Vegas* (1963). Skinny high-heeled boots, stovepipe pants, and a short, tight-fitting ivory jacket without cuffs or lapels, worn over a black shirt. The sharp clothes match the mood of the new Graceland. It comes as no surprise, somehow, that an early version of the chandelier in Elvis's remodeled dining room may be glimpsed dangling from the ceiling of a casino in *Viva Las Vegas.*

The costumer Edith Head, who put Elvis in short jackets in the first place and designed the wardrobes for many of his better films, mistakenly assumed that because he never objected to the clothes provided he was uninterested in fashion and design. But the same sensibility that accepted her decisions and then

outfitted the guys in tight pants and short boots à la Head from the Hollywood tailor Sy Devore also chose the red drapes, the gold, and the ivory furnishings that matched his outfit to a tee. His intense concern for personal style—what made Elvis, above all, a visual icon—meant that his person and his surroundings were precise mirror images. Long before he decided to cover the downstairs walls in slivers of looking glass, Elvis could sit back on the big couch and see himself wherever he looked. He was Graceland. Graceland was Elvis.

He was forever fiddling with the house, says his friend Alan Fortas. Changing things. Elvis liked red and the bright Technicolors of the movies, says his cousin Billy Smith. The red of Christmas, the happiest time of the year, and the red of the ornaments on the white nylon tree in front of the big north window in the dining room. The red-and-white Graceland of the 1960s looked like Christmas all year long. But it never felt that way. *Esquire*'s 1968 profile of the newly married Elvis at home compared Graceland to an antebellum funeral parlor, with the inhabitants frozen in place on the long white couch like grief-stricken mourners.

His retinue was no more bored and dispirited with life in a gilded cage than Elvis himself. Between 1961 and 1969 he made no live public appearances. Instead, he spent most of every year in Hollywood, churning out twenty-one formulaic films that annoyed and frustrated him in direct proportion to the profits he made. In between times, he returned to Memphis to wait for the next bad script and the next rotten soundtrack. The *Commercial Appeal* photos of 1965 show Elvis in a state of virtual inertia, glued to his big sofa and big TV set, cocooned in the fabric-swathed recesses of the Music Room. The look of Graceland matched the prevailing mood. Neither Christmasy nor festive, the red, white, and gold decor of the 1960s seems perfunctory and enervated instead. It's all B-movie splendor, without the passionate, gleeful irreverence of the '50s.

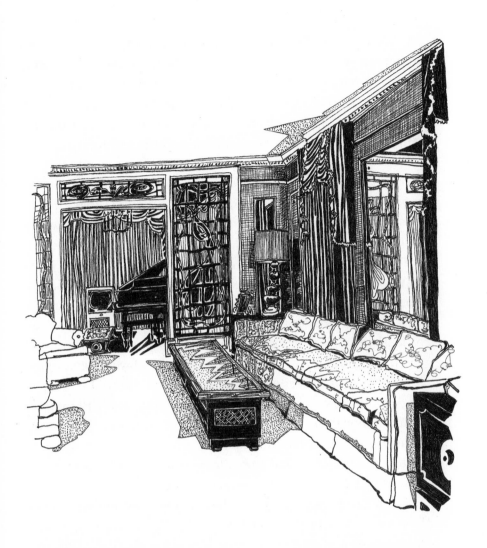

Graceland looked like the country place that showcased Lana Turner in the 1959 tearjerker *Imitation of Life*. Playing a successful Broadway star, a kind of female Elvis Presley, Turner is set off by I-made-it possessions of an intense and telling theatricality. Many of them are also found in Graceland: a giant stereo console, gilding, smoked-glass mirrors around the fireplace, built-ins of all sorts, patches of bold color in snowy white rooms, and white couches of enormous length. Decorator

clichés by 1959 (and easily readable to movie audiences as indices of wealth and power), these salient details were being lauded for their novelty by home and women's magazines in 1956 and 1957. *House Beautiful* liked gold in combination with white: "It is a reflection of the times, sociologists tell us, for whenever in history there has been an era of well-being, men have expressed their prosperity by giving their surroundings a golden look." Valences were recommended, too, to give modern rooms the weight and consequence of period settings. *House and Garden* adored white furniture, formality, high-powered color contrasts, red, and gold.

The transition to red that began in Graceland when Elvis returned from Germany in 1960 looks boring and ordinary because, by then, it was. Off-the-rack class. Graceland in the 1960s was a tuneless dirge to the glories of purchasing power, at least in the row of formal rooms lined up across the front of the house from north to south: dining room, foyer, living room, Music Room. The sections of the house that Gladys had helped to decorate, they were the slowest to change after her death. Color changed in the '60s, and fabrics. But the original furniture remained, in its old positions, as if waiting for Mama to wake up and come home from Forest Hill Cemetery and run the house again.

When Elvis fussed and tinkered, he did it in the back or the basement, in the parts of the house that nobody but close friends and kinfolk had any business being in. The waterfall in the den and the Polynesian Primitive furniture. The Blue Room, site of the Memphis-only wedding reception, once a closed-in patio where Elvis ran the slot cars Priscilla bought him for Christmas in 1965. Sometime during the late '60s or early '70s—sometime before Priscilla walked out in 1972—small, incremental changes seem to have taken place elsewhere. Not upstairs: remodeled around 1965, with the addition of tufted

suede padding on the walls, Elvis's suite remained a red, black, and gold *Playboy* lair, with overtones of Latin machismo and a golden door that smacked of hubris and the gates to paradise. But downstairs, according to eyewitness testimony, new touches quietly appeared in the front rooms, one by one. Blue satin drapes were hung in place of the red set. The glass table in the foyer was flanked by a pair of high-backed chairs in pale blue velvet. Priscilla did it, and then she was gone, like Dee Stanley before her.

Elvis didn't put his wife out on the lawn, but his attitude toward her efforts to modify his house was always edgy. He gave her a free hand out in L.A., but Graceland was sacrosanct. And even in the California homes they shared (which Elvis treated as hotels without elevators), her taste for organdy and calico, for soft and sheer and pastels and delicate wicker took a back seat to his preference for deep colors and oversized seating arrangements. He didn't mind the frilly country kitchen she designed for their last home together, in Holmby Hills, Priscilla states. But he didn't spend much time in front of the stove, either.

Priscilla stayed on in California after the divorce and designed clothes from time to time. Soft, fluttery things, in beige and pale blue. Elvis went back to Graceland and thought about the mother who had really loved him. And her house. Their house. Intense. Mysterious. Forever. Like mother love. He would stay inside, surrounded by the things they had loved, and be safe forever. Nothing would ever change at Graceland again.

lvis exoticism:

the Jungle Room

In the established Elvis mythology, wretched excess is often a positive value, a mark of generosity or of a buoyant, fun-loving frivolity. He gave Cadillacs to relatives, friends, and total strangers, much as Rockefeller once doled out shiny new dimes. Two hundred seventy luxury cars, in a lifetime of midnight raids on showrooms. The first, a Pepto Bismol–pink Crown Victoria, went to his mother, who couldn't drive. It proved, however, that Elvis was a good son.

The stories about the TV sets—that he shot 'em out whenever the show failed to please—are harder to link to some admirable trait, except maybe the growing national impatience with network dreck. But tour guides at Graceland stress Elvis's fondness for *I Love Lucy*, the *Dick Van Dyke Show*, the *Carol Burnett Show*, and any game show starring fellow Memphian Wink Martindale, so perhaps his outbursts were the result of a specific aversion to Robert Goulet. For Goulet is the offending party in the definitive version of the story, in which Elvis, breakfasting in his den early one evening in 1974, puts down a forkful of crispy bacon, picks up a .357 Magnum, and plugs the set when

the crooner appears. "That jerk's got no heart!" runs one quote explaining the assault. "That will be enough of *that* shit!" says another.

Either way, the story paints Elvis as impulsive. Vernon Presley, defending his son from scurrilous posthumous attacks in 1978, admitted that the incident (and others like it; Elvis also had a thing about Mel Tormé) really happened. "But he was in his own home and shot out his own TV set," the elder Presley argued, "and when he'd done it he could afford to buy a new one." The rich can afford to be impulsive.

The Graceland tour is generally careful to avoid anecdotes that might lend support to the unbeliever's mental image of a bulging, besotted King who was fatally out of control or dying of his very excessiveness. In the mansion proper, for example, the fourteen TV sets are all intact. But there is one odd exception to the editing process, in the ersatz airport lounge outside the jet Elvis named the *Lisa Marie* after his little daughter. His flying Graceland.

Brought back to Memphis and added to the roster of Graceland attractions in 1984, the *Lisa Marie* is introduced by a film in which members of the Presley inner circle discuss the purchase, refurbishing, and use of the plane. When his turn comes, pilot Elwood David, looking vaguely guilty, describes a 1:40 A.M. run to Denver for peanut butter sandwiches on Groundhog Day 1976—a story that is to Elvis hagiography what the cherry tree legend is to George Washington. As Captain David tells it, the incident is silly and a little obscene: a five-hour flight, 3,000 miles, 42,000 gallons of fuel, and $16,000 worth of bills, all to indulge a late-night craving for something readily available in one's own kitchen. And besides, Americans hate fat, and all the greasy, sugary foods that might make a person tend to look like Elvis in the 1970s.

The film leaves the trip unexplained. The facts are more in-

he den was a never-ending source of amusement. The usual Graceland Christmas party in 1971 was a tense affair. Elvis and Priscilla had been quarreling and spent the evening pointedly ignoring each other. That put the guests on edge, too—until the waterfall caught fire.

Never a very sophisticated apparatus (the plastic intake hoses are still visible, for instance), the waterfall shorted out in the middle of the festivities and a panicky Vernon took a sledgehammer to the wall to get at the wiring before the whole house burned down.

Elvis said the flaming waterfall was best thing about the party, the funniest thing he'd seen all night.

teresting, though, for what sent Elvis off to Denver in the middle of the night was no ordinary Skippy-on-Wonder-Bread snack. It was, instead, just about the best thing he'd ever tasted in his life, a $49.95 extravaganza from a restaurant in suburban Glendale known as the Colorado Mining Company. Elvis had just returned from a ski vacation in Vail and while passing through Denver stopped long enough to sample their Fool's Gold sandwich and to buy new Lincolns for the two acquaintances who sat listening to his lip-smacking description of that repast in the den at Graceland on Groundhog Day, 1976.

The Fool's Gold, Elvis told them, was made from a whole loaf of homemade bread, slit down the middle, smothered in the usual peanut butter and jelly, and topped off with a pound of hot, just-fried bacon. And then deep-fried, the whole thing. It was an Olympian p-b-and-j, the ordinary raised to an overripe state of perfection—lush, luscious, grandiose, but comfortable withal and familiar. Excessive. Expensive. Impulsive. The saga

of the peanut butter sandwich has much in common with the history of the room in which the nocturnal plot to procure one was hatched.

The den at Graceland was also the place where Elvis executed the television set. Originally a patio or open porch on the back of the house, the long, narrow room was enclosed in the early '60s and further refined in 1965 with the construction of an indoor waterfall enlivened by a rainbow of colored lights. A relative of a friend did the work with little concern for the architectural integrity of the house as a whole. During the same decade a space for racing slot cars, a playroom, and a kitchen addition were tacked on, and for a brief period in 1961 Elvis even contemplated building an all-aluminum, two-story octagonal wing behind the pool for offices and an at-home recording studio. Earlier he had been talked out of installing amusement-park Dodgem cars on the same stretch of empty lawn.

The additions—constructed and merely dreamed of—share an erratic, spur-of-the-moment quality, a lack of a unifying theme that contrasts strongly with the formality and balance of Graceland's traditional Georgian design. The front is all stately columns and pediments; the backyard is a randy vernacular of mismatched parts, each one built on a whim. Graceland resembles a movie set, with a serene facade concealing the assortment of clunky mechanisms that make it all work, or a typical suburban house with a manicured lawn out front and in the back, hidden from the street, a messy assortment of barbecues and kiddie pools. The ceremonial versus the functional. Illusion, or public image, versus the untidy realities of life.

In the beginning, the furnishings of the new den were fairly conventional. According to one of the domestics who came to work at Graceland as the room was being completed, there were two sectional sofas and a special tall-backed chair for Presley, all done in gold leather, along with blond cocktail and end

tables, draperies with big red flowers and big green leaves, and a huge color TV. Oh, and wood paneling. In its first incarnation, the den recreated the interior of Elvis's first house on Audubon Drive, comfortable, unpretentious, and familiar.

Unlike the starchier formal rooms at the front, the unbuttoned den was clearly intended for hard everyday use: Elvis ate his breakfast before the big-screen television, and most of the group activities that involved his quasi-permanent retinue of friends and employees took place there, too. This was where "the guys" fooled around and waited for Elvis. And except for the gold upholstery, the only outrageous touch was the electrified cataract, which suggested a motel lobby or the fieldstone feature wall from the decorator-moderne living room of Elvis's rich movie parents in *Blue Hawaii* (1961). In the home of a star, a little Hollywood glamour was perfectly appropriate.

The first inkling that something deeply peculiar had happened to the den came in September 1977. Caroline Kennedy, then working as a part-time reporter for the *New York Daily News*, went to Memphis in August for Presley's funeral. Much to the chagrin of the family, who admitted her to Graceland on the assumption that she was paying a legitimate condolence call, Kennedy later sold a politely horrified description of the interior appointments to *Rolling Stone*. She laid it out, all right, a record of bad taste carried to spectacular heights of folly: crimson carpeting, scarlet satin chairs with *rhinestones,* no less, woven into the seat cushions, paintings on velvet, statues of naked women simpering under ersatz waterfalls of plastic beads. But the most intriguing room on her Graceland tour was the private living room (aka the den), to which the grieving relatives had retreated from the cool scrutiny of the curious and the genteel. It was "paneled in mahogany," she wrote, "and decorated with fur-covered African shields and spears."

There are no shields or spears visible to the naked eye, but

it's easy to imagine they must be there, somewhere. Caroline Kennedy's disbelieving once-over did not begin to do justice to an ensemble of cypress-crotch coffee tables, green shag carpeting (on floor *and* ceiling), mirrors framed in the breast feathers of pheasants, flocked Austrian shades, Wookie-fur lampshades, and massive pine chairs and couches carved with chain saws in a style other stunned observers have labeled Polynesian Primitive, Early Goona-Goona, or Tahitian Provincial. Angry South Sea gods fume silently in every corner. Ceramic tigers prowl the artificial greenery.

If such a creation requires explanation, any number of plau-

sible reasons can be supplied. Elvis, say some apologists, just wanted to be reminded of happy holidays in Hawaii. He vacationed there many times, often in the same kinds of tourist settings spotlighted in his Hawaiian movies. During the filming of *Paradise, Hawaiian Style* in 1965, his dressing room at the Polynesian Cultural Center on Oahu was a replica of a native royal palace. The Coconut Palms Hotel, where he stayed during location work on *Blue Hawaii,* reserved a row of "royal" cabanas on the beach for celebrities, with carved lava baths, crossed spears over the beds, and bamboo fences. In the evening he liked to take in the luaus at the Ilikai, the Hilton Hawaiian Village, and the other big resort hotels. The signal fires, the palm leaves, the pseudo ceremonies. All Hawaii needed at dinnertime, he used to say, was the ducks that waddled on cue across the lobby of the Peabody Hotel back in Memphis.

He liked the drumbeats and the torches and the mumbo-jumbo performed for the off-islanders from the cruise ships who figured in the scripts of his formulaic Hawaiian musicals. Hawaii was exotic—but not too. Foreign but part of the USA. You didn't have to speak the language but it made for great song lyrics. The vowels whispered like an ocean breeze on Waikiki. "Aloha Oe." Farewell to Thee. "Drums of the Islands," sung by Elvis as he glides through a picturesque native village in an ornate war canoe just in time for the dinner show. Like a handsome Thor Heyerdahl bound for Easter Island on a raft of reeds, the King wafts by on a chorus of "Aloha Oe." And the tourists clap.

The floor-and-ceiling carpeting in the den isn't Hawaiian, of course. It made for great acoustics, some say (a theory disputed by the poor quality of two albums Elvis recorded there at the end of his life), or made the room look like the business end of groovy bachelor's van. It was California, man. Pure California. Or Hollywood cool, like the penultimate scene in *Girl Happy*

(1964), when Elvis fights for the honor of Shelley Fabares in a Tiki bar abounding in den-like details. Or just plain cool.

Felton Jarvis, Elvis's producer at RCA records, had a Nashville office decorated in a jungle motif, just for the hell of it. Jarvis and Elvis met at Studio B in 1966 and hit it off from the first because they shared a wacky sense of humor. Jarvis kept a fifteen-foot boa constrictor in a burlap sack on the floor of his jungle office to watch his visitors' faces when the snake began to slither. Elvis thought it was the craziest thing he'd ever seen. And the coolest. Of course, when everything is said that can be said to account for the den at Graceland, there is also the possibility that Elvis Presley had terrible taste, or that Elvis chic occupies an aesthetic dimension in which conventional standards of good taste are irrelevant. And that's cool, too.

The various pieces in the room—the seven-foot throne that glowers at the projection TV system, the chairs with gargoyles carved into the arms—were not custom made. Other folks had similar stuff. Big, dark, exotic living room suites were sold to the bedazzled by slick pitchmen at state fairs in the 1970s. Todd Morgan, who works at Graceland today, remembers seeing "almost that exact same furniture in Clarendon, Arkansas, in the Pettigrew Furniture Store on Madison Street" when he was twelve years old, and wanting it for his room. But let's face it. Most grownups agree with Caroline Kennedy on this one: the Jungle Room is stunningly, staggeringly tacky even if it isn't (or wasn't) one of a kind.

A recent article celebrating Graceland's listing on the National Register of Historic Places maintains that the Jungle Room only looks strange to the 1990s because times and tastes have changed: in another hundred years, we are told, the Tiki sofas will seem no more or less tasteful than a roomful of Belter Victoriana in the American Wing at the Metropolitan. But leaving the Jungle Room to the drowsy embrace of history sup-

presses the barefaced ha-ha-ha vitality of the place and the evanescent glee of a really good joke.

The den became the Jungle Room when house tours began because the decor embarrassed the staff. Giving it a name made the excruciating lava-lamp, semi-hipness of the place seem meaningful. That everybody has a funny story about the Jungle Room indicates just how peculiar it does look and how important it becomes for the custodians of the Presley legacy to explain the decor away as a spontaneous three-dimensional gag rather than a decorating gaffe of major proportions. All accounts of the purchase of the furniture stress that the dirty deed was done quickly. In 1974, when Elvis and his live-in girlfriend, Linda Thompson, were in the throes of a redecorating fever, he is supposed to have walked into Donald's Furniture in Memphis and picked out every last Don-the-Beachcomber ashtray, plastic plant, and bunny-fur pillow in the space of thirty minutes (better make that forty-five), for immediate delivery. David Stanley, one of Elvis's three stepbrothers, claims to have gone along on the expedition. He maintains that Elvis didn't like to shop for furniture and took the first thing he saw to get out of the store. In the Stanley version, the Jungle Room is the product of bored impatience.

Yet others who watched as the mansion's windows were removed and the massive pieces shoehorned into Graceland remember things differently. Elvis was watching TV in the den one afternoon, saw a Donald's ad, and had to have that furniture right away, they insist. Furniture dealers in Memphis—now they're mostly dressed as Elvis—still intrude on afternoon programming with folksy, funny homemade spots that feature their most telegenic suites on E-Z credit terms, ready to take home *tooo*-day. Or maybe, as another telling of the story has it, Vernon Presley saw the ad, walked in on his son's breakfast and said, "I just went by Donald's Furniture Store, and they've got the

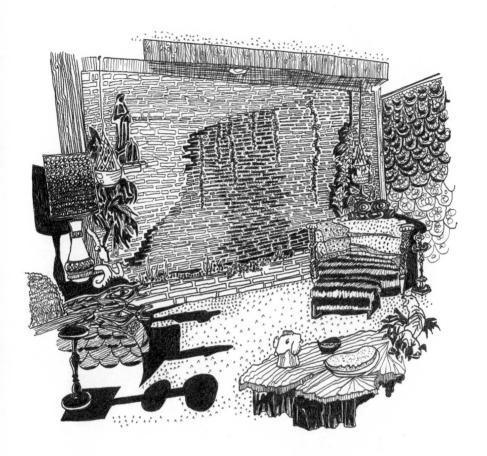

ugliest furniture I've ever seen in my life." "Good!" Elvis replied. "That sounds like me." And bought it. Or maybe Elvis listened, said nothing, but later slipped out to Donald's and had the new Trader Vic look in place by suppertime, as a joke on his daddy.

Even the best jokes wear thin with retelling, and there is no indication that Elvis meant the Jungle Room to be preserved intact for posterity. On the contrary, when Felton Jarvis and RCA set up recording equipment there in February 1976 to coax Elvis into making a new album, he was reluctant to send the speakers and music stands back to Nashville because he had come to like the room better without the funny furniture. The

\mathcal{T}he Jungle Den was a gendered space for Elvis and guys. They watched football games and Kung-fu movies there. The furniture was massive, guy-type stuff. Dads all across America had similar retreats, done up in wood and leather, dark colors, "masculine" trophies and curios.

The difference was mainly one of nuance. The Jungle Room suggested the storied leisure of the South Seas, a place of relaxation and escape. So far, so good: every Dad needed a little time out from the rules and regulations governing proper deportment in the living room. But for the man who virtually invented beach movies in *Blue Hawaii*, the Polynesian motif also carried with it sweet memories of beach-bunnies in bikinis, warm tropical nights, and torrid romance. Perpetual bachelorhood. Jungle madness. *Paradise, Hawaiian Style. Girls! Girls! Girls!*

The Jungle Room epitomized something primal and primitive left out of the soundtrack album from *South Pacific*. In *Jailhouse Rock* (1956), a smoldering Elvis kisses Judy Tyler with ferocious intensity and then purrs, "Honey, it's just the beast in me!" "Tiger Man" was on the Las Vegas show list in the 1970s: "I'm the King of the Jungle," Elvis growled, as he paced the apron of the stage like a caged beast. "An' they call me Tiger Man."

Felton Jarvis thought Elvis liked him because they shared "the same crazy sense of humor." Crazy meant jungle offices and snakes. A disinclination to do business the way the rest of the corporate suits at RCA did. Crazy meant doing exactly as you pleased. Or having a Jungle Room to watch TV in.

joke no longer tickled him as much as a 2,000-mile round trip for a peanut butter sandwich. But a stale whiff of ham-handed humor still clings to the Jungle Room, as the tall chairs elbow one another self-importantly and the dust motes settle on the leaves of tropical flowers scented with Lemon Pledge.

Humor is most always a serious business, a way of attacking and changing the status quo. Since his teen years, when he

reveled in flashy lime-green and pink outfits from Lansky's, Elvis Presley had chafed at the stylistic strictures of established good taste. The redecoration of Graceland in the 1970s was another gesture of knowing contempt for the givens, couched as a Polynesian joke. Alan Fortas, one of the long-term members of Elvis's so-called Memphis Mafia, described the chosen appointments of the period as "all the furniture you wouldn't buy—not in a million years." You wouldn't. I wouldn't. But Elvis Presley did, thereby measuring out the existential distance between Elvisdom and the dens of mere middle-class mortals, trapped in pastel blandness by their own timid yearning to conform.

The joke was that Elvis treated a whole roomful of furniture as another American disposable, like a no-deposit, no-return Pepsi bottle. In 1956 he bought himself a one-of-a-kind red-and-black Messerschmitt. Three months later he was bored with the car, and traded it to Bernard Lansky for an armload of clothes. The Tarzan suite appeared at Graceland in 1974, and by the beginning of 1976 it was on its way out. But Elvis had the great misfortune to die before his den, in all its temporary awfulness, transmuted itself into "Louis V" (for Vegas) velveteen, Early Locker Room, or Country-Southern Curlicue.

You and I wouldn't consign a set of almost-new furniture to the attic because we were tired of it. We probably wouldn't have bought it in the first place if we suspected the appeal would fade overnight. Elvis did, though. What good was money if you couldn't spend it? The rich furnished their libraries and studies—their upscale dens—with expensive antiques. Elvis had no use for those whatsoever. "When I was growing up in Tupelo, I lived with enough . . . antiques to do one for a lifetime," he explained. New was better, but alas, nothing stays fresh and new for long. Especially not a joke, a mid-'70s fad, or a Tahitian end table fashioned from a slab of distressed myrtlewood glistening under a thick coat of polyurethane.

The Jungle Room is an act of faith in serial novelty. Out with the old, in with the new, over and over again, or the same restless side of the American character that drove the pioneers ever westward in search of fresh scenery and perpetual rebirth. When Elvis ensconced himself in his den to watch TV, he shot the set if his interest flagged. When he rented whole theaters and took his friends to the movies, he stopped the film and showed another one if he got bored. In the 1970s he treated solid, tangible artifacts as though they, too, were flickering pictures on a screen, images that could be made to appear and— poof!—disappear at a snap of the fingers. Cadillacs and custom-made clothes came and went, given away in acts of impulsive generosity that were also purges of sorts. At the finale of his globally televised "Aloha from Hawaii" special in 1973, he tossed a jewel-encrusted cape into the audience as if to put the performance behind him and get on to something new.

Graceland has the same nervous, episodic quality. It is not quite real—a Technicolor illusion. The facade is *Gone With the Wind* all the way. The den in the back is *Mogambo* with a hint of *Blue Hawaii*. Living in Graceland was like living on a Hollywood backlot, where patches of tropical scenery alternated with the blackened ruins of antebellum Atlanta. It was like living in a Memphis movie theater—the Memphian on Cooper, say—during an endless private screening for Elvis Presley.

Diehard fans are sometimes disappointed by the formal rooms along the highway side of Graceland. They're beautiful, in a chilly blue-and-white way, but remote and overarranged. Displays in decent furniture stores seem to have more real character. The Jungle Room feels different. Personal. Partly, it's the story. "That's the room he picked out the furniture for himself," notes a visiting dealer in Presley memorabilia from Pennsylvania. Partly, it's a matter of personal style, a defiant sleaziness expressed in upholstery almost too repellent to touch. "It's funny," says the fan, "but you can feel him there,

like it fit his personality." Nonbelievers prefer the Jungle Room, too, because the overt bad taste lets them recoil in horror and imagine themselves a notch or two higher than Elvis on the class scale. Or the maturity scale, for the Jungle Room affords a glimpse of a rich man spending his money like a ten-year-old with a huge allowance and an overactive imagination fed on too many old Johnny Weissmuller movies.

Elvis's friend Liberace, whose many gilt-on-white estates overflowed with functional objects tortured into piano shapes, embraced an overemphatic fauxness that formed the basis for his stage act. "I love the fake," he told an interviewer. "As long as it looks real, I'll go for it." His movie-star houses—the Astro-turf lawns and the mock-elegant candelabra—were teasing advertisements for a public persona masquerading as a private one, or vice versa. There is no similar irony in Elvis's Krakatoa-style den. Only a rush of pleasure enhanced by the awareness that there were more jokes to come, more wacky stuff from Donald's to buy someday, more Saturday matinee fantasies to be lived out in the privacy of Graceland.

In the garden

The south garden looked pretty much like this in 1966 when the picture was taken: Elvis, in sunglasses, pale skin, and black hair, and Priscilla, a bouffant blonde for the summer, stand in front of the new fountain behind Graceland's swimming pool with two friends on a sunny day. The fountain is working; five single jets and a big one in the middle whoosh the water high into the air and catch it in a round, twelve-foot pool. The central column of spray is taller than Elvis in the photo. It no longer leaps quite so exuberantly today.

The pool is hemmed in by wrought-iron fencing, lest the water dance into the air and escape. At each of the four cardinal points on the circle, a covered iron smudge pot stands guard upon an altar-like podium made of lengths of extra fencing of the same curlicue design. Burnt offerings. Southern backyard barbecue. Ancient rites. The ashes of some local godlings. The four black pots must have looked ominous and strange even in 1966, when Elvis had no inkling that he was preening for the camera not fifteen feet from his own gravesite.

Behind the fountain, eight columns set in an embracing half-

circle support a wooden trellis. There were no vines or roses on the trellis in 1966 and there are none now. The columns are unfluted and squat, hollow tubes with a white, roughcast coating. They are properly swollen in the middle, like the columns of the Parthenon in Greece, but because they are so short, the shafts look saggy and overweight. In the classical tradition, columns have a human aspect. Those of the Ionic order are eager, slender, young, and feminine, with a willowy grace of proportion. The columns in the Meditation Garden seem weary and jaded, getting on toward middle age. The tops—the Ionic capitals—are "antiqued" with black paint. The patina of artificial age has blurred the details of volutes and rosettes the way years of discontent can dull the features of a handsome face.

Mrs. Moore, who sold the house to Elvis, used to have a pergola or covered arbor in the back yard, built of columns

\mathcal{L}**ike** an unknown soldier or a national hero, Elvis lies there with a perpetual flame burning at his head. Much was made of the flame lit at Arlington Cemetery when John F. Kennedy was buried in 1963. A sign of martyrdom and a commitment to remember, it took the form of a space-age metal brazier that would not have been out of place at the funeral of Agamemnon or the brave Achilles. Eternal Flame defies death by promising to burn forever, from generation to generation, past the fleeting lifespan of a grieving generation.

Too fragile to stand against the elements, the torch of remembrance at Graceland flickers inside a transparent hexagon. The casing undercuts the built-in bravado of a flame that never dies. This one could, were it not enclosed and tended. It is as fragile as life. As fragile as the dying flowers left on the tomb. Or the dusty plastic ones in lurid colors that measure out the distance between living things and replicas.

Friends bought the apparatus for the flame, an odd assortment of friends. A Graceland groundsman and his wife. A secretary. A wardrobe man. Guys and ex-guys, but surprisingly few of those. Employees who lived in the mini–trailer park behind the big house. The record producer with the jungle-themed office and the pet snake. Dr. Nick—the bad doctor who gave Elvis his drugs. The lady from Tupelo who would build the Meditation Chapel there, on the site of Elvis's birthplace.

Everything in the garden, it seems, has somebody's name on it: the flame, the statue of Jesus, the inscriptions on the burial vaults, the flower arrangements. Everybody wants a piece of the action still. Everybody wants to be close to a star that still burns inside a hexagon of glass.

rescued from a fine old Memphis house. Mrs. Moore was proud of her ancestors, who had lived in such places, and so she brought her Old South heritage to Graceland and used the remnants to create a pastoral retreat from modern times and Highway 51 out on the south lawn. When Elvis felt the need of such a private place, he hired somebody's brother-in-law to do the work. In the rose garden the contractor stumbled on the ruins of Mrs. Moore's bird bath and, just beyond it, four tottering columns from the old pergola. A circle of water, an arc of columns. The builder's family remembers four old columns worked into the new design: a nice story that ought to be true, but isn't. The columns aren't old—just meant to look that way. But the design, the plan, the circle of water cradled in the embrace of a peristyle evoke the memory of Mrs. Moore, and link her vision of old Memphis with the new iron smudge pots and the colored floodlights hidden beneath the water of Elvis Presley's brand-new garden fountain.

The garden at Graceland was constructed in the mid-'60s. Larry Geller, the New Age guru/hairdresser Elvis met in the spring of 1964, says he and Elvis and one of the guys designed it that fall, if by "design" one means imagining a formal garden and the mood projected by such a place. They didn't draw a picture, but Elvis was deeply into moods. Discouraged by a string of bad movies, he had begun to dabble in mysticism and Eastern religions. It was the 1960s, and he was not alone. When he was on the Coast, he became a frequent visitor at the Lake Shrine of the Self-Realization Fellowship in Pacific Palisades. The Fellowship, founded by a fashionable yogi in the 1920s, maintained the spectacular twelve-acre garden on a lakeshore as a place for quiet meditation. There were statues of Buddha, Jesus, Gandhi, and other spiritual leaders to focus the mind, and benches under the trees to rest the body. Elvis liked the Lake Shrine because there, for the first time since he bought

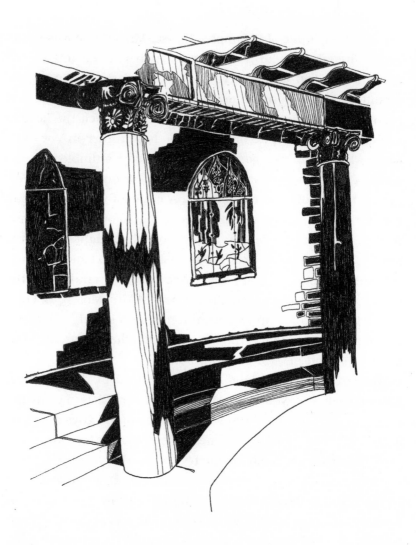

Graceland and hit the big time, he didn't have to be Elvis Presley.

The Meditation Garden at Graceland was a home-grown version of the California ashram, a private place for not being the Elvis who burst into song at the slightest provocation in the movies. It was an outdoor room of sorts, strewn with symbols to ease the mind and heal the soul. Two steps led up through

the columns, under the trellis, to a thick curved wall of brick treated to resemble ashlar masonry. Inset in the wall were four stained-glass windows, nineteenth-century Spanish, by some accounts, Moorish in flavor: two views of a medieval town with towers and turrets, a garden full of birds and hooded figures and a boatload of pilgrims, perhaps, setting off upon some esoteric journey. The columns and the wall formed a passage-way, a viewing platform overlooking the fountain and the plant-ings and the concrete walks and a patch of empty grass at the bottom of the steps. Foot traffic in the garden funnels through that covered walkway today, along the top of the curving steps that resemble the rows of seats in a Greek or Roman outdoor theater. The drama in this garden is a tragedy: the Presley family buried in a sunburst pattern in that patch of grass, with Elvis in the middle.

Right above the Presleys, on the steps with those who file past to pay their last respects, stands a statue of Jesus, his arms stretched out in benediction over the graves below. He is a generic sort of Jesus, featureless and smooth, white like the columns, tubular like them, too. A nonsectarian Jesus, utterly benign and boneless, without wrath or passion. A nameless Memphis sculptor made the statue to order. The guys gave it to Elvis for Christmas in 1966 as if to take back their open ridicule of his contemplative kick. Some of them had gone along to Pacific Palisades when he visited Sri Daya Mata, the holy woman, to ask "why God had chosen me to be Elvis Presley." They had laughed at him in his perplexity. They had made fun of the Meditation Garden, and Jesus was their peace offering. A plaque on the pedestal spelled out all their names. When Elvis found it broken, he took that as a sign God didn't want him to be angry at them any more.

Gardens were places for miracles, for direct communication between deity and supplicant. "In the Garden," the much-loved

*R*ichard **Wagner,** Andrew Jackson, and Franklin D. Roosevelt are all buried within sight of their homes. But it's not the done thing. Who wants to buy a house with the owner still on the premises? The grand gesture, the interment in the back garden, presupposes that the public veneration will never cease, that fame is not a fleeting thing. History teaches, however, that public hysteria over the demise of a celebrity is often followed by a burial of thundering obscurity.

Take the 1926 rites of Rudolph Valentino in New York City, with hysterical crowds and floral tributes that included a blanket of 4,000 perfect scarlet roses sent by Pola Negri. Afterward, Valentino was hastily deposited in a borrowed crypt in Hollywood where he still reposes today, a kind of curiosity corpse, when he is remembered at all, at whose feet a mysterious "lady in black" (or her granddaughter) leaves a single rose every August 23rd.

Or Hank Williams, whose 1953 send-off had to be staged in the Municipal Auditorium of Montgomery to accommodate a clutch of mourners estimated at 25,000. The floral tributes were so large that fewer than a dozen could be crammed into the big truck sent down from Nashville's best florist. The flowers came in guitar-shaped sprays or in the form of open Bibles inscribed with the first few notes of "I Saw the Light." Men wept and women screamed.

But it took the Williams heirs almost two years to set a marker over his grave. It was a monstrous thing anyway, with bad poetry by his ex-wife on the back, musical notes and sheet music, clouds with rays of heavenly light a-burstin' through, and a bronze replica of the Stetson hat Hank wore with his Nudie suit to disguise incipient baldness. Periodically, vandals make off with the hat and the built-in urns for flowers that are seldom left these days. In the music video the country singer Alan Jackson made about Hank's grave, it's a haunted, spooky place, not a theme-park tourist mecca. It's "Midnight in Montgomery."

hymn Elvis recorded in Nashville in May 1966, shortly before he had his picture taken in front of the fountain, is a story-song. The narrator, alone in the garden at dawn when the dew is still on the roses, hears the voice of Jesus, "so sweet the birds stop their singing." The Elvis impersonator Julian Campo heard voices telling him to go to the Meditation Garden and pray at the grave of the King. And there Elvis spoke to him. "Be more humble to the Lord," Elvis said. Keep on being me, being Elvis, but in a spirit of gratitude and concern for others.

It was there, in the garden, where the blue floodlights lit up the columns and the smooth marble Jesus, that Vernon recounted for Elvis the story of his miraculous birth, in a halo of blue light—Jesse, the firstborn son, dead, and little Elvis alive. Elvis = LIVES, in the mystery of a death that attends upon a birth. Is Elvis an emanation of the godhead? Standing by the pool on the south lawn he once reached his hand out over the blue waters toward that blessing Jesus and commanded the clouds to move across the face of the sun. Roll away, he told the clouds. Roll away. And they did.

On the bronze tablet atop his grave, Vernon inscribed a touching tribute to his only son. Elvis was generous, the text reads, and full of "kind feeling for his fellow man." So it was only right that God should call him home for a rest. But did he fly away to heaven or stay right here, in the garden at Graceland? People feel him in the garden, a kind of *divus loci*, present in the flashy carriage lamps on the brick wall, the curlicues on the fences, and the colored lights. Legend has it that on the night of his passing the lights in the garden went out for no reason at all. He seems at home here, in his own backyard, behind the fountain, an eternal flame flickering at his head and Jesus at his feet, with Grandma Presley and Vernon and Gladys and a marker for poor little Jesse, left behind so long ago in the

Priceville Cemetery in Mississippi. People see Elvis here, in the faces of the angels that dot the garden.

Angels are heaven's winged messengers. They fly between Paradise and the terrestrial gardens of mankind—Shazaam!—like the superheroes in the comic books. In the 1940s, Elvis wanted to be Captain Marvel, Jr. In the '70s, Elvis wore capes on stage that unfurled like the wings of the Great Speckled Bird. Was he, he wondered as he built his garden, one of God's special emissaries to earth? A rock 'n' roll angel sent from on high to accomplish some mysterious task, as yet unknown to him? The largest angels in the Meditation Garden kneel in perpetual adoration at the feet of the Sacred Heart, a Catholic Christ in a long robe, his arms outstretched to match the shape of the crucifix at his back. Above him, on the cross, are the letters IHS, for Jesus (or "in his service," according to Protestant interpretation). Below him, on the plinth that holds the angels, it says PRESLEY.

This is the family headstone, Gladys's gravestone, purchased in 1958 and placed in Forest Hills Cemetery, north of Graceland on Highway 51. Elvis was interred there, too, in 1977, in the mausoleum on the hilltop, until the crush of visitors swamped the burial ground and Vernon heard tell of desperadoes about to steal the body and hold it for ransom. In October, with the blessings of the city, Vernon moved his wife, his son, and the Sacred Heart to the security of the garden behind the house. A year later, more than a million guests had climbed the steps to the curved brick wall and looked down through the screen of columns at Elvis, his mother, and a choir of marble angels.

The tombstone angels are off to one side, closer to Gladys and the marker for baby Jesse. Models of marble-cutter piety, they are icy white and still and stiff, with praying hands, huge eagle's wings folded primly at their backs, and pallid ringlets falling to their robed shoulders. Smug and girlish. But just in front of

them, in a clump of hot orange flowers, stands a little black angel, perched on an inverted column, naked as a jaybird. A grinning angel in the contrapposto pose of action, one chubby knee thrust forward to support the empty basket or pot tucked under his right arm. His little robin's wings flutter with the effort. His black curls bounce. Good angels and a bad one, a cupid, Eros, son of Venus. Earthly love and love divine. Sensuality and the spirit. What is right and what is not? What can ever fill that empty vessel of desire?

The garden figures, according to the official guidebook, mean nothing in particular. Just decoration. Saint Francis, in a cowl and hood. A black river goddess, emptying a jug. A white goddess of God knows what, with a profile just like Elvis's. But at night they're green or amber anyway, or amethyst or gold, depending on the lights. Cherubs praying in low relief on Jesse's marker. Putti wearing satanic grins. A cuddly cherubim of cast stone (taller cousin of the "Precious Memories" figurines in gift shops) praying over the dead Elvis. Fake Ionic capitals from the lawn-and-garden store turned upside down for pedestals and benches. Everything is upside-down—pagan and Christian themes tossed together in a casserole of recently antiquated columns. What cult is this? The church of no church at all? The church of going shopping? The temple of the very groovy? What are we to meditate *about* here, in the Meditation Garden. Mortality? The Presleys? The death of the American Dream? Heaven, hell, and Memphis, Tennessee?

The little at-home cemetery is filled up now, and the garden belongs to the tourists who can make of it what they will. It is the one part of Graceland that can be visited free of charge, every morning, beginning at 6 A.M. During the ninety minutes before the tours begin, the penniless pilgrim can toil up the hill to visit Elvis and his family. And the guided tours end there, too, spewing the paying customers out into the humid air

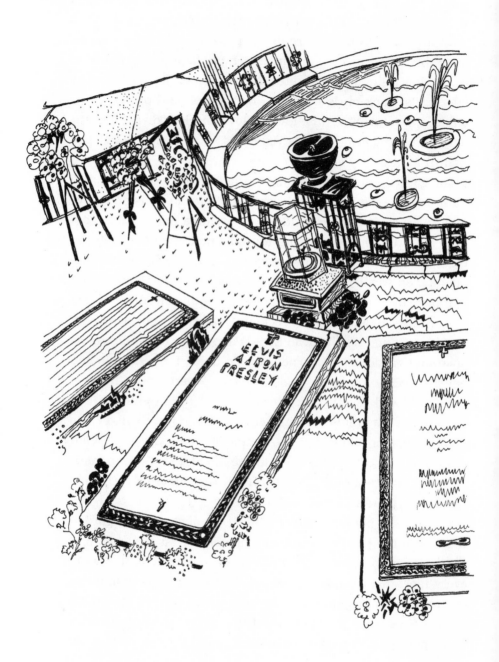

trapped under the trees, toward the wall of Mexican brick, the raised passage, and the peristyle, to be the audience for an ancient tragedy about family ties and heaven and human weakness.

The graves come as a shock, though, even if you know they're there. The house is normal and domestic. Even at its exuberant worst, it's full of life and living. Nothing prepares you for the abrupt end to all that. Suddenly there is no more burnt bacon to be relished in the Jungle Room in front of the TV set. No more fifteen-foot-long custom couches to be ordered. No more gilded pianos to be played. No more buttons to be pressed to whisk the draperies closed. Only the Presleys' private cemetery, on the other side of the sky-blue, kidney-shaped, movie-star swimming pool. Death and pagan love and angels—but not a word about how it happened: the dying and the graves laid out in a sunburst shape behind the fountain.

Elvisophobes celebrate their annual day of ridicule in mid-August when organized fandom holds its graveside vigil in the Meditation Garden. At sunset on the fifteenth, crowds begin to gather outside the Music Gates. As darkness settles over Graceland they come first by the hundreds, then by the thousands; Elvis Presley Boulevard is impassible. At 11 P.M. the gates finally swing open and torch-bearers lead the candlelight procession up the driveway to the garden. Once inside the arc of columns, the procession slows to a solemn crawl. Tears fall. Rosaries dangle and sway like strings of teardrops. Lips mime silent messages of grief and love. And then the line shuffles on, back down the hill and out the gate. Elvis = LIVES. JESUS LIVES! I know that my Redeemer liveth.

The ritual offends almost everybody. Churches find the vigil idolatrous. And it provides another fine excuse for making fun of po' white trash and middle-aged women who fell in love with Elvis long ago. The emotional gulf between the upper middle

class and those who just get by, between the college-educated and those with high school diplomas, between young men who work out and ladies of their grandmothers' vintage who do not is never so well defined as it is right here in August. Every media outlet comes to Memphis to watch the goings-on. Crazy fans. Fat fans. Grotesque fans dressed in polyester Elvis costumes. Too-fat, too-thin, too-goddamn-*old* women, whole squealing gangs of them, with pictures of a dead man pinned over their hearts. They might as well be Martians. They surely aren't *us*. Why don't these people get a life?

But maybe they've come to think about a death, a taboo subject in ever-young America. The grave in the garden is about their own—our own—mortality, about our families, our losses, our pain. About how we believed things would turn out right, and how they very seldom did. About the pleasure of getting things you'd always wanted and how the feeling fizzled out in emptiness. The American Dream died along with Elvis and we know it now. The trip up the driveway is all about a little hard-won wisdom.

The march through the garden ends, generally, at the mall across the road, in an orgy of necrolatry and Elvis souvenirs. Consumerism never dies in Elvisland. Souvenirs are means of bragging tangibly: I was here and you weren't. They're ways of remembering, of taking something away from the experience forever. But part of the death-day ritual at Graceland involves leaving a token behind on the grave as an offering—a kind of reverse souvenir. A single rose sometimes. A blanket of flowers in the shape of a teddy bear or a hound dog. The votive signifies respect for Elvis and for the process of thinking hard about life and death. But it is a thing left behind for everyone to see, a gesture that shows that one person who stood on this spot has remained faithful to Elvis through all the trials and revelations, for all time to come. Unlike the faithless disciples in the Garden

of Gethsemane, or that cheatin' no-good you married under the rose arbor in 1950-something, here, in the Meditation Garden, someone does abide. It is a wish for a world where promises are honored and love endures, a world of forgiveness. The rose asserts these values on behalf of the fat, the old, the unattractive, the hair-sprayed, and the deeply crazy. Jesus, or Elvis, speaks softly and tenderly to all of them here in the garden of Graceland.

Given half a chance, the fans might prefer to celebrate the birth of Elvis in January. Graceland executives do not encourage that happy practice, however. The date falls too close to Christmas to be good for sales or travel. Although August in Memphis is so hot that pilgrims routinely pass out from the heat at midnight, summer is vacation time, and the garden is in bloom. The timetables of tourism determine the ways in which Elvis is remembered. So tourists pant and jockey for a patch of shade when the guides in the Trophy Room, at the back of the house, usher them past a wall of jeweled jumpsuits and out the door, out of polar gusts of air-conditioning and into the torrid waves of shimmering air that hover over Elvis Presley's backyard pool. Is this the Meditation Garden? I thought he had a guitar-shaped swimming pool a lot bigger than that!

The pool and the patio around it used to be the only garden Graceland had. Built in 1957, at the height of Elvis's delight in the attributes of stardom, the pool gave as much symbolic pleasure as respite from the August heat. For a while, Vernon's donkeys were penned up in it. And Elvis rarely swam unless he had to, in a beach movie. He might lie at water's edge sunbathing, with an electric fan on a long extension cord, an ice bag, and a pitcher of cold drinks, but he didn't relish getting wet. The pool was a contemplative object, an aid to a protracted meditation on success. Except that he was in a lather of impatience to have it finished, he might have built a guitar-shaped

one (promised for his projected youth center in Tupelo). Liberace's pool was piano-shaped.

Freddie Bienstock, who scouted for new songs that Elvis could record, visited Graceland in the summer of 1957, just after the pool was filled, to talk about music. Invited to take a swim, he was attacked by one of the flock of ducks the family kept out back. But the pool impressed him nonetheless. Elvis had recently had a screen of columns set up around the perimeter because, he told Bienstock, that was how the pool in *The Philadelphia Story* looked. The basic configuration—a pool of water and a peristyle—was later followed precisely in the Meditation Garden in the mid-'60s. The swimming pool was Hollywood's version of classical classy, a flat-out celebration of the good life. Using the same materials, the garden aimed to spiritualize the secular realm, to purify and chasten the fleshly delights of a house conceived for the amusement of a boy who believed everything he saw in the movies. The man had begun to suspect he had been wrong. The Meditation Garden was a gesture in the direction of becoming a grown-up, sad and empty, filled with thoughts of dying.

When Elvis first heard about his favorite California yogi, what fascinated him most was the story about the corpse of the holy man, left on display for twenty days at Forest Lawn with no signs of mortal corruption. After his mother's death he talked to her body, and tried to pull her from the casket, as if he could raise the dead by the sheer force of wanting. As if he could heal, like Jesus, and make Lazarus walk again, back through the gates of death and into the Promised Land, the garden of eternal joy. His garden was a place for miracles aplenty. A midnight thunderstorm over Graceland. A terrible crash. A flash of glory near the fountain. A statue marked with a bolt of lightning, hot upon her pretty bosom. A sign from heaven. A lightning bolt and three letters—TCB. On diamond rings and basement walls and

the tail of his airplane, to ward off evil. Takin' Care of Business, in a flash. I must be about my Father's business.

There's a TCB and a lightning bolt on the bottom of the bronze tablet over Elvis's grave. On top, there's a cross, and then it says ELVIS AARON PRESLEY, January 8, 1935—August 16, 1977. Aaron was the name of Vernon's best friend back in Tupelo. Aaron rhymed with Garon, poor Jesse's middle name: in Mississippi, the names of twins were supposed to rhyme. The Presleys said A-ron, like the minister did: A-ron, the musician, who spoke for old Mo-zez on the journey to the Promised Land; A-ron, sweet singer, who heard the melodies of heaven. And they spelled it the way they said it: Aron. There have been slimmer cases made for Elvis's victory over death, but the most ingenious holds that AARON is a brazen message for true fans everywhere. Elvis lives! And he spelled his name wrong on his marker to tell us so. He cheated death and he will come again. So far, reported sightings have been confined to Burger Kings in out-of-the-way places far from Memphis, except for the story told by the alcoholic trucker who picked him up a couple of days before Christmas in 1980, a hundred miles from Graceland, trying to make it home in time for the holidays, to celebrate the birth of Jesus. To see the lights in the garden where Jesus stands in eternal benediction over Vernon and Gladys, Jesse Garon and Elvis Aaron.

*P*eckerwood palace

August 16, 1977; a Tuesday. Elvis Presley was dead, or so the
75,000 mourners rapidly assembling outside the gates had
been told. The King was dead. Was it drugs? Boredom? Fame?
An intimation that he had done about as much as he was ever
going to do? A massive failure of imagination? A heart attack,
the doctors said. He was finally going to be with his mama,
Vernon cried, over and over again. "Oh, son. Now you'll see
Gladys."

On Mr. Presley's orders, a plane took off for Oklahoma City to
pick up the nine-hundred-pound, solid copper casket in which
his boy would lie in state in Graceland. It was the same casket
that had stood in the doorway between the living room and the
Music Room on August 16, 1958. Gladys Presley's casket. Poor
Mama in her coffin, inside the big casket, in her baby blue dress,
in the Dresden blue front room with the golden molding up
around the ceiling and the soft wine-colored plush underfoot.

When Gladys died, Vernon and Elvis wanted to have the view-
ing and the funeral at the house—her house—in the old South-
ern style, and invite the 3,000 fans lined up at the foot of the

driveway, peering through the music notes emblazoned on the gates. Colonel Parker talked them out of it. This time, Vernon had his way. At noon on Wednesday, a hearse dashed through the back gate and pulled up to the house before the crowd half noticed. The undertakers spread out white canvas runners, from the front door to the foot of the staircase, on top of the bright red shag that now oozed like heart's blood through the downstairs rooms. In 1974, after Elvis had the new carpet laid, he had told the uncles at the gate to give the scraps left over to fans who wanted them for souvenirs.

The white runners stopped under the crystal chandelier that lit up the foyer and spilled a brilliant beam of light out past the columns, onto the lawn, through a big red P-for-Presley worked into the new stained-glass window over the door. Electric candle flames in crystal dishes danced and multiplied on the mirrored walls. Dangling teardrops tinkled in the breeze whenever the door swung open. There was another chandelier in the dining room that shot back reflections from the rhinestones worked into the red upholstery of the high-backed chairs around the table. And another above the landing where the family sat to keep watch over Elvis as the line of weeping fans shuffled forward, past the copper casket, until twilight fell. Omens. Portents. Elvis had bought all three chandeliers on August 16, 1974, three years to the day before his death.

The funeral proper took place on Thursday afternoon. The casket was wheeled into the living room. Surrounded by plastic greenery, it was positioned at the entrance to the Music Room, in front of the piano. On either side of the door to her solarium, Mrs. Moore, who had built the house at the end of the 1930s, had installed a screen of glass block. Along with the picture windows, the glass walls were the most contemporary details in a structure that otherwise masqueraded as a Civil War–era mansion. Elvis never liked the glass bricks: they smacked of a

concept of modernism that had come and quickly gone. There's nothing sadder or frowzier than yesterday's notions of tomorrow. For years, the opening between the two rooms was muffled in drapery. Then, in 1974, the walls came down and the bricks were stacked in the garage. Stained glass panels went up. Preening peacocks, in a pseudo–Art Nouveau style—Tiffany, with an undertone of Coca-Cola collectibles. Blues, greens, yellows, and Coca-Cola red. Peacocks stand for eternal life.

Mrs. Moore had planned her home so that when she held her musicales she could throw all the formal rooms together into one vast concert hall. The performers took up positions where Elvis would later lie in his copper casket, and an audience of five hundred could watch and listen from tiny gilt chairs set up in the dining room, the foyer, and the living room, facing the proscenium of glass block. Now, in August of 1977, the white canvas was spread in the living room, and the furniture pushed back against the walls. Folding chairs were lined up in rows. Metal folding chairs, painted gold and white, rented from the funeral parlor. Two hundred fifty places. For the Smith cousins, the Presleys, and the old bunch from home; Vernon and Grandma; Ann-Margret and her husband, from Hollywood, and George Hamilton, the star who finally played Hank Williams in the movies, a Southern boy, come out of concern for his friend Colonel Parker; the guys who stayed, or left as friends, the ones who hadn't written books detailing a cycle of drug abuse and sexual excess; Priscilla, little Lisa Marie; the other girlfriends, including Linda Thompson, ex–Miss Tennessee, tall and bold and beautiful in a lavender sundress with spaghetti straps she wore because Elvis had always liked bright colors. The backup singers from the live stage show sang his favorite gospel songs.

Just before the service started, word came from the gate. Caroline Kennedy, the late President's daughter, wanted to come up and offer her respects. The assumption up at the house was that, having been the victim of tragedy herself, she was

paying a kind of state visit to the sorrowing family of the King. It seemed only right. And so, before the hymns and the comforting words from the clergy, she was ushered into Graceland as those closest to Elvis said their last goodbyes, and gently steered into the Jungle Room where the members of the household huddled together, inconsolable. Poor Vernon. His mother, Minnie Mae: Grandma, the "Dodger." Aunt Nash. Aunt Delta. Priscilla: "Would you like a Coke, or Seven-Up?" It was a most peculiar room, Kennedy later wrote in well-bred distaste.

The whole house was peculiar for an antebellum mansion. The transparent statue of a naked woman just behind the casket, which revolved under a waterfall of plastic beads. The plastic plants. The picture of a city skyline on one wall, painted on black velvet. The scarlet portieres tied back with gold tassels that framed the graceful arch leading to the dining room. The huge chairs inside, with their scarlet satin covers quilted in gold thread and speckled with rhinestones. The scarlet carpet, everywhere. On the floor. Glued in squares onto the carved panels of every white door in the house, as though Graceland were hemorrhaging from every orifice.

As it turned out, Miss Kennedy had not come to pay a simple condolence call. She was working for a New York daily and her assignment was the Presley funeral. Because she missed her deadline, the story wound up in the *Rolling Stone* in September, at the height of the tabloid frenzy over Elvis's death. Sales of the so-called bodyguards' book of scandalous revelations had been flat: after August 16, the paperback version became a bestseller at supermarket checkout counters everywhere. One of the relatives accepted $75,000 from the *National Enquirer* for a fuzzy picture of the dead Elvis taken surreptitiously during the private viewing. The picture wound up in the same place as the paperback, among the racks of chewing gum, flashlight batteries, and Lifesavers.

The cumulative message was clear. Elvis Presley had been a

freak. And his awful scarlet house proved it. Oh, it looked just fine on the outside, dignified and stately. Perfectly normal. But past the front door, in the inner recesses of Graceland, horror lurked. Edgar Allan Poe. "The Telltale Heart." Bill Cosby's giant chicken heart. A Valentine for lunatics. Elvis had ended his days inside the pulsing red ventricle of some giant organ of perverted love. No wonder he died of a heart attack.

People who saw the roseate Graceland between 1974 and Priscilla's postmortem restoration of 1981–82 were just as stunned as Caroline Kennedy was. Everything above the basement—everything that wasn't gilded or mirrored or befurred—was a violent Christmastime-lipstick-cherry-Coke-fire-engine-hellfire red. It began at floor level, with a Red Sea of shaggy carpet in screaming cerise. Elvis's live-in girlfriend Linda Thompson had spotted it at Duck's Carpets and modified the rest of the decor to match: the drapery swags (of the same cut and pattern as the blue ones in use today), the velveteen-covered Louis-somebody living room suite, the tall dining room chairs with the rhinestones, and the stained-glass room divider with the peacocks. The squares of Duck's best red shag stuck to places on the woodwork previously innocent of redness. And that wasn't all. White fur rugs were tossed over the carpeting at random intervals. Whatnot tables were borne aloft on the gilded torsos of busty female caryatids. The lamps were metallic fountains that spewed forth hanging diamonds and ersatz rubies. The throw pillows on the sectional sofa had sewn-on mirrors to match the strips of mirror applied to the walls, the mirrored tabletops, and the series of stark, mirror-covered cubes mixed in willy-nilly among the Frenchified curlicues.

Elvis was no passive observer of the reddening of Graceland. It wasn't all Linda's fault, as members of the inner circle have claimed. He picked out the living room suite and told a writer that he got the idea for the mirrors from the inside of a ballet

studio. Out on tour, mirrors let him see himself as the fans would see him on stage, bejeweled like one of his own living room lamps. At home at Graceland, the mirrors let Elvis be the star of his own daily life. He put them on the ceiling of the cellar stairs and on the ceiling of the basement room in which he could lie back in splendid repose upon a bank of velvet cushions and, from underneath one heavy, half-closed eyelid, watch himself as he would someday look in death.

The red phase was probably better known to the world at large than any other period in the history of Graceland. All the journalists who covered Elvis's funeral and the public viewing that preceded it mentioned the redness with varying degrees of amazement. Even those closest to Elvis sensed that the red Graceland was a truly radical thing, an affront to the dignity attached to mansions and the notion of home. That this time Elvis might have gone too far. But in one sense the red Graceland was only a more insistent version of the Art Nouveau revival that coincided with the high-water mark of the rock era. Though the curvy, Peter Max–Toulouse Lautrec mode did not find ready expression in cash-and-carry furniture, the Louis styles, ranging from a pallid French Provincial to the ornate magnificence of the Graceland parlor suite, generally satisfied the home decorator's hankering for pliant forms. Graceland's rectilinear mirrors, in contrast, are reminders of the Art Deco fad that followed hard on the heels of Art Nouveau. While Nouveau was sensuous and decadent, Deco was sophisticated, witty, and only as wicked as a martini cocktail. As for the red, it was a Presley favorite that appeared on the menu of colors readily available in all home furnishing lines from the late '60s through the mid-'70s. Everything from plastic dishpans to the seats of $69.95 occasional chairs came in Elvis Presley red.

This whole curious mixture of things comes together in the two basement rooms of Graceland, in which the guiding hand of Memphis decorator Bill Eubanks, then twenty-three years old, is most apparent. The blue-and-yellow TV Room, for instance, takes its character from a Deco-inspired Op Art supergraphic painted on one wall. The lightning-bolt design amounts to a family crest, the Elvis Presley logo that adorned his jewelry and the tail of his airplane, the *Lisa Marie*. The juxtaposition of jagged lightning angles with circular cloud shapes is carried over into the chrome lamps, the pillows, and the mirrored tables.

The TV Room is hard, however, despite the pillows. The adjacent pool room is cloyingly soft. The walls and ceiling form a tent made of umpteen hundred yards of polished cotton fabric, printed in a pattern that manages to evoke stained glass, calico quilts, and Indian paisley all at once. Predominantly red in color, the fabric shell is the perfect backdrop for the red Louis XV chairs in the corners and the fin de siècle prints and nostalgic advertising showcards fixed to the pleated walls. One room is cool and angular. The other is warm and organic.

Taken together, the two sections of the basement suite form a unity based on the range of possibilities in high-end decor of the 1970s. It is tempting to call it suburban Americana, but the studied disposition of parts suggests public or quasi-public spaces, like cocktail lounges and hotel rooms. Despite Elvis's lightning-bolt symbol and the colors he favored most over the years (his 10,000-foot Imperial Suite in the Las Vegas Hilton was a brilliant yellow, set off with black), these spaces remain impersonal and lifeless in a way the funkier, more idiosyncratic red rooms upstairs were not. If the basement resembles the Las Vegas penthouses where Elvis entertained himself between shows, the red front rooms on the main floor were infused with all the feverish, tinselly glamour of the midnight show itself, with Elvis Presley at center stage, wearing a hot red jumpsuit slit to the waist and a cape lined with liquid gold lamé.

Bill Belew, who designed Elvis's stage wardrobe, never disavowed his connection with the stunning end result. Bill Eubanks, who still maintains a practice in Memphis, is more circumspect about associating himself with Graceland. Elvis and Linda wanted something "youthful and fun and eclectic" in 1974, the decorator says. They ran in and out of stores like two children, buying whatever struck their fancy and then calling him up to come and look at what they'd done. The red Graceland was Elvis's house, Eubanks insists, "not my house. Nobody could ever make Elvis's taste anything but what it was." After

the funeral, however, everybody associated with the Presleys and the house seems to have felt abashed and a little protective about the Venus in the plastic waterfall, the bleeding floors, and the smiley-face yellow hideaway in the basement with the bank of three TVs, the ceramic monkey, and the mirrored ceiling. It wasn't *really* garish, writes one of the round-the-clock nurses who joined the household staff toward the end of Linda's reign. It was just, well, a little exuberant. The Roadside Regal style in full bloom.

The whole look was as disposable as a worn-out pair of pants, of course, but Elvis died before Graceland changed again. Bill Eubanks remembers the TV Room being blue and green and then brown and white: Cub Scout blue and yellow was just another blip on the fever chart of Elvis's impatient dissatisfaction with the status quo. In 1980 the room might have been green again; in 1985, mauve and grey. One of the Jordanaires tells about Elvis driving to Nashville one Christmas in the late 1950s, and deciding on the spur of the moment to go to the Grand Ole Opry. But he didn't have anything to wear that would reflect his dramatic reversal of fortune, after an early brush-off at the Ryman. So he bought a new tux, shoes and all—a garment he otherwise wore only under duress. He posed for pictures backstage with Faron Young and the other headliners. When the picture-taking was done, Elvis changed back into his street clothes and, as he left the building, tossed the outfit into the nearest trash can, shoes and all. Things were like words. You said 'em and they were gone. Poof. You sang your song and then you went home.

In the red years, the distinction between what Elvis wore on stage and off broke down. Although his at-home dress consisted of pajamas or warm-up suits, any garment in which he was liable to be seen by photographers or fans bore strong monarchical overtones. His dress suits had attached Byronic capes

and tall wizard collars and were tailored in unusual menswear fabrics like fur. At the height of the red period, Linda and Elvis often arrived in Las Vegas in identical velvet suits based on paintings of famous rulers of history, with ruffled shirts and real gold buttons, canes, capelets, and seven-league boots. For performances at the Hilton, Elvis took to wearing two-piece leather suits decorated with reproductions of famous works of art. He ordered the pomp-and-circumstances duds he dreamt up in a remarkable range of colors, including red, orchid, and royal purple. He looked like the exiled king of some principality in another dimension of time and space. Or rather, he looked remarkably like the living room back at Graceland that would embarrass his relatives and titillate the readers of tabloids in August 1977. The king is dead. Long live the king. King Elvis and his Peckerwood Palace.

The palace did, nonetheless, constitute one of the major tangible assets in the much-depleted estate Elvis left to his daughter. As Lisa Marie's guardian, Priscilla Presley hired a management team and took steps to open the house for paying tours. The hope was to have Graceland, Inc., ready for business in 1982, to catch traffic en route to Knoxville for that summer's World's Fair. The problem was what to let ticketholders see. The red rooms—the whole downstairs—had already been subjected to cruel ridicule in the media: Caroline Kennedy's exposé was a ladylike update of her mother's televised White House tour in comparison to other efforts to capture the full awfulness of Graceland.

Goldman's vitriolic biography was of special concern because it devoted whole chapters to the red zone, insinuating all the while that bad taste (and the author had no doubt that Graceland was the Taj Mahal of aesthetic misjudgment) was synonymous with decadence and evil and whatever else ailed the South. Because the book appeared in 1981, as the final

The more you're told you can't see something, the more vivid and important it grows in the imagination. Like the upstairs of Graceland, and the death chamber. Is there something so grotesque up there that, were a tourist to see it, the whole Graceland enterprise would collapse overnight? Elvis on life support, in a gilded bed shaped like Ezekiel's chariot? Elvis fat and gray, drooling in a playpen? Elvis restored and living in connubial bliss with Natalie Wood? A prosaic toilet in a funky bathroom that smells vaguely of mildew? No Elvis? Nothing?

If you can't climb the stairs, you wonder. What if I made a break for it while the guide for the living room was handing off the group—Tour #8, 11 o'clock—to the next spieler, who talks about the mirrors on the ceiling of the basement stairs? Would there be sirens and steel grates that slam shut electronically?

If you can't climb the stairs, you're meant to think about happy times in Graceland: parties, watching TV during dinner, fooling around with the guys in the Jungle Room, shooting out a TV or two over Robert Goulet and Mel Tormé. The madcap Elvis. That wild and crazy guy. But you think about the upstairs anyway. There's nothing happy about the faint current of air-conditioned air that oozes down the staircase. It's as cold as the grave out in the backyard.

You can't climb the stairs because the house was never built for all those feet, lumbering up and down, day after day, looking for Elvis.

decisions on the character of the tour were being made, Goldman's distaste for redness touched off a coloristic purge and helped to create the posthumous, largely fictitious Graceland visible today.

Today's Graceland is a study in vibrant cobalt blues sailing on an ocean of white: plump white damask chairs, white carpeting (except for the island of black marble tile under the

dining room table), white grasscloth walls and woodwork, and a large white breakfront crammed into one corner of the living room, to the right of the white stone fireplace. The punctuation marks are saber-thrusts of black and gold. Gold fringe on the hangings. Gold dentils and stair balusters. Black upholstery on the dining room chairs. A black and gold étagère. None of these tasteful items was purchased for the public opening of Graceland. Like the étagère and the 1957 end tables in the living room, the individual pieces turn up in family snapshots and other documents. They came, for the most part, from storage and from the capacious attic. The inventory of the contents of the mansion, taken for probate in 1977, was seventy-six pages long. But there are serious questions about whether the overall effect, this controlled combination of colors and forms, ever existed at Graceland at any given moment during the lifetime of Elvis Presley.

It's nice enough. Furniture-store tasteful in a 1980s way, just on the showy, show-biz side of upper-middle-class oh-so-gentility, the formal rooms of Graceland represent a determined effort to polish the reputation of the deceased. In its normality, the blue Graceland alludes to the appearance of the house when Elvis was a nice young man, still living with his parents, and to the years of his marriage to Priscilla. Priscilla *Presley,* that is, professional widow and Queen of Graceland, mother of the King's little princess. Graceland is all-American, apple-pie normal. As it now presents itself to the passing tourist trade, Elvis's house could have belonged to anybody with a little money. Except, maybe, for the telltale gold dentils, the Jungle Room, and the excessive number of TV sets, Graceland is not rock 'n' roll tacky, Southern, degenerate, or even weird. It's merely blue, and, as the tour guides tell you, blue was Elvis's favorite color. "Blue Moon." "Blue Suede Shoes." *Blue Hawaii.* "Moody Blue."

There's a lot of talk about blueness around Graceland.

Friends and aged aunts are cited as authorities on Elvis's abiding fondness for blue and for the remnants of the first Elvis-and-Gladys decorating campaign preserved, reupholstered, and cleverly integrated into the new look. According to one story, Elvis spent the last year of his life creeping up the back staircase so as not to have to look at the hated red carpeting on the front stairs. He had repented of his folly, after all. Of girlfriends, and bad taste, and bloat. Of middle age. Of the fetters of mere mortality. Hosanna! Gloria in excelsis! If he had been able to manage it, he would have chosen to expire in a home appointed in celestial blue, with a snowdrift of pure white carpet surging up the gilded staircase toward the heavenly abode of the blessed.

The second floor, at the top of the staircase, is a place of mystery and redemptive hope. Is there a tourist anywhere, in all of Elvisdom, who does not know that he died in his upstairs bathroom, under seamy circumstances that have been the topic of bad jokes ever since? By confining visitors to the basement and the main floor, by insisting that *nobody*, under any circumstances, is allowed upstairs, Graceland defuses the humor and resanctifies the King's Room suite as the liminal zone between home and heaven. Between the blue of Graceland and the deep blue sky of eternity.

oing home

You can drive from Memphis to Minneapolis in a day if you have to. I've done it twice now, once out of homesickness and the other time because the trip had gone badly wrong.

That second time was unpleasant from the start. A drug dealer slammed into the back fender of the van in the lighted parking lot of the Wilson World Hotel, across the boulevard from Graceland, on the night that O.J. Simpson made his slow-motion escape in the white Bronco down the freeway in L.A. Everybody in the place was watching the spectacle on TV: the little truck, the empty road, the people out in California hanging off the bridges to see O.J. go by, as if highway travel had suddenly become a spectator sport. The popcorn machine in the back lobby at Wilson World never stopped its noise, except when the black teenager who handed out the greasy bags told us all to sit down for a minute and shut up, because she wanted to see O.J., too. After an hour or so of popcorn and strained conversation among a crowd of ill-assorted strangers all stuck in a lounge that smelled like the Arnett Theater in Rochester, New York, in 1956 (or the Fox, in Laramie, Wyoming, circa 1957), people

drifted off to their own rooms and the call came in about the van.

The security guys who worked for the hotel didn't want to do a thing. The van still ran. Even though the guest assumed the risk when parking in the only lot provided, a police call wouldn't do the company any good. The rent-a-cops wanted to talk about Elvis, Graceland, the best route back to Minnesota. Anything but the accident. They perspired a lot and wouldn't shut up. The real cops, when they arrived, were matter-of-fact. South Memphis was drug dealers' heaven, they said, without so much as an ironic nod toward the mansion gleaming whitely through the trees across the road. A rough place. Best come by the station in the morning and fill out a report for your insurance company.

Spookiness comes with the territory when you think about Elvis on a semi-professional basis. Fans always have stories about Elvoid coincidences, about crucial personal decisions changed for the good because "Blue Suede Shoes" came on the radio in the moment of crisis. I myself once mistook an Elvis impersonator in a white Aztec Sun–model jumpsuit drinking a Pepsi out of the bottle under a tabletop umbrella for the genuine article. It happened on a hot and humid Sunday afternoon in the picnic area out behind an Elvis souvenir stand not a hundred yards from the parking lot of Wilson World in Memphis. I was tired and giddy. I admit it. But even afterwards, when a short, bow-legged man of forty or so who wasn't Elvis Aron (or Aaron) Presley levered himself out of his plastic chair, carefully deposited his plastic bottle in the designated receptacle, and drove away in a rusted-out Volkswagen, I wondered.

I still do. I remember feeling that reality had slipped sideways a notch or two. This wasn't anything like Stephen King and his zombie musicians, who entice innocent tourists to a rock 'n' roll hell 'way past Lonely Street. Uh-uh. It was a swift shot of joy, a

chill, and a memory that has never faded in any particular. A friend once gave me a business card inscribed with a California area code: Elvis in a nimbus of light staring thoughtfully from the blue card of somebody who called himself a certified Elvis worker and promised "Healing through the inner Elvis." It could have been a joke. And probably was. But it didn't matter one little bit. Logic skittered off to one side again, like a severed hand in a horror story, and something as blue as the wide Pacific took its place. Something as blue as a blue suede shoe.

O.J. was on every channel now, the mountains and Pacific behind him, just out of camera range. O.J. running slowly toward something or away from it, running for his life. Crime. Celebrities. Scandal. Public faces, private lives. O.J. Simpson, minor movie star, the beautiful Priscilla Presley's sometime co-star. Elvis and Priscilla and O.J. and death. And all this before the tabloids swore that Lisa Marie, Priscilla's daughter and Elvis's only child, had run away to the West Indies to marry Michael Jackson.

As the networks cut away, one by one, to the highway and the Bronco, I pulled a square of gilded cardboard out of my pocket and sniffed the spray of Priscilla's signature perfume they had given me at the Graceland gift shop an hour or two before. Priscilla Presley's "Memories" mingled with the aroma of popcorn. Even as it was happening—the white Bronco rolling toward the existential edge of collective madness—the whole thing already felt like a memory. Like two or three hours of an Andy Warhol film of the Empire State Building, this picture was too bright, too finished and inevitable to be quite real: one van circling the freeway, heading for Brentwood and O.J.'s movie-star estate; another banged up in a parking lot across the street from Elvis's estate in Memphis. Everywhere, the pungent smell of memories.

Something was wrong in Memphis that night. Time to go.

Time to boogie up U.S. 55 toward home, as fast as a dinged-up right-rear tire could go. To go north, you've got to cross the Mississippi, west of downtown. You know you've done it, too. The old iron bridge bristles with trusses and girders, as if to impress the passerby with the effort that went into lifting up the road and setting it down again on the other side of the river, in Arkansas. Dawn creeps out of cloudbank halfway across, and down river, to the left, the Delta ought to be humming and shining "like a National guitar." So says Paul Simon, on his way to Graceland.

On the way home, the chords sound sour and the oil slicks on the current flicker darkly as they snake their way toward New Orleans. Look back at the city, like Lot's unsatisfactory wife lamenting the day she left Sodom. Or Moses out of Egypt. Let my people go! The glass pyramid Memphis has deposited on the Tennessee shore looks phony and weightless alongside the river and bridge. Which is what postmodern things are supposed to look like: signs, symbols. But it doesn't help the mood in the van.

West Memphis, Arkansas, is one big truck stop. The highway has been chewed to rubble by eighteen-wheelers out of Tulsa and Houston. The air is brown with exhaust. The only scenery is the forest of poles, taller than California redwoods, with Exxon and Chevron signs on top. On an earlier escape from Memphis, we got this far and stopped for the night, to get a good start on the morning. West Memphis offers a mile or so of battered motels, right alongside the truck corridor. This one had one working light bulb per room, to be unscrewed and rein-stalled as needed. And a drawerful of used condoms in the bedside stand. The air conditioner hissed out boiling steam. It was the kind of place where sleeping on top of the covers with the window open seemed best, even at the risk of death from diesel fumes.

Next door, across a minefield of dirt and potholes and slabs of tire treads that periodically kited over the crash barriers along the highway, sat a big corrugated metal shed with a sign on a tall pole outside. While the hot afternoon sun still hung in the sky, the parking lot was empty and the sign unreadable. When darkness came, however, a yellow square of sooty plastic glowed above the stretch of ruts. Paw-Paw's, the sign said. Fresh fish. There were no windows, no way to look before you leaped. But yellow light spilled out the screen door and something smelled delicious.

Dining at Paw-Paw's was like eating in 1956, in the *Twilight Zone.* There was a steam line just inside the door, with ancient cafeteria trays and stainless, and see-through paper napkins and greasy old Melmac plates, scored by tine marks, with the designs worn off from use. And every fishy thing that swam in the river, a quarter-section's width of swamp from the kitchen door, out back. Fried catfish. Boiled crawdads. Deep fried anything. Bullheads tonight. Huge hot heaps of 'em: white bread and bottled pickles on the side. Card tables and old square wooden tables that walked on wobbly legs. Metal folding chairs, the rickety kind with a brace between the back legs. The braces had buckled years ago and left the customers teetering on a lumpy concrete floor. The chairs rocked and sagged under the weight of huge butts, black ones and white ones, hunkered down on Friday night to eat some serious fish.

Paw-Paw's had worked out a dress code for itself. Old ladies and little girls came all dressed up. Hats and nylon frills and big white pumps. Younger women reeked of drug-store perfume, "Memories" and musk, and had poured themselves into anything lowdown and tight. Men of all ages wore work clothes. Black men favored pressed twill outfits, with matching pants and shirts. White men wore their denims and blue chambray workshirts with the sleeves cut off, straining against lumps of

fat and muscle. The black men had little mustaches. The white men over thirty all had sideburns just like Elvis in his Las Vegas period. The younger ones had shorter haircuts but they looked like Elvis, too. They aimed for an aura of dangerous languor and inspected their fish slantwise out of the corners of half-closed eyes that didn't see the shed, the steam table, the formidable Paw-Paw in his homemade paper hat, or the Melmac. They ate their fish and dreamed—or so it seemed to me—sexy, violent dreams along the edge of U.S. 55.

Every table had its own sorghum bucket for bones and shells and a cloudy plastic pitcher full of sweet cold tea. By the time we forked over our $4 apiece—yup, all ya kin eat; c'mon back, hee-ah?—and sailed back to the motel on a cloud of *eau de catfish,* the trucks didn't sound so loud, the room didn't look quite so much like a recent crime scene, and the temperature had plummeted to 85 degrees, or perfect sleeping weather in a $12-a-night hostelry on the beginning of the road to Minneapolis. We were gone by 5 A.M.

On this trip, less than a year later, we rolled through West Memphis early in the morning, when the fish were just beginning to decide whether or not to jump into the boat and then into the vat of boiling grease. But Paw-Paw's was no more. The metal shed was still standing, ready to become a warehouse for big-rig hitches or a storage shed for recapped tires. The signpole was snapped off clean at the top. It listed over the interstate like a blunt instrument imperfectly impaled in a corpse. Paw-Paw's looked bad. The roach motel next door, in the meantime, had had the window trim painted and the parking lot restriped.

All the way up through Arkansas, the river bottom is flatter than a pancake. There's no landscape to speak of. Just horizons, and the river off somewhere to the east, doing amazing twists and pirouettes along the edge of the map, unseen from the road, except for wisps of morning dampness that creep up

on the van from the passenger's side like cutthroat river pirates. In the movies, the paddies of Vietnam are always a very Technicolor green; these Arkansas rice fields are no particular color at all in the wet light of dawn. Yellowish and smoky: the fields Leonardo da Vinci painted in behind his virgins look this way, as if something terrible had happened over yonder, or was about to. The Italians call it *sfumato*. On U.S. 55 it lasts through the paddies and the catfish farms, into Missouri, halfway to Sikeston. Right in the middle of the milky flatness, there's a green-and-white billboard for a restaurant a long way up ahead. Home of the Throwed Roll, they call themselves, whatever *that* may be. A picture of a manic cartoon chef tossing a dough lump snaps the road back into focus. There's something up ahead, besides humidity and rice.

A stop is not in order, sad to say. On Sunday mornings before the church bells have begun to ring, they don't throw rolls on U.S. 55. Exxon and Conoco are both open though. It would be possible to breakfast there on moon pies and RC Colas or Coca-Colas with cellophane sleeves of salted peanuts poured into the bottle. We settle for last night's coffee instead, thick and nasty and free, and a side of fat-free Hostess chocolate cupcakes with a squiggle of white frosting across the tops that matches the contortions of the river, shimmying down from Cape Girardeau toward Cairo, Illinois, where the American Egypt begins: the shoots of rice, then Memphis, the Pyramid, the cotton bolls, the Delta.

Something Southern stops before you hit St. Louis. The view out the window is flat and hilly and flat again but always scuffed and bare. Unproductive, as if consigned to growing asphalt roads and gas stations so long ago that the sullen tracts of weeds parallel to the Illinois line never learned how to yield up better crops than these. Then 55 leaps abruptly into the tangle of never-done arterials around the city and strangles itself

somewhere near the Arch downtown. Headed north-by-north-west for Iowa, 61 comes out the other side alone, after a stretch of stunted no-name office cubes and suburbs where every house is beige.

Hannibal, Quincy, then Keokuk, Iowa. Hannibal first: Mark Twain on every side—namesake for a motel and a family restaurant and then a T-shirt store—and the river again, at last, high and swift under tall bluffs. Huck and Tom and Becky. The frontier, where the west began, once upon a time. And boys like Elvis dreaming along the Mississippi, listening to the tunes that steamed upriver from the Delta on the showboats. The lunch and dinner cruises on the riverboat "Mark Twain" start from the landing at the foot of Center Street, in the heart of quaintness. Once-abandoned storefronts are stockpiled with kitchen gadgets in the shape of cows or country objets d'art in ecru lace and pink and blue. There's a fence that can be whitewashed for a fee. Antiques. Collectibles. And here and there an Elvis, the national icon, emblazed on a shot glass or a cherry red guitar-shaped plank that also sports a clock. An Elvis coverlet for the couch back home.

The cruises last one or two hours, depending on the time of day. On the early trips, kids in striped scarlet vests and plastic skimmers sell sandwiches and pop. Dinner is dispensed on the twilight cruise from a serving line like Paw-Paw's, except the choices here are shreds of beef sloshing gently in a sea of Kraft's bottled barbecue sauce and parts of chickens steamed to a fare-thee-well. But nobody comes along for the food. They come for the placecards, scripted with your name even if you walked on board just before they pulled the gangway back. And the red candles. And the entertainment. Senior citizens dressed like a whorehouse orchestra in East St. Louis in 1890-something play Golden Oldies for anniversary parties steeped in nostalgia for the good old days in Hannibal. Glenn Miller. World War II.

Sinatra. Early Elvis. If you buy a cocktail, you get to keep the glass. The Sam Clemens—pineapple juice and vodka with a splash of coconut milk—is popular. The best of the lot is the Mississippi Mud: chocolate milk, heavy cream, soda water, and peppermint schnapps. It tastes like drinking "Love Me Tender."

After Missouri comes Iowa, bland and pretty and close to home. From Des Moines on, it's a straight blast up 35 into the heart of Minneapolis where the highway finds the river one last time, narrow, prim, and mannerly, still making up its mind about becoming a northern version of the Nile and heading south to Memphis. I-35 is just what you'd expect of an interstate in the great Midwest. The comfort stations are scrubbed within an inch of their lives. They have built-in recycling bins for every conceivable waste product. The gas oases are just as clean, with meatloaf on the menu and giant-size packages of chips and Pepsi. Everybody's huge. Big-boned. Fat, too, mostly, just like Elvis—and proud of it: porky and pink. Friendly and chatty yet not exactly hospitable. They don't care if y'all come back, so long as you don't cause a fuss while you're there. Incurious. Paw-Paw wanted the story of our lives. The bubbas in the parking lot wanted to hear about why we liked ol' Elvis. In Iowa, they want your nickel and some assurance that you will leave the toilet the way you found it.

Except in Eldon, at the raggedy-ass end of the universe in southeastern Iowa, between Ottumwa and the Missouri border. Normally, you wouldn't go anywhere near Eldon on the drive from Memphis to Minneapolis, or vice versa, unless the trip was a pilgrimage in the first place, and then it might be better to stop in Iowa on the way down. My theory is that if the sheer psychic drain of standing where Elvis actually stood doesn't get to you, then the steambath humidity of a Memphis summer and the excitement of being a crime victim will. So normally you'd want to scoot back home to Minnesota as quickly as possible,

up the interstate, through Kansas City and Albert Lea, with no dawdling on back roads in Iowa. The long way down, through eastern Missouri, where there isn't much to see anyway and the true meaning of the songs of the Las Vegas years begins to reveal itself on the fortieth or fiftieth hearing, helps to build the anticipation, though. And coming back this way, the slow way, puts a week's worth of oddities and miracles into some perspective. Iowa does that—especially an afternoon spent in the environs of Roseanne and Tom Arnold's Big Food Diner.

By the time you get there, the name will have changed. Tom and Roseanne are kaput. She's married to her chauffeur/bodyguard now and he's engaged to a college kid from Michigan. Vitriolic remarks have been exchanged in front of talk-show hosts, grisly acts of physical violence rehashed, and whole wardrobes dumped into swimming pools. But Eldon is Tom's home turf. He was an Iowa meat packer once and his relatives, freed from bondage to spare ribs and loin chops by Roseanne's alimony checks, still run the restaurant. In its heyday, the Big Food Diner was covered with photographs of the happy couple, looking fat and sassy and thumbing their piggy little noses at the culture of weight control.

Eldon. Elvis. Coincidence? I don't think so. The menu used to feature a sly tribute to Elvis in the form of his beloved peanut butter and 'nana sandwich, improved for the '90s with the addition of a little chocolate. It was big. It was sweet and smooth. It cost $2 and change: cheap, in other words. If the basic food groups were grease, candy, and Wonder Bread, it would have been nature's perfect dietary delight. It was just dangerous enough to your health to be truly interesting. It was, in short, the perfect gastronomic metaphor for the Elvis Presley whose August Tribute Week was once celebrated by a Memphis radio station with a giant give-away of bath mats bearing the chalk outline of a pudgy human figure lying beside a half-eaten donut.

Of all Elvis's many sins, the most terrible to our day and age are the aesthetic ones. Tacky furniture. Sideburns. Clairol "Black Velvet" hair dye. Sequined bell-bottoms. Shag carpeting. Get real, El! He also liked big, gas-guzzling Detroit cars at a time when the rest of the United States was primly shoehorning its collective self into little foreign numbers. Hell, your average Toyota or Honda Civic couldn't have held Elvis at the end. He was too damned fat. And that was, perhaps, his gravest offense against the sensibilities of virtuous, cholesterol-hating, marathon-running, Nike-wearing, live-forever, just-a-salad-for-me American yuppies with alumni association decals from middling institutions stuck in the back windows of their gray Saabs.

Leave it to Roseanne Barr Arnold, now just-plain-megastar Roseanne—Madonna. Elvis. Cher. ROSEANNE—to root out the awful class snobbery that spawns Fat Elvis jokes. To watch her in action is to witness a kind of perpetual Elvis sighting, anyway; she's pudgy and patently fabulous, in her red satin bustiers and spangles. She's crude and loud but oh, so wise. She's rich enough to have the chocolate bars sliced off her thighs and cheeks from time to time. Rich enough to buy the closetsful of dreck that *People* magazine photographs in mind-bending de-

tail, yet blue-collar poor forever in her yearnings after more flash and glitz. She's Pork-and-Bacon Woman, the Link-Sausage Queen. She's Tom Arnold in drag (or Tom's mama), and her complex public persona is, in many ways, a running commentary on our darkest fears of Elvisness. She's Michael Jackson, the plastic surgeon's dream. She's O.J. *and* Nicole. She's Elvis, crying for his little lost 'Cilla. And she's Priscilla, too, crazy in love, and mad to be gone. The tragedy of love gone sour hangs over the Big Food Diner like the stench of rancid fat. It's spooky.

Actually, Eldon has been spooky for quite a while. There's the matter of eating Elvis, of spiritual communion through deep-fried chocolate. There are, or were, the Tom and Roseanne sightings. Papers as far away as Minneapolis reported drop-ins at comedy clubs and rumors that the couple was (or was not) later seen heading for Iowa loaded down with booty from the Mall of America. At the Big Food, motherly waitresses with hankies tucked in the breast pockets of their uniforms used to give you the bad news with the coffee. "She was just in for breakfast." Or worse. "Ya just missed 'em." Until the floods of '93 swept most of it away, the Arnolds were building a huge new house outside of Eldon. It was hard to find but the locals were always willing to draw maps and warn you that there wasn't a lot to see from the road yet. The hide-and-seek game was part of the charm. The house was private but it wasn't, something like Graceland in the days when Uncle Vester ran the gate detail. So near and yet so far.

In the house department, Eldon already had a beauty before the Arnolds began pouring concrete in a fair-sized subdivision composed entirely of their own construction trailers. All you have to do is follow the rusty arrows that start behind the diner out to the place where the streets suddenly veer off at odd angles and the pavement ends. And there it sits. The famous American Gothic House, Eldon's oldest tourist attraction, looks like a

slightly enlarged and beautified version of Elvis's birthplace in Tupelo, Mississippi. A modest board-and-batten structure of the 1880s, it is pretty much of a piece with the rest of town, except for a large, pointed Carpenter-Gothic arch window on the front that caught the fancy of the painter Grant Wood when he passed through on a visit to one of his pupils in August 1930. Legend has it that Wood drew a sketch of the facade on the back of an old envelope, went back to Cedar Rapids, and painted *American Gothic* in the white heat of inspiration, with his sister and his dentist posed before the house in the guise of a farm couple whose moral rigidity is suggested by the sacral associations of the window. A parody of rural fundamentalism. House as church. Now what was it that Elvis called his house? Graceland? Glory hallelujah! Spooky, huh? Told ya.

Grant Wood was one of the fathers of the regionalist movement in art. Popular among ordinary, picture-lovin' folk in the 1930s (although anathema then and now to intellectuals who fancy "modern art"), regionalism looked at the particularities of American life. Gothic houses in Eldon, Iowa. What the Midwest or the South looked like, or wanted to look like, or wished it

didn't. All those guilt-making black-and-white pictures of underfed sharecroppers taken in the Depression era were by New Deal photographers who believed in regionalism, too.

After World War II, the movement was discredited as being fascist, parochial, embarrassing, or insufficiently attuned to the rising internationalism of business and the la-di-da sophistication of abstract art. But abstractions don't count for much on the road from Memphis to Minneapolis via Eldon, Iowa. The interstates try to grind the particularities out of us: squiggles and all, Hostess creme-filled cupcakes look and taste alike. But Paw-Paw's and Elvis, Graceland, Grant Wood and the Big Food Diner resist the trend. In the 1950s Elvis became the last great Dixie regionalist (the second-last was William Faulkner). Because of his connectedness to Memphis and the South, he was to bear until the end of his days—and beyond—the stigma of being tasteless, po' white trash. Tasteless fat trash. But pungent and distinctive, unlike a storebought cupcake that tastes like cellophane whether you get it at a rest stop in West Memphis or in Hannibal, in Eldon or in Minneapolis. I would recommend the Mississippi Mud pie at the Big Food Diner instead, all nuts and goo and chocolate and ice-cold pleasure. As the waitress says, there's nothing quite like it anywhere else. Not in Iowa, at least.

From Des Moines on into Minneapolis, it's I-35 all the way, running due north, straight as an arrow, along the edges of counties ruled out in squares like a granny quilt. It's as dark as the inside of a hat, and everybody's run out of words. Now and then, when the floodlights aimed at the Conoco signs recede into the void, there's a little spot of yellow light way off in a field. A farmhouse. I remember coming home from my grandmother's farmhouse on inky nights like this, after Sunday supper. When you looked back, the house had turned into a tiny firefly spot of yellow light, the kitchen window winking in the darkness. And

then, as my father's Chevy picked up speed, the light flickered out in the distance and disappeared.

The country was the past, our family history. But it was also my grandmother who betook herself to the new record store up the highway, in the first suburban strip mall to sprout in her part of the world, and bought me an Elvis Presley 45. "Love Me Tender," swaddled in white tissue paper with my name written right on the wrappings in her elegant, spidery hand. And a record player to go with it: a real RCA. Cloth of gold stretched stiff and shiny across the speaker. A nubby green-and-white striped vinyl finish that looked like the striped sport jacket with the velvet collar Elvis wore in the dreamiest pictures in the fan magazines. I've never been so surprised or so delighted, before or since. I looked at that record player as much as I listened to it. The glitter, the flecks of abstract pattern on the stripes, the plastic handle in whose milky depths swirled magic sparks of stardust.

I remember my grandfather and me, on Sunday afternoons when it was too nasty to fly a kite and too late in the season for berry-picking—when there were no baby bunnies to be rescued, no holes to be dug in absolute confidence that China was just a shovelful away—tramping across the fields to the new subdivisions that were marching toward his garden from every side. We'd pick our way up gangplanks made of two-by-fours and, careful to stay on the newspapers laid across the floors, inspect new houses, as if we were really going to buy ourselves a mansion, my grandfather and me. We'd look in every cupboard, flush every toilet. Admire the walk-in closets.

We liked the new stuff best: picture windows, built-in ovens with glass windows (the farmhouse had a coal stove), formica countertops in brilliant colors, patios, knotty-pine dens, and fireplaces with sunburst clocks and matching candelabra over the mantlepiece. When I first read F. Scott Fitzgerald in college,

and thought about Gatsby and his fabulous mansion and his beautiful multicolored shirts, I remembered those Sunday afternoons. A solemn old man and the little girl who clutched his hand, tiptoeing through half-built houses, discussing built-in ovens and trying to decide between the turquoise and the pink.

Now, I thought about Elvis and Graceland and Grampa and Gatsby and home. In the dark at the back of the van, with Minneapolis all aglow like Oz on the horizon up ahead, with Memphis back there someplace in the void beyond the rearview mirror, I cried. For all of us. Grampa and Grandma. Gatsby. Paw-Paw. For poor Roseanne and love gone wrong. For O.J. For Elvis, bless his heart. And for me.

Sources / Acknowledgments

Sources

Tupelo: blue lights, shotgun shack

This chapter is based on my own visits to Tupelo in 1993 and 1994. The best descriptions of the city, 1935–1948, are Elaine Dundy, *Elvis and Gladys* (New York: St. Martin's, 1985), pp. 60–118, and Howard A. DeWitt, *Elvis: The Sun Years* (Ann Arbor: Popular Culture Ink, 1993), pp. 41–69. Bill E. Burk, *Early Elvis: The Humes Years* (Memphis: Red Oak Press, 1990), p. 59, includes details on the young Presley's early returns to Tupelo. For the dates of important events in the star's youth and early career, see Lee Cotten, *All Shook Up: Elvis Day-By-Day, 1954–1977* (Ann Arbor: Popular Culture Ink, 1985). His reaction to Paris is described in Charlie Hodge with Charles Goodman, *Me 'n Elvis* (Memphis: Castle Books, 1988), p. 16. The most thorough treatments of tourist sites in Tupelo are Sharon Colette Urquhart, *Placing Elvis: A Tour Guide to the Kingdom* (New Orleans: Paper Chase Press, 1994), pp. 17–39, and Jack Barth, *Roadside Elvis* (Chicago: Contemporary Books, 1991), pp. 48–68. First-person memoirs of Elvis are notorious for including long passages of dialogue attributed to him on the flimsiest of evidence. Throughout this book, I have tried to quote Elvis Presley only when his words can be verified in a journalistic source or sources, such as the report of a press conference. Jerry Hopkins, *Elvis:*

A Biography (New York: Warner Books, 1972), the most reliable biography to date, also follows this practice.

Oxford: Mr. Billy's mansion

This chapter is based on a delightful trip to Oxford in June 1994, and on conversations with Professor Thomas Spight Hines of UCLA, who grew up there. Tom was kind enough to share with me his own moving family history of the Spights, the Hineses, and their cousins, the Faulkners. The best published descriptions of the architecture of Oxford are Herman E. Taylor, *Faulkner's Oxford: Recollection and Reflections* (Nashville: Rutledge Hill Press, 1990), pp. 16, 22, 198, and Dan Hise, *Faulkner's Rowan Oak* (Jackson: University Press of Mississippi, 1993). Direct quotations from Faulkner come from *Absalom, Absalom!*, corrected ed. (New York: Vintage, 1965), pp. 153–157, 215, 328, 351, 358–359, 366, 411. Joseph Blotner, *Faulkner: A Biography* (New York: Vintage, 1991), pp. 647–651, describes the genesis of *The Mansion* in detail. For a telling and unusual comparison between Faulkner and Margaret Mitchell, see Louis D. Rubin, Jr., "Scarlett O'Hara and the Two Quentin Compsons," in *A Gallery of Southerners* (Baton Rouge: Louisiana State University Press, 1982), pp. 26–48. Also useful are Charles S. Aiken, "Faulkner's Geography," in Charles Reagan Wilson and William Ferris, eds., *Encyclopedia of Southern Culture*, vol. 2 (New York: Anchor Books, 1989), pp. 289–290, and James Seay, "Yoknapatawpha County," in vol. 3, pp. 526–527.

Main Street at Beale

I spent time in Memphis during the summers of 1992, 1993, and 1994, and profited from reading several histories of the city in advance. These include Perre Magness, *Good Abode: Nineteenth Century Architecture in Memphis and Shelby County, Tennessee* (Memphis: Junior League of Memphis, 1983), pp. 7–14; Eugene J. Johnson and Robert D. Russell, Jr., *Memphis: An Architectural Guide* (Knoxville: University of Tennessee Press, 1990), pp. 1–9, 133–137; *1948–1958 Memphis* (Memphis: Memphis Brooks Museum of Art, 1986); James Conaway,

Memphis Afternoons: A Memoir (Boston: Houghton Mifflin, 1993); Federal Writers' Project of the Works Projects Administration, *Tennessee: A Guide to the State* (New York: Viking, 1939); and Shields McIlwaine, *Memphis Down in Dixie* (New York: E. P. Dutton, 1948).

In addition to the Presley literature cited above, *The Whole Elvis Tour* (Memphis: Memphis Explorations, 1990) and Tom Carlson, "Babylon of the Old South," *Elvistown*, 1 (1991–1992), pp. 22–25 and 52, both provide good accounts of Memphis sites specific to Elvis and his family. Margaret McKee and Fred Chisenhall, *Beale Black and Blue* (Baton Rouge: Louisiana State University Press, 1981) is the standard text on the music of Beale Street.

Of the many Elvis cookbooks, the most thorough on the subject of hamburgers is Dave Adler, *The Life and Cuisine of Elvis Presley* (New York: Crown, 1993), p. 38. The most revealing is Mary Jenkins as told to Beth Pease, *Memories beyond Graceland Gates* (Buena Park, Calif.: West Coast Publishing, 1989), p. 101.

A Cadillac cowboy goes to Nashville

Dick Vellenga with Mike Farren, *Elvis and the Colonel* (New York: Dell, 1988), paints a vivid picture of the country music scene in the 1950s. Dave Marsh, *Elvis* (New York: Thunder's Mouth Press, 1992), pp. 55–61, reprints a revealing set of photographs of Elvis on the road. Dundy, *Elvis and Gladys*, p. 180, quotes guitarist Scotty Moore on the Ryman appearance. The notoriously unreliable Albert Goldman, *Elvis* (New York: McGraw-Hill, 1981), p. 122, quotes Atkins on Elvis's eyeshadow.

Bill C. Malone, *Country Music, U.S.A.*, rev. ed. (Austin: University of Texas Press, 1985), pp. 184–186, and Bob Millard, *Country Music* (New York: Harper, 1993), pp. 24, 68, and 77, discuss the Opry, the Hayride, and country music history of the period. Wilbur F. Creighton, *The Parthenon in Nashville* (Nashville: privately printed, 1989) is a fascinating case study in local boosterism.

The careers of Nudie Cohen and his rivals are analyzed in Tyler Beard, *100 Years of Western Wear* (Salt Lake City: Gibbs-Smith, 1993), p. 72.

June Carter Cash often tells her Elvis stories on stage; I heard her

run through the repertory in June 1993, at the Wayne Newton Theater in Branson, Missouri. A version of the Arkansas story appears in June Carter Cash, *From the Heart* (New York: Prentice Hall, 1987), pp. 126–129.

Chet Flippo, *Your Cheatin' Heart* (New York: St. Martin's, 1981), Colin Escott, *Hank Williams, The Biography* (Boston: Little Brown, 1994), and Lycrecia Williams and Dale Vinicur, *Still in Love with You: The Story of Hank and Audrey Williams* (Nashville: Rutledge Hill Press, 1989) are richly detailed biographies of the greatest Cadillac cowboy of 'em all.

New frontiers: the Las Vegas strip

Alan Hess, *Viva Las Vegas: After-Hours Architecture* (San Francisco: Chronicle Books, 1993), and Robert Venturi, Denise Scott Brown, and Steven Izenour, *Learning from Las Vegas* (Cambridge, Mass.: MIT Press, 1972) are the definitive studies of the aesthetic of the Strip.

The long-term relationship between Liberace and Elvis is explored for the first time in Patricia Jobe Pierce, *The Ultimate Elvis: Elvis Presley Day by Day* (New York: Simon and Schuster, 1994), pp. 128–129, 133. The "Saint Elvis" phenomenon receives respectful treatment in Ted Harrison, *Elvis People: The Cult of the King* (London: Fount, 1992).

The wedding breakfast (Redd Foxx seems to have been one of the few show business guests) and its menu are discussed in Brenda Arlene Butler, *Are You Hungry Tonight?* (New York: Gramercy Books, 1993), pp. 54–63. Butler gives detailed instructions for making an Elvis-Priscilla cake at home.

Jane and Michael Stern, *Elvis World* (New York: Alfred A. Knopf, 1987), pp. 93–107, are the ranking experts on Elvis Glitter. Although blighted by its author's usual bad attitude, Albert Goldman, "A Gross Top-Grosser: Elvis Presley at Las Vegas," *Life,* 68 (March 20, 1970), p. 17, gives a superb physical description of an early concert. Jill Pearlman, *Elvis for Beginners* (London: Unwin, 1986), p. 140, also has some interesting observations on the resurrection of Elvis in Las Vegas.

The 1956 debacle has been widely discussed. Jim E. Curtin, *Candids*

of the King (Boston: Little, Brown, 1992), pp. 54–55, provides the pictorial evidence. "Hillbilly on a Pedestal," *Newsweek*, 47 (May 14, 1956), p. 82, is typical of the negative publicity surrounding the New Frontier date.

Egil Krough, *The Day Elvis Met Nixon* (Bellevue, Wash.: Pejama Press, 1994), gives a minute-by-minute account of the White House visit.

Route 66: Hollywood to home

The story of Elvis in Hollywood is told firsthand in Alan Fortas, *Elvis: From Memphis to Hollywood* (Ann Arbor: Popular Culture Ink, 1992); Hal Wallis with Charles Higham, *Starmaker* (New York: Macmillan, 1980); Red West, Sonny West, Dave Hebler, and Steve Dunleavy, *Elvis: What Happened?* (New York: Ballantine, 1977); and Larry Geller and Joel Spector with Patricia Romanowski, *"If I Can Dream"* (New York: Simon and Schuster, 1989).

The early Elvis movies are treated by Steve Pond, *Elvis in Hollywood* (New York: New American Library, 1990); Steven and Boris Zmijewsky, *Elvis: The Films and Career of Elvis Presley* (New York: Citadel Press, 1991); and Richard Peters, *Elvis: The Music Lives On* (London: Souvenir Press, 1992). *Elvis in Hollywood: The 50s* (New York: BMG Video, 1993) is a superb visual account of the period.

Michael Wallis, *Route 66: The Mother Road* (New York: St. Martin's, 1990), pp. 1–2, 19, and 24, sets the scene for the trek westward. Greil Marcus, *Mystery Train: Images of America in Rock 'n' Roll Music* (New York: Dutton, 1976), pp. 201–203, supplies the traveling music.

George Barris and Jack Scagnetti, *Cars of the Stars* (Middle Village, N.Y.: Jonathan Davis, 1974), pp. 57–61, describes the bus. The maiden voyage to Las Vegas is recalled in Priscilla Beaulieu Presley with Sandra Harmon, *Elvis and Me* (New York: Berkley Books, 1986), pp. 76–85.

Tom Wolfe, *The Kandy-Kolored Tangerine-Flake Streamline Baby* (New York: Bantam, 1980) is a feast of pertinent essays on Southerners and their cars, customizing, and driving to Las Vegas.

Jack Gould's devastating review of Elvis's appearance on the Berle show in San Diego appeared in the *New York Times*, June 6, 1956.

All aboard the Mystery Train:
New York to Memphis

W. J. Weatherby, *Jackie Gleason: An Intimate Portrait of the Great One* (New York: Pharos, 1992), p. 108, discusses the Dorsey appearances. Rick Stanley with Paul Harold, *Caught in a Trap* (Dallas: Word Publishing, 1992), pp. 50–52, offers an interesting interpretation of the possible effect of the Allen show on Elvis in an otherwise exploitative book by one of Elvis's three stepbrothers.

John Lardner, "Devitalizing Elvis," *Newsweek*, 48 (July 16, 1956), p. 59, took Allen to task for his actions. Most of the stories that appeared in the popular press in 1956 pursued the hillbilly angle: Thomas C. Ryan, "Rock 'n' Roll Battle: Boone vs. Presley," *Collier's*, 138 (October 26, 1956), pp. 109–111; "A Howling Hillbilly Success," *Life*, 40 (April 30, 1956), p. 64; "Elvis Presley . . . He Can't Be . . . But He Is," *Look*, 20 (August 7, 1956), pp. 82–85; and "Elvis—A Different Kind of Idol," *Life*, 41 (August 27, 1956), pp. 101–102, 105–109.

Samuel Charters, selection from *Elvis Presley Calls His Mother after the Ed Sullivan Show*, in Lucinda Ebersole and Richard Peabody, eds., *Mondo Elvis* (New York: St. Martin's, 1994), pp. 17–21, illuminates that episode as well as the tension between home and life on the road.

The Audubon Drive house is described in Alfred Wertheimer and Gregory Martinelli, *Elvis '56: In the Beginning* (New York: Collier, 1979), and in the video version that appeared on Cinemax, August 16, 1987. Billy Smith, "The Audubon House," *Elvis: The Record*, 1 (June 1979), pp. 8–10, is a first-hand account by a relative. Jane and Michael Stern's *Elvis World* and Chet Flippo's introductory essay in *Graceland: The Living Legacy of Elvis Presley* (San Francisco: Collins, 1993) also add detail to the picture.

U.S. 51 South

Mark Winegardner, *Elvis Presley Boulevard: From Sea to Shining Sea, Almost* (New York: Atlantic Monthly Press, 1987), looks at Graceland from the perspective of the folks out in the street: the diehard fans, the quasi-cynics, and the merely curious.

The definitive gatekeeper memoirs are Vester Presley as told to Deda

Bonura, *A Presley Speaks* (Memphis: Wimmer Books, 1978), and Harold Loyd, *Elvis Presley's Graceland Gates* (Franklin, Tenn.: Jimmy Velvet Publishing, 1987).

Robert A. Sigafoos, *Cotton Row to Beale Street: A Business History of Memphis* (Memphis: Memphis State University Press, 1979), pp. 223–227, and Alice Fulbright, "Graceland . . . Before Elvis," *Commercial Appeal Mid-South Magazine*, April 11, 1971, both discuss the growth of Whitehaven.

Neal and Janice Gregory, *When Elvis Died* (New York: Pharos Books, 1980) describes the funeral in minute detail.

The touching story about the Hofman visit to Graceland after Gladys's funeral is one of many new pieces of information in Peter Guralnick's excellent *Last Train to Memphis: The Rise of Elvis Presley* (Boston: Little, Brown, 1994), pp. 481–482.

The Southern mansion

My information on sundry Moores, Browns, and Toofs came from the clipping files of the Memphis-Shelby County Library. Max Furbringer's treatise, his album of recent work, and clippings about his career can be consulted in the Special Collections Division, Mississippi Valley Room, Memphis State University Library. I visited the historic houses described several times over a three-year period, beginning in 1992.

Important commentary on the *Gone With the Wind* phenomenon in American culture is provided in Donald Albrecht, "Home Screen Home," *Architectural Record*, 180 (April 1992), pp. 46–47; Patricia Leigh Brown, "Tara, the Myth, Lives On in America's Suburbs," *New York Times*, October 3, 1991, p. C1; Darden Asbury Pyron, ed., *Recasting Gone With the Wind in American Culture* (Miami: Florida International University Press, 1983); Virginius Dabney, *Below the Potomac: A Book about the New South* (New York: D. Appleton-Century, 1942), p. 16; William Pratt, *Scarlett Fever* (New York: Collier, 1977); and the special *GWTW* issue of *House and Garden*, 76 (November 1939).

McIlwaine, *Memphis Down In Dixie*, p. 287, describes the effect of *GWTW* on the Cotton Carnival. David M. Tucker, *Memphis Since Crump*

(Knoxville: University of Tennessee Press, 1980), p. 93, cites the Housing Authority reports on the Presley family.

Darden Asbury Pyron, *Southern Daughter: The Life of Margaret Mitchell* (New York: Oxford, 1991), and Richard Harwell, ed., *Margaret Mitchell's Gone With the Wind Letters, 1936–1949* (New York: Macmillan, 1976), both detail the battle of the columns. The making of the movie is a fascinating story in itself: Susan Myrick, *White Columns in Hollywood* (Macon, Ga.: Mercer University Press, 1982); Ronald Haver, *David O. Selznick's Gone With the Wind* (New York: Wings Books, 1986); and Judy Cameron and Paul J. Christman, *The Art of Gone With the Wind: The Making of a Legend* (New York: Prentice-Hall, 1989), are among the best accounts of this Hollywood reprise of the Civil War.

Heavenly mansions

The first Graceland descriptions in the Memphis press are reprinted by Bill E. Burk, *Elvis Memories: Press Between the Pages* (Memphis: Propwash Press, 1992), pp. 57–58.

The appearance of the second floor of Graceland is still a closely guarded secret. Although the accuracy of his descriptions is not always to be trusted, the only systematic look at this part of the house is found in the opening chapters of Goldman, *Elvis*. Glimpses of the bedroom can also be seen in the opening minutes of the quasi-documentary *This Is Elvis* (Warner Home Video, 1986).

The Jaycees speech and the social events surrounding it are covered in detail by Cindy Hazen and Mike Freeman, *The Best of Elvis: Recollections of a Great Humanitarian* (Memphis: Memphis Explorations, 1992), pp. 3–15.

"Elvis! David!" *New Yorker,* 48 (June 24, 1972), p. 28, is one of several reviews of the period comparing Elvis to a celestial apparition.

Lyrics about mansions are especially prominent in *His Hand in Mine,* the 1961 RCA gospel album. All the gospel music, including a number of outtakes and unreleased cuts, has recently been issued as a two-cassette (or two-CD) set entitled *Elvis Presley Amazing Grace: His Greatest Sacred Performances*

Howard Finster as told to Tom Patterson, *Howard Finster, Stranger*

from Another World, Man of Visions Now on This Earth (New York: Abbeville Press, 1989), pp. 174–78, describes the vision and suggests correlations between the ecstatic religious beliefs of Finster and the character of rock music.

A. J. Jacobs, *The Two Kings: Jesus, Elvis* (New York: Bantam, 1994) is a spoof on the religious aspects of the Elvis phenomenon and his occasional suspicion that he might be a messiah. Clive Barker, "Notes on St. Elvis," in Paul M. Sammon, ed., *The King Is Dead: Tales of Elvis Postmortem* (New York: Delta, 1994), pp. 208–215, also takes up this theme.

Hollywood houses

The requisite characteristics of the movie-star home are codified in Charles Jencks, *Daydream Houses of Los Angeles* (New York: Rizzoli, 1978), pp. 7–12. Other treatments of the subject include Sid Avery and Richard Schickel, *Hollywood at Home: A Family Album, 1950–1965* (New York: Crown, 1990); Charles Lockwood, *Dream Palaces: Hollywood at Home* (New York: Viking, 1981); and special theme issues of *Architectural Digest* for February 1983, April 1990, and April 1992. Paige Rense has also edited several volumes of *Architectural Digest* excerpts on celebrity homes.

On Hollywood-style postcards of Southern mansions, see Jim Auchmutey, "White Columns," in Jim Auchmutey and Lea Donosky, eds., *True South* (Atlanta: Longstreet Press, 1994), pp. 51–53.

Cynthia McAdoo Wheatland and Eileen Sharpe are the coauthors of the *Ladies' Home Journal* series on young marrieds in Hollywood: "Ann Blyth and Jim McNulty: Young Hollywood at Home," 74 (February 1957), p. 64; "Tony Martin and Cyd Charisse," 74 (June 1957), pp. 70, 112; "Debbie Reynolds and Eddie Fisher," 73 (November 1956), p. 89.

Stanley Booth, "A Hound Dog to the Manor Born," *Esquire*, 69 (February 1968), pp. 106–108, is one of the only detailed descriptions of the interior of Graceland around the time of Elvis's marriage and "comeback."

Bob Thomas, *Liberace: The True Story* (New York: St. Martin's, 1987)

discusses Liberace's houses and his attitude toward architecture and fandom.

My "Elvis Presley's Graceland, or the Aesthetic of Rock 'n' Roll Heaven," *American Art*, 7 (Fall 1993), pp. 80–82, takes up the issue of the Hollywood star style.

Inside Graceland

George Golden's claim to have been the original decorator of Graceland is advanced in Flippo, *Graceland: The Living Legacy of Elvis Presley*, pp. 60 and 62, and Guralnick, *Last Train to Memphis*, pp. 397–398.

The research on which this chapter as a whole is based is outlined in my "Elvis Presley's Graceland," *American Art*, pp. 93–96. Dorothy Thompson, "The White Sofa," *Ladies' Home Journal*, 74 (February 1957), p. 11, provides fresh insight on a major cultural artifact of the period.

Priscilla describes her timid forays into decorating for Elvis in Sandra Shevey, "My Life With and Without Elvis Presley," *Ladies' Home Journal*, 90 (August 1973), pp. 82–83 and 139; and Vance Muse, "Amazing Graceland," *Life*, 10 (September 1987), p. 46.

Elvis exoticism: the Jungle Room

The sanctioned history of the Jungle Room and its reconstruction appears in *Elvis Presley's Graceland: The Official Guidebook* (Memphis: Elvis Presley Enterprises, 1993), pp. 22–23, and Marty Lacker, Patsy Lacker, and Leslie S. Smith, *Elvis: Portrait of a Friend* (Memphis: Wimmer Brothers Books, 1979), p. 82. Flippo, *Graceland*, p. 55, repeats the story about the Christmas fire.

The destruction of television sets is documented and discussed in Vernon Presley as told to Nancy Anderson, "Elvis," *Good Housekeeping*, 186 (January 1978), p. 160, and Greil Marcus, *Dead Elvis*, p. 196. Jenkins, *Memories beyond Graceland Gates*, pp. 60–61, describes the room before junglefication.

Todd Morgan's story about seeing jungle suites in Arkansas has been retold frequently. The most detailed version is quoted in Jane Brown Gillette, "Elvis Lives," *Historic Preservation*, 44 (May-June

1992), p. 95. Caroline Kennedy, "Graceland: A Family Mourns," *Rolling Stone*, 248 (September 22, 1977), p. 38, contains the first public disclosure that there was such as thing as a Jungle Room. David Stanley with David Wintish, *Life with Elvis* (London: Marc, 1987), pp. 167–168, gives one account of the purchase of the furniture. Fortas, *Elvis: From Memphis to Hollywood*, p. 118, also discusses the appointments.

For Elvis on antiques, see Filler, "Elvis Presley's Graceland," *House and Garden*, p. 186. Fan comment on the Jungle Room is cited in Julia Aparin, "He Never Got Above His Raising: An Ethnographic Study of Working Class Response to Elvis Presley" (doctoral dissertation, University of Pennsylvania, 1988), p. 79. Liberace is quoted in Thomas, *Liberace: The Untold Story*, p. 159.

Richard Peters, *Elvis: The Music Lives On* (London: Souvenir Press, 1992) p. 93, describes Felton Jarvis's office.

In the garden

The construction of the garden is a major theme of Larry Geller and Joel Spector with Patricia Romanski, *"If I Can Dream"* (New York: Simon and Schuster, 1989), pp. 125 and 131–134. Lacker, Lacker, and Smith, *Elvis: Portrait of a Friend*, pp. 90–91, is an important first-hand account. Marty's sister Anne and her husband, Bernie Grenadier, did the actual design and construction.

Gillette, "Elvis Lives," *Historic Preservation*, p. 52, includes interesting details about the south garden before Elvis.

Bienstock's story appears in Guralnick, *Last Train to Memphis*, p. 428.

Raymond A. Moody, Jr., M.D., *Elvis after Life* (Atlanta: Peachtree Publishers, 1987), is the best of the Elvis-is-alive-and-well books, with a mystical flavor. Gail Brewer-Giorgio, *Is Elvis Alive?* (New York: Tudor, 1988), packaged with an hour-long tape recording of Elvis speaking on the phone long after his supposed burial, is the book that bases a theory of his faked death on the spelling of "Aaron" on the grave tablet.

Elvis impersonators and their visions are chronicled in *I Am Elvis* (New York: Pocket Books, 1991) and Karin Pritikin, *The King and I: A Little Gallery of Elvis Impersonators* (San Francisco: Chronicle, 1992).

Fan rituals at the grave are analyzed in Harrison, *Elvis People*. Sue

Beckham, "Death, Resurrection and Transfiguration: The Religious Folklore in Elvis Presley Shrines and Souvenirs," *International Folklore Review*, 5 (1987), pp. 88–95, covers the same ground more thoroughly and with greater empathy.

Peckerwood palace

Kennedy, "Graceland: A Family Mourns," *Rolling Stone*, p. 40; Chet Flippo, "Love Me Tender: Funeral in Memphis," *Rolling Stone*, p. 39; and Joe Esposito and Elena Oumano, *Good Rockin' Tonight* (New York: Simon and Schuster, 1994), include descriptions of the funeral.

Albert Goldman, *Elvis: The Last 24 Hours* (New York: St. Martin's, 1991); West, West, Hebler, and Dunleavy, *Elvis: What Happened?*; Jerry Hopkins, *Elvis: The Final Years* (New York: Berkley Books, 1981); and Marion J. Cocke, *I Called Him Babe: Elvis Presley's Nurse Remembers* (Memphis: Memphis State University Press, 1979), all provide views of Graceland in the 1970s.

David E. Stanley with Frank Coffey, *The Elvis Encyclopedia* (Santa Monica: General Publishing Group, 1994), has some insights to offer on the relationship with Linda Thompson.

This Is Elvis, the 1981 video produced by David L. Wolper with Jerry Schilling and Joe Esposito as consultants, was partially shot inside Graceland before the restoration. This is the only known footage of the King's Room and the upstairs of the house. The carpeting of the red period is clearly visible.

Pagan Kennedy, "Elvis's Bathroom," in Ebersole and Peabody, eds., *Mondo Elvis*, pp. 154–169, and Lawrence Bloch, "The Burglar Who Dropped in on Elvis," in Sammon, ed., *The King Is Dead*, pp. 72–86, explore the allure of the upstairs that nobody can visit.

Jerry Hopkins, *Elvis*, and Dave Marsh, *Elvis*, are both essential to the study of the contextual Graceland. Rose Clayton and Dick Heard, eds., *Elvis Up Close In the Words of Those Who Knew Him Best* (Atlanta: Turner Publishing, 1994), is an important new source of interviews with members of the inner circle.

Acknowledgments

I wrote this book while teaching an Elvis seminar at the University of Wyoming, Laramie, where I occupied the William Robertson Coe Distinguished Chair in American Studies in 1994. My colleagues were unfailingly stimulating and encouraging: I am grateful to John Dorst for reading versions of several chapters and to Eric Sandeen for letting me tell him early every morning how yesterday's work had gone. Laramie loved Elvis, too—or feigned interest out of boundless kindness. The material on Faulkner was presented first as the Smith Lecture in the Department of English. My discussion of Tupelo was framed in response to an invitation to do a reading at Second Story Books.

Bob Haddow, Barb Coleman, Vicky Skorich, and Andy Lainsbury, my graduate students at the University of Minnesota, all helped with my research and served as boon companions on trips to Memphis, Nashville, Tupelo, and Oxford (Mr. Lainsbury's title for this book: *Going to Graceland with Andy and a Bunch of Other People in the "Silver Bullet"*). Adam Harris, Alice Wondrak, Jim Vander Hooven, and Matt Hyland, from my Wyoming seminar, had wonderful things to say about rock videos, Michael Jackson, Elvis and the press, and Eggleston. Erika Doss of the University of Colorado at Boulder took time out from her own work on Elvis fans to discuss my preoccupations with costumes, cars, and cultural geography. Many years ago, before the house

was open for tours, Erika and I spent a midnight hour with our faces pressed to the Graceland gate. Neither one of us ever got over it, apparently.

Colleen Sheehy invited me to speak about Graceland as part of the inaugural ceremonies for the new Art Museum at the University of Minnesota. Jim Cuno did the same at the Harvard Art Museums. Lisa Seigrist and the other brave editors of *American Art,* the journal of the National Museum of American Art, the Smithsonian Institution, were also receptive to the topic; the resulting article on the aesthetic of rock 'n' roll heaven received the Robert C. Smith Award from the Decorative Arts Society in 1993. High art. Elvis really *is* everywhere!

Greil Marcus lent a sympathetic ear. Susan Lehotsky, Eric and Judy Monkkonen, Sue Kendall, Gabe and Yvonne Weisberg, Steve Benson, Lisa Fischman, Cori Ander, Carole Lindstrom, Laura Evert, Pat Hemmis, Eric and Sue Sandeen, John Wetenhall, and Bob's mother, Barb Haddow, all contributed great Elvis artifacts to the cause. Chris Roberts interrupted a vacation to photograph "Miniature Graceland" for me.

Steve Kaplan at *Minnesota's Journal of Law and Politics* and Drexel Turner at *Cite* both supplied travel funds in exchange for occasional Elvis commentary. The Department of Art History, the University of Minnesota, picked up the tab for van repairs after that peculiar incident in the Wilson World parking lot. Minnesota Public Radio let me babble about Elvis on the air from pay phones all over the South.

Lindsay Waters and Alison Kent at Harvard University Press talked me into this book in the first place. Lindsay is the only person in America who likes Patsy Cline and the Grand Ole Opry as much as I do: our musical/gastronomic tour of Nashville was one of the brightest highlights of the project.